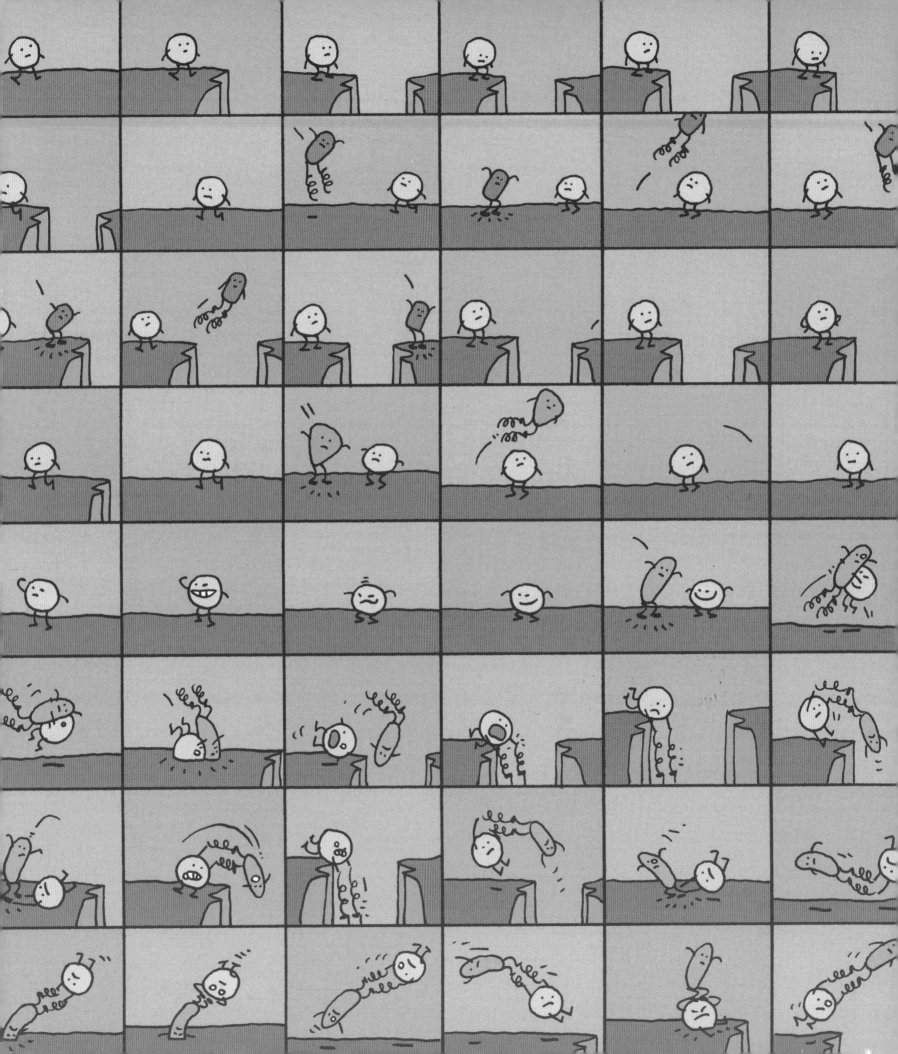

COMIC BOOK DESIGN

GARY SPENCER MILLIDGE

Watson-Guptill Publications / New York

◉ SPIDER-MAN/BLACK CAT:
THE EVIL THAT MEN DO,
MARVEL COMICS, 2002

First published in the United States in 2009 by:

Watson-Guptill Publications, an imprint of
the Crown Publishing Group, a division of
Random House, Inc., New York
www.crownpublishing.com
www.watsonguptill.com

This book was conceived, designed and produced
by

I L E X

210 High Street
Lewes
East Sussex BN7 2NS
www.ilex-press.com

Publisher: Alastair Campbell
Creative Director: Peter Bridgewater
Managing Editor: Nick Jones
Commissioning Editor: Tim Pilcher
Editor: Isheeta Mustafi
Art Director: Julie Weir
Designer: Jon Allen
Art Editor: Emily Harbison

Library of Congress Control Number
2009921478

ISBN 978-0-8230-9796-8

Printed and bound in China

10 9 8 7 6 5 4 3 2 1

CONTENTS

Foreword

In my experience, good design and creativity usually stem from limitation and constraint. Once the boundaries are set, it becomes easier to focus on and resolve specific problems.

As the saying goes—it's harder to park in an empty parking lot.

For a medium that deals primarily in expansive, larger-than-life scenarios and vistas, it's ironic that the comics medium has always been constrained by limitations of space like few others.

Pushed by the economics of publishing to a marginal status on the newsstand or magazine shelf, comics have traditionally enjoyed scant real estate from which to tout their wares; their covers becoming—of necessity—miniature masterpieces of attention-grabbing design. There's no time for subtlety when you're the runt of the litter.

And even once the reader has been persuaded to buy the comic and open its cover, space is still at a premium, its scarcity now dictated by the nature of the medium. Each panel of a comics narrative competes with its neighbor for space and impact and it is the successful resolution of this conflict that makes for a good comic book page.

Furthermore, within each individual panel, elements are in contention and need to be carefully resolved and related. It's always seemed to me that where and what size you draw something is more important than how you draw it, as far as narrative is concerned.

It's also surprisingly easy to lose sight of the fact that narrative is what comics are all about. Anything that impedes the flow of the story or unnecessarily calls attention to itself should be excised or adjusted. Great draftsmanship is wonderful until you notice it, or—put another way—the effect is always more important than the means.

Which is fortunate, because the means have usually been pretty elementary when it comes to comics. Simple line-cut printing technology using crudely applied color separations has been the norm for much of the history of the medium, with text elements usually added by hand rather than typesetting. Paradoxically, this has given comics much of their appeal; the sense of informality that connects so directly with the reader.

Even today, when the computer has become as ubiquitous a tool as the sable brush, the dip pen, and the scalpel in the production of comics, the challenge is still the same; grab the reader's attention and then keep it.

This book should go a long way in identifying the problems and solutions inherent in doing just that. Happily, it is, in itself, an example of good publication design. The fact that you're reading this introduction means that this book's grabbed your attention; the content you're about to encounter should have no problem in keeping it.

As a lifelong student of the medium, I can tell you that in a crowded field of instructional books, this volume is unique and indispensable in addressing an aspect of comics previously only mentioned in passing.

May all your creative parking lots have one perfect space left for you.

Dave Gibbons

○ THE ORIGINALS,
VERTIGO/DC COMICS, 2002

Me and Bok were always friends. The stupid kids used to pick on him because he was black and I used to pile in to help him. We got really good at fighting.

We liked the same music. Wore the same clothes. Chased the same girls.

We both wanted the same things when we left school. Make some money, of course.

What Is Design?

Design is an ever-present aspect of modern life. Everything, from product packaging, cars, phones, newspapers, websites, shop fronts, clothing, advertising, television, and the programs that appear on them has been subject to conscious and deliberate design.

More specifically, graphic design is said to be all about visual communication and presentation, a discipline which combines symbols, images, and/or words to express ideas and messages.

That's not a bad definition of comics in itself.

Comics in the form of newspaper strips, comic books, or graphic novels are a combination of words and pictures in a specific sequence in order to communicate stories and ideas. Will Eisner's term "sequential art" probably remains the most concise description.

Design is a crucial aspect to creating comics. It's not enough to have a compelling story and beautiful artwork; these two elements must work together to create a clear, comprehensible narrative that invites the reader into its world and keeps him there.

Graphic design involves combining various, sometimes disparate elements together in a readable, attractive arrangement.

In comics, this design needs to function at several levels; the content of each panel often incorporates an image, graphical elements containing speech or narration, type representing sound effects, and color. The page usually contains several interlocking panels, arranged not only to provide an intuitive reading sequence, but also to create a pleasing, overall design.

At the highest level, these pages are placed in a book or pamphlet format with additional materials such as text pages, illustrations, and covers, all working together to produce an attractive package.

It doesn't end there; details like the book title or masthead, the publishers' logo, and other elements all need to be consciously designed. The characters that play a part in the stories, and the clothes and costumes they wear are also subject to the design process.

What Are Comics?
Comics are a unique synthesis of words and pictures; a distinct art form with its own strengths and weaknesses. Unlike cinema, the pictures don't move. Multiple images are presented in a single composed page and "read" like a prose novel, even when there are no words present.

Comics are more than the sum of their parts; they're not just a sequence of images over a number of consecutive pages in a pamphlet or book, or on a computer screen. They're not just pretty pictures illustrating a story. They're

not just the words, the lettering fonts, the speech balloons, the size and shape of the panels, the borders around the panels, or the lack of them. Comics are a combination of all these things and more.

The way all these disparate elements are designed to work together to create a storytelling experience is what results in comics. The success or failure of each comic story is largely dependent on the talent, experience, style, and craft of the creators involved.

Comics and the Single Creator
Perhaps most crucially, successful comics are often the product of a single individual. Other forms of visual communication like theater, animation, film, and television generally require the input of many other minds, usually resulting in a dilution of the original creator's vision.

Many of the medium's finest works have been produced by a single creator. From Will Eisner to Chris Ware, Art Spiegelman to Frank Miller, Dan Clowes to Posy Simmonds, Robert Crumb to Alison Bechdel.

The traditional, much criticized "assembly line" method of creating comics (which usually involves different individuals to script, pencil, ink, letter, color, and edit) has nevertheless produced a large number of outstanding examples of comic art. This is often the result of a close, sometimes near-symbiotic relationship between writer and artist.

With such collaborations, it is essential that the writer is visually minded—perhaps an artist or former artist himself.

Alan Moore, probably the greatest comics writer of his generation, not only started out as an artist, but has the rare and uncanny ability of playing to the strengths of each collaborative artist he works with.

Incredibly talented comics creators in their own right—Eddie Campbell, Melinda Gebbie, Dave Gibbons, Kevin O'Neill, David Lloyd, J. H. Williams III, and several others—are still probably best known for their respective collaborative masterpieces with Moore.

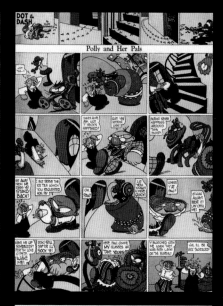

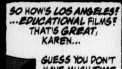

⌂ ⌂ **POLLY AND HER PALS, SUNDAY 26 SEPTEMBER 1926, THE COMPLETE COLOR POLLY AND HER PALS, VOLUME 1**
KITCHEN SINK PRESS, 1990.

Cliff Sterrett incorporated various modern art influences, from surrealism to art noveaux in his beautiful Sunday page designs.

⌂ **THE FILTH #1,**
DC/VERTIGO COMICS, AUGUST 2002

Carlos Segura's pictographic cover designs for Grant Morrison's dense, imaginative mini-series were a huge departure for American comic books.

◁ **ELEKTRA LIVES AGAIN,**
MARVEL/EPIC COMICS, 1990

A typically innovative page design by Frank Miller with color by Lynn Varley.

Frank Miller is perhaps one of the most important comics creators in recent years, transforming Marvel's *Daredevil* and creating his nemesis Elektra, updating Batman for the 1990s, creating from cloth *Sin City* and *300*, all hugely successful in both the original comics and their more recent movie adaptations.

Miller does not claim to be a perfect draftsman or have an absolute command of anatomy; he doesn't need to. His distinctive art style, his storytelling skills, and most of all, his sense of design are second to none.

Historical Context

One might think that the advent of single creator comics is a recent development, but some of the best examples from the early part of the Twentieth Century were created by a lone auteur. The full-page Sunday newspaper strips by the likes of George Herriman, Winsor McKay, Frank King, and Cliff Sterrett were funny, energetic, inventive, and often stunningly beautiful.

Their influence is still visible today in works by Chris Ware, Tony Millionaire, Seth, and many others.

Every decade in comics' short history has thrown up a new wave of creators who break the status quo and propel the medium forward.

Created during the early Twentieth Century, the constantly imaginative, innovative, and decorative Sunday newspaper layout designs of Herriman's *Krazy Kat* and McKay's *Little Nemo in Slumberland* remain landmarks of comics history.

Jack Kirby and Steve Ditko's prolific collaborations with Stan Lee at Marvel in the 1960s introduced soap opera elements and forever raised the standard of the American superhero comic, while the underground movement produced a comics genius in the shape of Robert Crumb.

In the 1970s, Jim Steranko and Neal Adams brought graphic design sensibilities from the advertising world and took the subject matter to more mature arenas.

Bill Sienkiewicz and Dave McKean pioneered a fine-art direction to comics in the 1980s, while the direct market opened up opportunities for self-publishers like Dave Sim. The seminal *Watchmen* and *Batman: The Dark Knight Returns* turned the superhero comic in a new grim 'n' gritty direction. The publication of Art Spiegelman's *Maus* signaled the start of a revolution in the public acceptance of the graphic novel.

By the 1990s, the US comics industry had become much more diverse, with small publishers like Fantagraphics and Drawn & Quarterly supporting the growing art comics movement of creators like Gilbert Hernandez, Jaime Hernandez, Dan Clowes, Chester Brown, and Chris Ware.

The new millennium has seen the impressive growth of the graphic novel in the bookstore market, creating mainstream stars of auteurs like Alison Bechdel, David B, and Marjane Satrapi. This has also enabled much of the medium's finest work to be brought back into print, giving today's comic book designer the opportunity to benefit from comics' rich history.

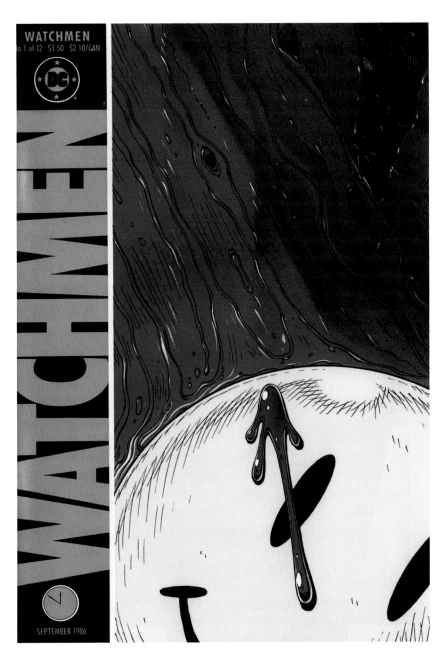

⬀ WATCHMEN #1, DC COMICS, *SEPTEMBER 1986*

Alan Moore and Dave Gibbons' seminal twelve-issue mini-series from 1986 transformed the way superhero comics were written and designed, and remains an all-time classic today.

⬀⬀ END OF THE CENTURY CLUB: COUNTDOWN, *SLAB -O- CONCRETE, 1999*

A stunning example of the type of storytelling which can only be achieved in comics. By British creator ILYA.

⬀ MR. PUNCH, *DC COMICS/VERTIGO, 1995*

Dave McKean brought a fine-art sensibility to the humble comic book, blending painting, sculpture, and photography to create his trademark style. His work with writer Neil Gaiman included *Sandman*, *Black Orchid,* and graphic novels like this page from *Mr. Punch*.

Going Global

Comics have long since outgrown their pulpy origins and are now correctly considered a medium rather than a genre. They are more readily available, not just as pamphlets in specialist comics stores, but as graphic novels in major bookstores and in digital form over the Internet.

Comics in general are becoming more contemporary, more experimental, more expansive.

It wasn't so long ago that to be a comics reader had unflattering, geeky associations. Today, comics are reflected in modern culture—they are trendy, cool, and vital.

Hollywood enjoys box-office smash movies adapted from major comics properties like *Iron Man*, *Spider-Man*, *Batman*, and *V for Vendetta*, as well as independent graphic novels like *300*, *Sin City*, *Persepolis*, *Wanted*, *American Splendor*, and *Ghost World*.

Comic book imagery by Dave McKean and Adrian Tomine adorns music CDs; a specially commissioned line of classic Penguin book jackets feature illustrations by Charles Burns, Chris Ware, and Jason. Cover art and comic strips by the likes of Seth and Dan Clowes often appear in the *New Yorker* magazine.

Comics have become as much a part of modern design and illustration as modern design has become part of comics.

Going Digital

Over the past decade or so, the digital revolution has transformed the world of graphic design and publishing—and along with it comics.

These days comics rarely make it to the printed page without being touched at some point in the process by computer applications like Adobe's Photoshop or Illustrator.

One-time traditional comics creators like Brian Bolland now use computers exclusively to create their beautiful illustrations. The younger generation of web comics creators find it is a natural process to produce all their artwork directly on the computer.

Still, many comics remain essentially low-fi. Even today, all that's required to create them is a pen, paper, and imagination.

The talent and craftsmanship, the design and storytelling skills, the imagination and innovation of the artists continue to be driving forces behind the creation of comics, no matter what the production method or delivery system.

Design and Comics

Design permeates every aspect of comics creation. The creator has to constantly make design choices regarding character and location designs, panel layouts, page composition, font selection, balloon placement, and color design.

Periodical comic books and graphic novels have to be designed as a distinctive package in a variety of formats, with attractively designed covers, logos, and various text pages.

Thoughtful, high quality design is vital for a comic book or graphic novel to succeed. No matter what techniques are used, an eye for design is one of the most important skills a comics creator should own.

Of course, design is not always a conscious process. The professional designer will make intuitive decisions based on experience and creativity as well as more cognizant thought processes.

There are no unbreakable rules in comics design. The old adage that you need to learn the rules before you break them is equally true in comic book creation as it is in any other discipline.

Finally

This book intends to individually consider the various constituent parts of the comic book or graphic novel, including character design, panel composition, storytelling, page layout, lettering, color, covers, and overall publication design. There are also feature spotlights on some of the most innovative and vital contemporary comics designers working in the industry today.

Even with a book of this size, the scope is limited in some respects. Although much of the content in this book can easily be applied to variations like single tier newspaper strips, manga, or web comics, the views, information, and analysis will primarily relate to traditional western print formats.

The geographical focus of this book will be mainly American comics with some examples of translated European works. No distinction will be made between comics of different formats or genres, be they superhero fantasy or art comics autobiography.

Chapter 1
Character and Location Design

◀ **COMPLETELY PIP AND NORTON VOLUME ONE,**
DARK HORSE COMICS, 2002
Dave Cooper's frenetic, hyperactive, visually distorted character Norton.

▶ **CAGES,**
NBM PUBLISHING, 1994
Subtle, naturalistic characterization by Dave McKean, from his superb *Cages* graphic novel.

Introduction

For many creators, characters are the most important element of a comic book story. A graphic novel may have a cool, original concept, a kick-ass plot, and stunning artwork, but without characters with which the readers can identify, it will almost certainly fail.

The design of a story's participants is therefore of paramount importance. For many writers, their stories are essentially about the transformations that their characters experience during the course of the plot.

Unlike devising characters for the majority of other media, creating characters for comic books requires a large degree of visual design in addition to aspects of personality and back-story. This is especially true with regard to the visual appearance of superhero characters, where the costume plays such a large part in their identity. But because of the huge diversity of drawing and cartooning styles in which a comic book may be illustrated, even everyday characters can be designed to be distinctive and memorable.

Character designs, as everything else, should serve the needs of the story.

Creating Characters

Creating characters for collaborative comic book stories usually involves the input of both the writer and artist, and often the editor too, particularly in the case of the assembly line production chain of the large superhero comics publishers. The writer will mainly be concerned with the conception of the characters, as well as their personality traits and backstory. But while the visual design is the responsibility of the artist, it's likely that the writer will give a certain amount of direction and suggestion.

In many cases, it's not necessary for solo creators to specifically "design" characters, as much of it is done intuitively. Independent art comics creators who write and draw their own material may develop characters from their sketchbooks, or simply improvise as the story dictates as part of an ongoing, organic process. Some solo creators eschew the idea of character design altogether, intuitively creating every aspect of the participants in their story.

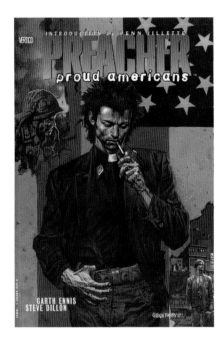

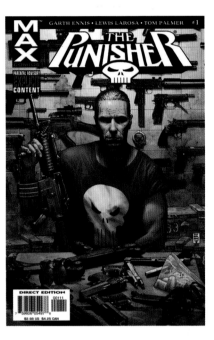

⬆ PREACHER: PROUD AMERICANS,
DC COMICS, VERTIGO, 1997
Garth Ennis' disillusioned reverend Jesse Custer's violent journey across America was wildly popular during its 66-issue run, each with a stunning painted cover by Glen Fabry.

⬇ THE PUNISHER #1,
MARVEL COMICS, APRIL 2000
Originally a Spider-Man villain, the Punisher became an anti-hero with a successful comic book series of his own. Photo-realistic cover art by Tim Bradstreet.

"PERHAPS YOU'LL KILL ME..."

⬅ BATMAN: THE KILLING JOKE,
DC COMICS, 1988
The perennial superhero antagonists Batman and the Joker as envisaged by Brian Bolland.

THE COMPONENTS OF CHARACTER

Every character in a story should be unique, with their own distinct visual appearance and personality. The essential components of each character can be broken down into three broad areas:
• Role and Function
• Personality and Backstory
• Visual Design

ROLE AND FUNCTION

Each character's relative importance to the story should be considered during development. Main protagonists should be much more clearly defined than less important characters, with a more developed history, motivation, and personality. It's worth bearing in mind that the readers should also be able to identify with the main character—the protagonist or hero—and their sympathies should lie with him.

The antagonist or the villain of the piece should likewise be well thought through, and although he should have logical motivations, he should evoke less sympathy than the hero.

The concept of having a clearly definable protagonist and antagonist—whether it be Batman and the Joker, or Tom and Jerry—makes it relatively simple for the writer to devise the second part of the classic three-act plot structure; set-up, conflict, and resolution.

Central characters do not always need to be the polar opposites of each other to create conflict, but their differences can still drive the story. Classic tales such as Beauty and the Beast and The Prince and the Pauper illustrate this.

The supporting cast are also important participants in the story, but they tend to be less developed than the central

characters; otherwise they may distract from the thrust of the narrative. It's unnecessary to spend a lot of time devising characters that may have only a small role to play in the plot. Not only is it a waste of effort, it can confuse the reader and interfere with the storytelling process.

There is nothing wrong in using character archetypes. However, archetypes like the hero or villain, the damsel in distress, the traitor, the dumb blonde, or the mad scientist can turn into stereotypes without carefully devised history and motivation.

Some stories are of course, more complex than a simple good-versus-evil concept. Anti-heroes have become more popular in fiction, with characters like the Punisher, Venom, and Preacher becoming fan favorites despite their dubious morals.

Naturalistic characters have more in common with real life and are changed by the events of a story over a period of time. These characters usually feature in self-contained graphic novels, where the character development is part of the story itself.

There are also stories where no one protagonist is central to the plot, but rather a group of characters interact together to create the story. Ensemble casts are popular in soap opera-style series like Terry Moore's long-running independent comic book *Strangers in Paradise*, or Alex Robinson's *Box Office Poison* graphic novel.

My own *Strangehaven* continuing series has a main protagonist, Alex Hunter, through whom the rest of the story's characters are introduced to the reader.

PERSONALITY AND BACKSTORY

In order to make a character more believable, some attention should be given to a fictional life history; where and how they were raised, pivotal events in their lives, their hopes and fears, motivations, and ambitions. These life stories don't have to be too involved or complicated, especially for the lesser characters, but a solid understanding of each character is essential for clear storytelling.

Behavioral traits such as speech patterns, body language, gestures, and facial expressions further refine the character. Many writers consciously or subconsciously use different aspects of their own personalities to shape their creations.

All these elements help to inform the uniqueness of the character's personality. David Mamet, in his book *On Directing Film*, argues that there is no such thing as "character"; there is merely habitual action. It's a useful point to consider, whether you agree or disagree.

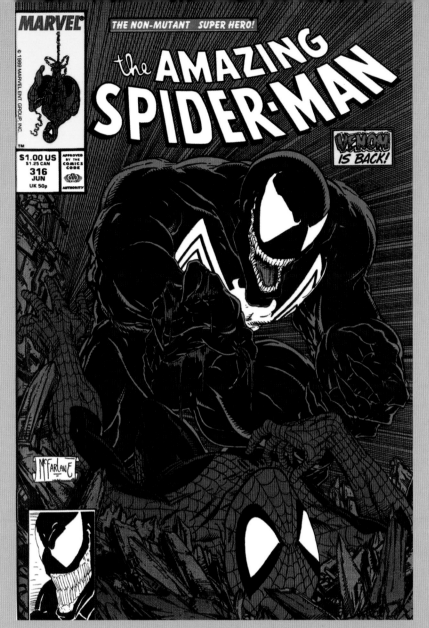

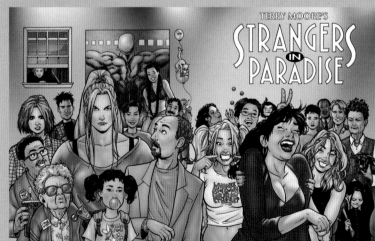

◔◔ SPIDER-MAN: BIRTH OF VENOM, *MARVEL COMICS, 2007*

Spider-Man and Venom as envisaged by Todd McFarlane.

◔ GASOLINE ALLEY, FEBRUARY 26, 1921, *WALT & SKEEZIX, DRAWN & QUARTERLY, 2005*

In Frank King's celebrated newspaper strip *Gasoline Alley*, the characters aged in "real time," growing up, dating, getting married, having babies, and dying.

◔ STRANGERS IN PARADISE SOURCE BOOK, *ABSTRACT STUDIOS, 2003*

Some of the highly developed characters from Terry Moore's delightful soap opera.

VISUAL DESIGN

The visual representation of the characters will of course, depend on the artist's inherent style. This can mean that the design may consist of anything from a stick figure to a fully rendered or photo-realistically painted character. But within the artist's style there must be clear variations to distinguish the characters from one another. Among the things to be considered are the character's physique, height, age, ethnicity, features, and hair.

The visual design should reflect the character's social status, occupation, and physical and emotional characteristics. Clothing may be anything from a loincloth to body armor, superhero costume, cocktail dress, business suit, or police uniform, with props to match. Even street clothes can suggest wealth or destitution, high fashion or nerdiness.

Visual character design can also be inspired by real people, sketches from life, or perhaps even celebrities and public figures, although it's advisable to make sure the likeness is distinct enough to avoid any potential lawsuits.

Character designs for biographical or autobiographical comics are not necessarily realistic depictions. Varying degrees of abstraction can be applied depending on the style of the artist, without losing the real-life characteristics of the subjects.

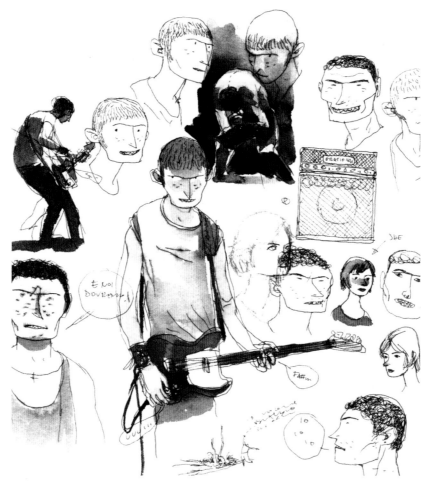

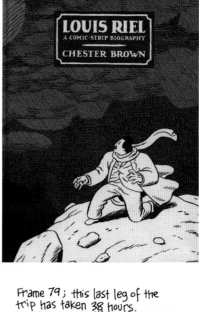

⊘ GARAGE BAND,
FIRST SECOND, 2007

One of Italian creator Gipi's elegant character studies for the members of his garage band.

⊘⊘ LOUIS RIEL,
DRAWN & QUARTERLY, 2006

Chester Brown's unusually chunky visual designs for characters in his award-winning biography of the Canadian hero Louis Riel were inspired by Little Orphan Annie's creator Harold Gray.

⊘ EMELIA WITHERSPOON FROM EXCALIBUR, *MARVEL COMICS*

The clairvoyant character Miss Emelia Witherspoon in Alan Davis' original *Excalibur* series was based on the English actress Margaret Rutherford. According to Davis, "This was prior to being able to freeze-frame movies or Google images so, when I noticed a film of hers was on, I grabbed a sheet of paper and made some very quick sketches. The gap in the drawing halfway up the page is where my thumb was holding the sheet of A4 paper on the back of a book. It really was that impromptu."

Frame 79 ; this last leg of the trip has taken 38 hours.

Life & Death - page 10

NOVEMBER 30, 2004

⊘⊘ THE ARRIVAL,
ARTHUR A. LEVINE, 2007

Shaun Tan's photo-realistic pencil artwork depicts a world almost like our own, but not quite; printed language, clothing, and animal and human physiques are slightly altered to contribute to a surreal reading experience.

⊘⊘ ALEC: THREE PIECE SUIT,
TOP SHELF, 2001

Using a character called Alec McGarry, writer/artist Eddie Campbell has been drawing thinly veiled autobiographical comics in his distinctive dip-pen style throughout his entire career.

⊘ AMERICAN ELF BOOK 2,
TOP SHELF, 2007

James Kochalka's depiction of himself on his daily web comics diary *American Elf*. A combination of well-observed autobiography and intentionally naïve artwork has gained him a huge following.

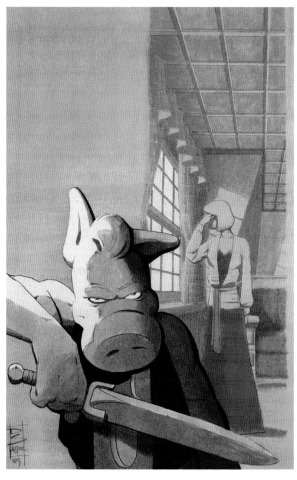

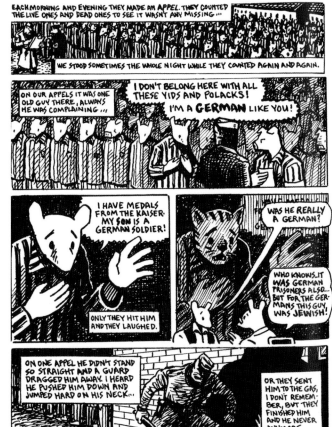

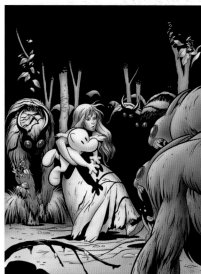

NON-HUMAN CHARACTERS

Anthropomorphic characters have always been popular in fantasy fiction, either as humanoid designs with animal heads, or upright-standing, partly modified animals.

Monsters and fantasy creatures are great fun to design, as are other non-humanoid characters like robots and extraterrestrials. The artist can depict them as simple cartoon exaggerations or as realistically rendered characters.

◑ CEREBUS #75,
AARDVARK-VANAHEIM, JUNE 1985

Despite the rest of the cast being human, the title character Cerebus is an aardvark; a talking, sword-wielding earth-pig who becomes prime minister, pope, bartender, and messiah. Creator Dave Sim and background artist Gerhard produced a staggering 300 issues on a monthly schedule.

◐ MAUS II: A SURVIVOR'S TALE,
PANTHEON, 1992

Art Spiegelman famously used an animal metaphor for the harrowing account of his father's experience of the holocaust. Jews were mice, Germans were cats, Poles were pigs, and so on. Although this has caused some controversy, Spiegelman has said that he intended to lampoon social stereotypes. It has also been suggested that the metaphor offers a degree of detachment for the reader, allowing Spiegelman to depict the horrific subject matter.

◑◑ TELLOS: RELUCTANT HEROES,
IMAGE COMICS, 2001

The cast of Todd DeZago and Mike Wieringo's fantasy adventure *Tellos* mixes human characters with animal hybrids. A young boy, a pirate princess, and a pointy-eared thief team up with a mischievous fox and a tiger warrior.

◐ THE BIG GUY AND RUSTY THE BOY ROBOT, *DARK HORSE COMICS, 1995*

Created by Frank Miller, robots Rusty and the giant Big Guy are sleekly designed by Geof Darrow.

◐◐ BONE #5,
CARTOON BOOKS, JUNE 1992

Within a well-defined and distinctive style, Jeff Smith mixes abstracted, cartoony creatures with more realistic backgrounds and figure work. It's proof of Smith's skill as writer and cartoonist that he convinces the reader that the title character Bone is infatuated with Thorn, despite their physical differences.

◑ A.L.I.E.E.E.N.,
FIRST SECOND, 2006

Lewis Trondheim uses his pared-down cartooning skills to design a variety of different-looking extraterrestrial monsters with just a few simple lines.

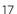

Designing superheroes

Visual design for superheroes usually follows a well-worn path: exaggerated, muscular bodies, tight-fitting costumes, and one or two matching accessories. There are many different takes, but most are derived from the trend-setting design of Siegel and Shuster's Superman.

SUPERHERO ARCHETYPES

In fact, the earliest superhero characters have become archetypes themselves.

◐◐ Captain Marvel's (or Shazam's) similarity to Superman initiated a successful copyright infringement lawsuit by DC Comics. Even so, since then, heroes like Supreme, Samaritan from *Astro City*, Hyperion, Prime, Tom Strong, and many others have been extensively based on the all-powerful Superman.

◐ Jeff Smith's interpretation of the Golden Age hero Captain Marvel.

◐◐ Even art comics creator Chris Ware has succumbed to the archetype with his own masked version of Superman.

◐ Batman, the super-fit, super-trained, but non-powered hero, has also had his own set of imitators, including Nighthawk and Moon Knight. The archetype could also be extended to include other athletic heroes like Daredevil and the Black Panther.

Of course, Bob Kane's Batman design was itself heavily influenced by the popular pulp character The Shadow.

◐ Despite his origin being based on Egyptian legends, Moon Knight is very much a bleached version of the caped crusader.

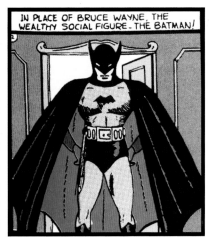

○ Supreme, created by Rob Liefeld and Brian Murray for Awesome Comics, was re-imagined by Alan Moore.

○○ A recent pulpy, gritty interpretation of the blind "Man Without Fear," Daredevil, by Alex Maleev.

Other archetypes include the underwater hero (Aquaman, Prince Namor), archers (Hawkeye, Green Arrow), the winged hero (X-Men's Angel, Hawkman), size-changers (the Atom, Giant-Man, Ant-Man), sorcerers (Dr. Strange, Zatanna, Dr. Fate), and the speedster (Flash, Quicksilver).

Animals used as a basis for character design have always been another popular solution; Catwoman, the Black Panther, Tigra, Wildcat, and the Black Cat are just some of the feline-inspired heroes.

Metaphorical casting can also be used to create groups of characters, for example members of superhero teams. The Fantastic Four are a team of elementals; the Human Torch represents fire, the Thing for earth, the Invisible Woman for air, and the fluid-bodied Mr. Fantastic is a slightly "stretched" metaphor for water.

Stan Lee based his version of Thor transparently on Norse mythology, with a supporting cast of Odin, Loki, et al., set in both the realm of Asgard as well as the Earth-bound Marvel universe. Neil Gaiman later created new characters from the same mythological roots in his celebrated *Sandman* series for DC Comics.

There are of course many different ways to categorize heroes, and combinations of different archetypes can provide another way to create a fresh, original character.

○○ Steve Gerber's "non-team," the Defenders, was created for Marvel Comics in the 1970s, and included their own Batman clone, Nighthawk.

○ MIDNIGHTER #1,
WILDSTORM/DC COMICS, JANUARY 2007
Ethnicity and sexuality are other factors that can be considered; Marvel's Black Goliath was an African American version of the Giant-Man archetype, while Warren Ellis' *Midnighter*, was an openly gay interpretation of the Batman character.

○○ Samaritan from *Astro City*, created by Kurt Busiek, Brent Anderson, and Alex Ross.

○○○ FANTASTIC FOUR # 554,
MARVEL COMICS, 2008
Bryan Hitch's current interpretation of the Stan Lee and Jack Kirby creation, *Fantastic Four*.

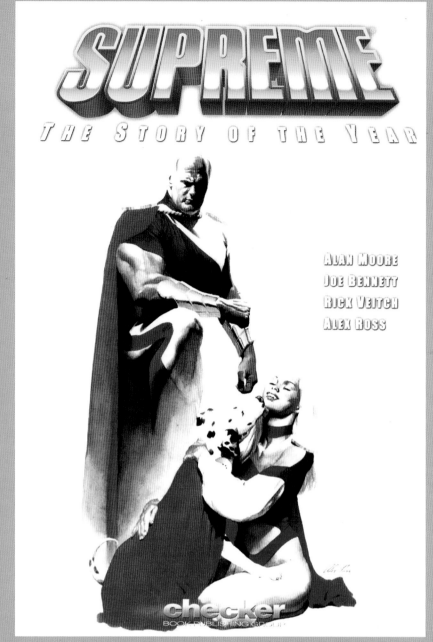

ALAN MOORE
JOE BENNETT
RICK VEITCH
ALEX ROSS

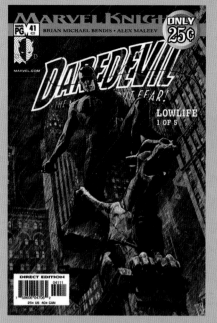

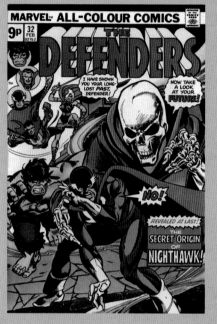

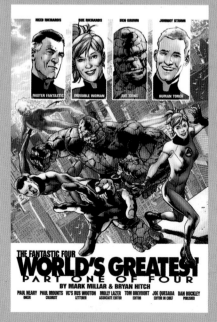

CHARACTER DEVELOPMENT

Heroes like Tarzan, Spider-Man, and Superman have simplistic motivations, and in the traditional style of the comic book story, the status quo is always restored with the central characters unchanged, ready for their next adventure. This was typical of the characters featured in periodical superhero or juvenile comics, where issues could be read in any order.

More recently, superhero characters have often been given the illusion of development, but sooner or later, the characters are forced to return to their archetype. Characters owned by corporations cannot be allowed to change for marketing reasons; the black-costumed Spider-Man had to revert to his red and blue, while Superman could not remain dead for long.

One of the most compelling elements of superhero character design is that they invariably consist of two separate characters: the hero and the (usually secret) alter ego. While Superman may be a one-dimensional character with simple motivations, the addition of Clark Kent makes him an immediately more complex—and interesting—character.

In fact, the maintenance of a secret identity suggests all kinds of psychological facets of a character that can be explored, providing an almost endless supply of inner conflict. This also presents the dramatic possibilities of the hero being unmasked—much exploited by DC Comics in the 1960s.

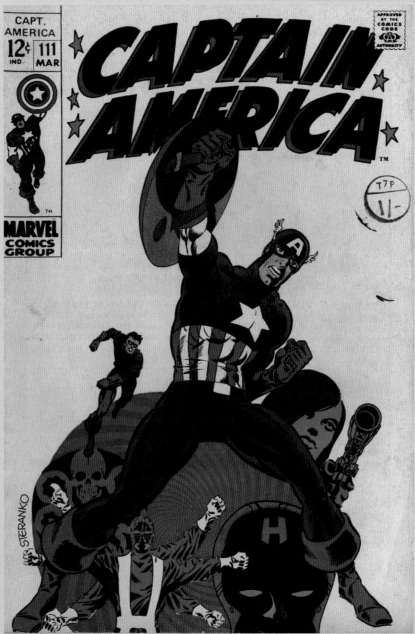

◮ **AMAZING SPIDER-MAN #70,**
MARVEL COMICS, MARCH 1969

Peter Parker suffers the anxiety of trying to balance the responsibilities of two identities.

◮ **CAPTAIN AMERICA #111,**
MARVEL COMICS, MARCH 1969

Jim Steranko's short but influential stint on *Captain America* was a landmark in comic book design.

◗ **X-MEN: DEADLY GENESIS,**
MARVEL COMICS, 2006

For the *X-Men* event *Deadly Genesis*, Marvel Comics commissioned Trevor Hairsine to design some new young mutant characters, "an unknown team of kids from between the original and New X-Men."

The designs for Darwin and Sway can be seen here. "I was trying for a cross between Neal Adams and Dave Cockrum," says Hairsine.

COSTUME ELEMENTS

A superhero's name is often closely linked to both his powers and his costume.

Captain America's famous outfit is liberally decorated with the red, white, and blue designs of his national flag. Batman's chest insignia, erect ears, and wing-like cape are all evocative of the bat. Spider-Man has the proportionate strength of a spider, shoots webs, and wears a costume with spider insignia on the front and back.

Spidey's costume design was quite remarkable nonetheless, apart from being in the most unspider-like colors of red and blue. An all-over leotard, with its intricate spiderweb design, has been a nightmare for artists to draw ever since. His full-face mask with large opaque eyes made it impossible to portray facial expression, so his emotions have had to be depicted by body language and other visual tricks.

The clichéd nature of the superhero costume makes it difficult to create an original, distinctive design for a new hero. Inspiration should be sought from places other than existing comics characters, such as theater costumes, fashion magazines, the animal kingdom, and other less-obvious sources.

For modern, realistic superhero costumes, practicality should be considered. The cape is a staple costume component for superheroes, but how sensible is it? Even though the cape appeared to be obligatory for "golden age" superheroes like Batman and Superman, Stan Lee's Marvel superheroes were different.

Introduced in the early 1960s, Spider-Man, the Fantastic Four, Daredevil, Iron Man, and the original X-Men were all cloak-free, and even the sorcerer Dr. Strange first appeared without one. Lee and his artists were a little more liberal with cloaks for villains like the Mole Man and Doctor Doom, but even these were in the minority.

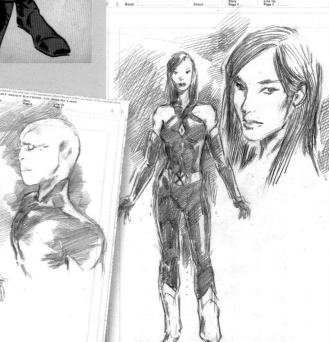

The Batman and Superman iconic chest insignias are the most recognizable symbols of the entire comics industry. A prominent costume logo was once almost obligatory for the superhero, but it's now less common.

Taking another fresh viewpoint, Marvel's original wave of heroes dispensed with insignias with the exception of Spider-Man and Daredevil, while the Fantastic Four and the X-Men sported subtle yet distinctive indications of their group allegiance.

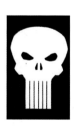

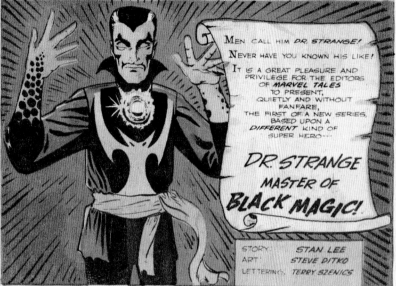

PROPS

Costume design can also extend to a superhero's props and accessories.

Superhero costumes are not only for "striking the fear into the hearts of criminals"; sometimes they also hide functionality. Captain America's shield doubles as a weapon. Batman's utility belt contains any number of useful items, including many an outlandish invention that writers have dreamed up to get him out of a sticky predicament.

Some costumes conceal useful weapons, such as Iron Man's powered body armor, packed with miniaturized gadgets. Dr. Strange's mystical amulet, Daredevil's billy club, and Spider-Man's web-shooters are all vital components of the superheroes' identities.

Even non-costumed, non-powered heroes can be identified by their unique costume paraphernalia. S.H.I.E.L.D. agent Nick Fury is recognizable by his impressively large gun, eye patch, and occasional cigar.

◄ **STRANGE TALES #110,**
MARVEL COMICS, JULY 1963

The first appearance of Dr. Strange in the 1960s, created by Stan Lee and Steve Ditko, featured the Sorcerer Supreme without his trademark cloak.

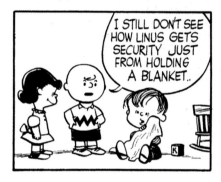

▲ **THE COMPLETE PEANUTS 1953 TO 1954,**
FANTAGRAPHICS BOOKS, 2004

Ubiquitous props aren't only limited to superheroes, of course. Where would Charles Schulz's *Peanuts* character Linus be without his blanket?

◄ **PALOMAR,**
FANTAGRAPHICS BOOKS, 2003

It's interesting to note that Marvel Comics' mighty Thor and Gilbert Hernandez's busty Luba from *Love & Rockets* both carry hammers, but in a very different context.

21

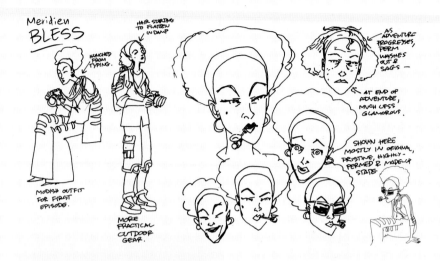

Creating Character Style Guides

A style guide, also known as a model sheet, is essentially a blueprint for a character. It's usually a single page depicting a character drawn from multiple angles, full-length and head and shoulders, sometimes with different facial expressions or body language.

There are variations of character sheets, including concept, action, and expression sheets, but usually the purpose is the same; to define the visual look and other elements of a single cast member.

These guides are particularly useful for corporately owned characters, where there are likely to be a number of different artists working on the comic book over a period of time. The model sheet will ensure that the essential visual elements remain consistent, even when interpreted by different artists.

Sometimes, even creators working in isolation keep style guides for their characters. In epic, sprawling series with large casts and frequent flashback sequences, the artist keeps a series of model sheets of the characters, sometimes at different ages. Model sheets can also be useful to the artist for size and height comparisons, as well as tricky details in elaborate clothing, period costumes, and props.

◐ + ◑ THE VORT, 2000 AD,
REBELLION, 2008

© 2008 Rebellion Developments/2000 AD. The Vort created by G. Powell & D'Israeli.

For *The Vort*, a serialized science fiction series appearing in the British comics weekly *2000 AD*, D'Israeli worked up this detailed character design for one of the central protagonists of the strip, journalist Meridien Bless. Variations on mood, hairstyle, clothing, and props are all illustrated to provide a comprehensive style guide for the editors.

◐ + ◑ STICKLEBACK, 2000 AD,
REBELLION, 2007

© 2007 Rebellion/2000 AD. Stickleback created by Ian Edginton & D'Israeli.

D'Israeli also created these character designs for the second series of *Stickleback—England's Glory*, which also appeared in *2000 AD*. Jiang Shi, or Chinese Hopping Vampires, were based on the pattern set by the classic Hong Kong martial arts horror film *Mister Vampire*, while the Traction Men from the same serial were described as Victorian England's answer to Mecha.

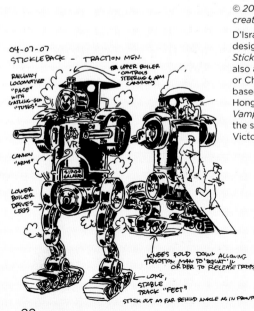

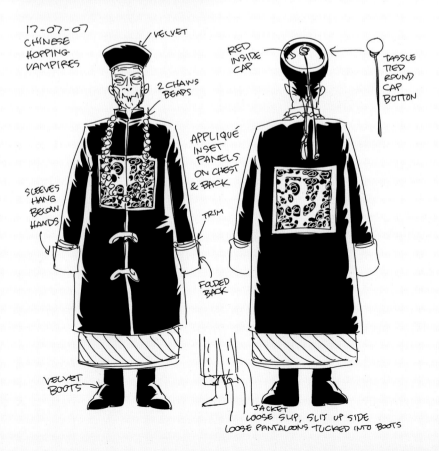

TURNAROUNDS

Character style sheets as used in traditional animation studios are known as "turnarounds" and are obviously necessary due to the large number of different artists working on any one single animated cartoon.

❍ TOO MUCH COFFEE MAN #1,
ADHESIVE COMICS, JULY 1993

Shannon Wheeler's self-published surreal gag strip *Too Much Coffee Man* was developed for a potential animated cartoon TV show for Comedy Central. The proposal got as far as a pilot script and Wheeler was commissioned to work up turnarounds for the show before production was halted. Too Much Coffee Man has gone on to appear in commercials for Converse and Hewlett Packard and to star in his own opera, produced by Wheeler himself.

❍ Character development sketches are also sometimes required as part of a proposal to publishers, or an artist is commissioned to produce model sheets for sculptures and toys. Trevor Hairsine produced these design drawings for a Cyclops action figure by ToyBiz. "The brief was 'anything OTT. Y'know, for kids.'"

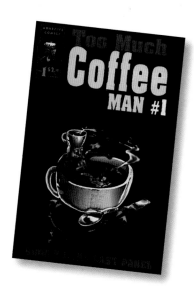

❍ Too Much Espresso Guy

❍ Too Much Coffee Man

▶ Mystery Woman

Revamping Existing Characters

A large proportion of the superheroes that feature in currently published comic books have been around for several decades. As a result, they have accumulated a complex, convoluted character history.

In order to reintroduce these characters to a new generation of readers, their backstories are often wiped clean and reset in such cross-title series such as DC's *Crisis* and Marvel's *Secret Wars*. More recently, Marvel's Ultimate line and DC's All-Star titles have reimagined the superhero giants' flagship characters afresh in new, continuity-free environments.

Even so, the heroes' basic motivation, personality, and costume design must remain largely unaffected, otherwise the essence of the character may be lost. Revamp too much and risk losing the trademark distinctiveness of the hero; change too little and they may not be different enough to have an impact on the readership.

Publishers of superhero comics are also very fond of relaunching old or defunct series and reviving popular (and often not-so-popular) characters from the past. This inevitably requires some form of updating at the very least, if not a complete "reimagining."

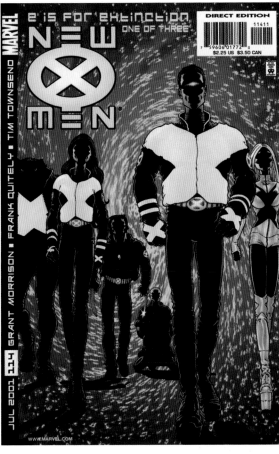

◁ NEW X-MEN #114, *MARVEL COMICS, JULY 2001*

Grant Morrison and Frank Quitely's revamp of the X-Men did away with traditional spandex costumes altogether and replaced them with casual uniforms of biker-style black leather jackets and turtleneck sweaters.

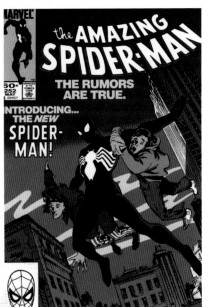

◁ AMAZING SPIDER MAN #252, *MARVEL COMICS, MAY 1984*

Spider-Man's shocking change in 1984 certainly gained attention. The new all-black, living "symbiotic" costume was inevitably short-lived, but a cloth version was used as a nighttime alternate outfit for a period. The original living version found a new symbiotic partner, creating popular spin-off villain Venom.

▷ JOURNEY INTO MYSTERY #105, *MARVEL COMICS, FEBRUARY 1964,* art by Jack Kirby & Chic Stone

▷▷ THOR #1, *MARVEL COMICS, SEPTEMBER 2007*

French artist Olivier Coipel was hired to revisualize the Thunder God's costume for the recent relaunch under the stewardship of J. Michael Straczynski. The essential, distinctive elements of Thor's costume remain from his earliest appearances, but Coipel has given the character a sleek, modern makeover.

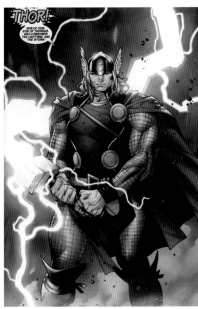

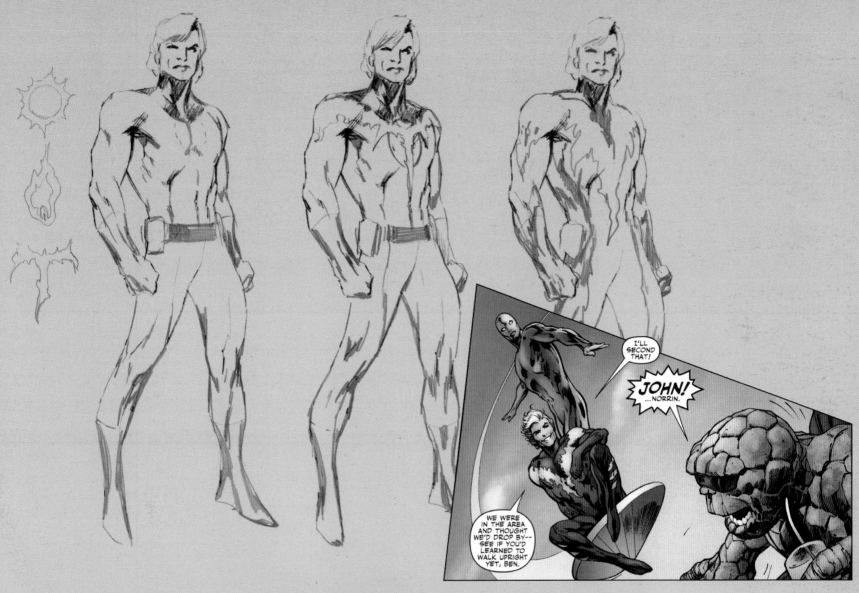

A + B FANTASTIC FOUR: THE END,
MARVEL COMICS, 2006

Alan Davis tweaked the costume designs of the Fantastic Four for his mini-series *The End*. He considered giving the Human Torch a radical makeover. "I always do any costume design over repeated copies of a single, basic, 3/4 angle character pose because, aside form the obvious economies, the repeated figure ensures my judgment (or the editors') isn't swayed by a superior drawing or position of different drawings."

C PROJECT SUPERPOWERS,
DYNAMITE ENTERTAINMENT, 2008

Alex Ross and Jim Krueger revamped a number of out-of-copyright superhero characters from the 1940s for the series *Project Superpowers*. Each issue features updated character designs by Ross, including the Fighting Yank, the Green Lama, the Arrow, Hydro, Masquerade, Samson, and the Black Terror.

Ross became one of comics' hottest talents by dint of his photo-realistic interpretation of iconic superheroes for Marvel and DC for series like *Marvels* and *Kingdom Come*.

Location Design

Whether the story calls for a realistic backdrop or an entirely fabricated fantasy setting, carefully designed locations can be very important in creating believable worlds.

Reference materials for a real world location or for use as the basis of an invented scene are usually researched by the artist, although sometimes the writer will supply specific images if they are integral to the plot.

Backgrounds can be elaborate and photo-realistic, or cartoony and minimalist, depending on the artist's drawing style. They can be intensively researched, historically accurate depictions of actual places, as in Moore and Campbell's *From Hell*; imaginatively surreal magical realms, such as those of Steve Ditko's *Dr. Strange*; or the impressionistic minimalism of Charles Schulz's *Peanuts*.

However the locations are rendered, they should always be part of the carefully designed fictional environment that the characters inhabit.

Many creators design maps of imagined worlds, cities, villages, or simply floor plans of buildings and single rooms in order to make sure their locations are convincing. This can also help guarantee the relative placement of furniture, objects, and figures are consistent from different viewpoints.

Some creators like to set the scene with multiple "establishing shots," slowly zooming in on a scene in order to draw the reader into the artist's fabricated world.

Humor comics are often rendered in a simplistic style, and the minimum amount of background information is all that is required to suggest location. For instance, a cartoonist's shorthand for a graveyard could be just a single gravestone.

Entirely invented fantasy landscapes or extraterrestrial worlds should be designed as precisely and thoroughly as any real world location. Basing a futuristic city or another invented location on a real place—or amalgam of places—is a good starting point, but careful planning is required for consistency and believability.

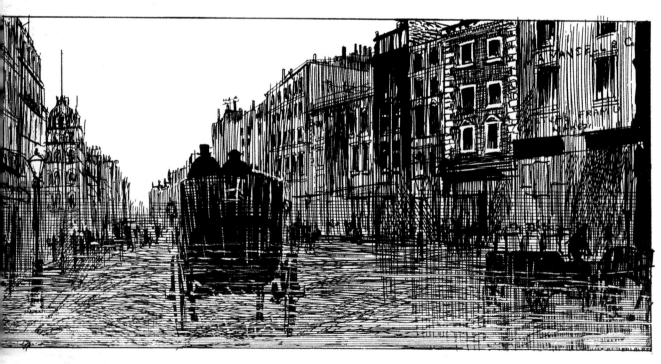

○ FROM HELL,
TOP SHELF, 2000
Meticulously researched Victorian London, as filtered through the evocative pen strokes of Eddie Campbell for his masterful Jack the Ripper collaboration with Alan Moore.

○ THE COMPLETE PEANUTS 1953 TO 1954,
FANTAGRAPHICS BOOKS, 2004
All Charles Schulz needed to suggest a tree for Snoopy to sit under was a few vertical strokes and a leaf.

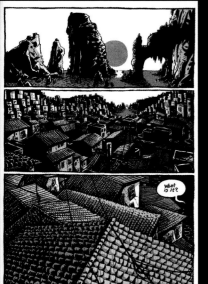

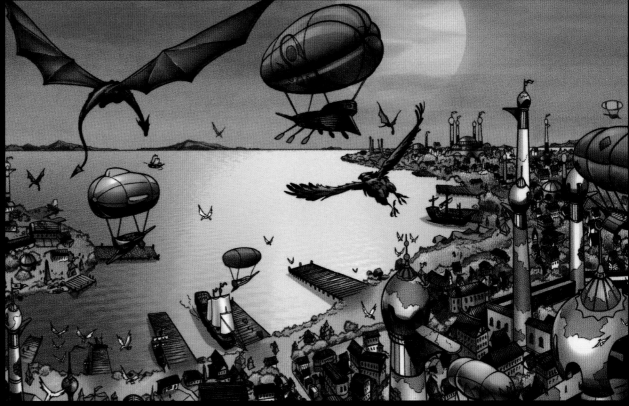

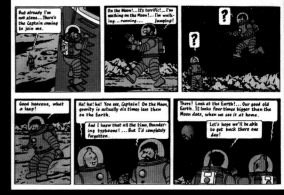 TIEMPOS FINALES,
LA LUZ COMICS, 2004

This beautiful page from Sam Hiti's graphic novel introduces a fictional Hispanic town via a three-panel zoom, first zooming back from the sunset, then tilting and zooming down onto the rooftops, drawing the reader into his world.

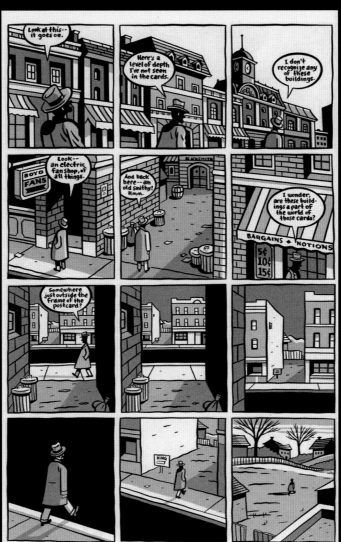 TELLOS: RELUCTANT HEROES,
IMAGE COMICS, 2001

This beautiful panorama leaves the reader in no mistake that this is a strange fantasy world. Not only are the tall, Arabian style towers and curved roofs unfamiliar, but the airships and flying creatures complete the suggestion that this is a fully realized alien city.

PALOOKA-VILLE #19,
DRAWN & QUARTERLY, FEBRUARY 2008

Seth's quiet methodical storytelling entices the reader to follow the progress of the character's journey through a convincing fictional town. The artist constructs cardboard models in order to familiarize himself with the setting and as a result creates a real sense of place.

EXPLORERS ON THE MOON,
LITTLE, BROWN, 1954

Historical and foreign settings may require a lot of careful research to provide a believable backdrop for the story.

Tintin's creator Hergé was famously meticulous about researching his far-flung adventures of the young detective. Photographic reference was used to make sure that landscapes and buildings were authentic in appearance, reputedly starting with Tintin's adventure in the Far East, *The Blue Lotus*. Hergé's research for Tintin's trip to the moon in *Destination Moon* and *Explorers on the Moon* was commended by *New Scientist* for its accuracy.

HEART OF EMPIRE,
DARK HORSE, 2001

A preparatory plan view of Dee's Laboratory from Bryan Talbot's *Heart of Empire: The Legacy of Luther Arkwright* graphic novel.

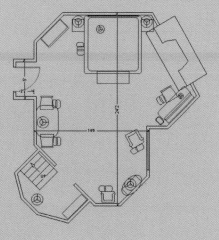

Whether the location is a science fiction world, a rural landscape, a bustling city, or an intimate interior scene, the design of each component should be consistent with itself. However outlandish the tables or vehicles of an alien planet are, they should still be recognizable as tables and vehicles.

If a lot of action is to take place in a limited number of locations, some artists like to create various reference materials, including invented floor plans, cardboard mock-ups, and even computer models. This allows the characters to interact with a world that remains consistent.

Cerebus background artist Gerhard has done all three, especially when some of Dave Sim's stories took place in one single location for many tens—even hundreds—of pages. Gerhard believes that the key to drawing one location for an extended period is to create floor plans and keep the layout simple and uncluttered. Sometimes, detailed sketches were drawn up complete with furniture and textures. On the floor plan, Gerhard could figure out where the reader's viewpoint—or camera—would be positioned, and which parts of the background to drop in.

⬇ THE ARRIVAL,
ARTHUR A. LEVINE, 2007

By placing almost familiar, recognizable elements in a dreamlike setting and rendering them in a photo-realistic style, Sean Tan creates a fantastic yet entirely convincing vision.

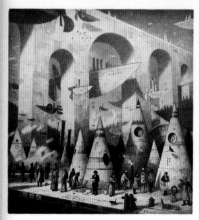

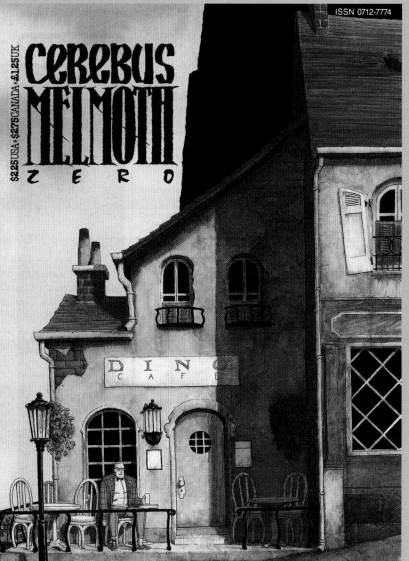

⬆ CEREBUS: THE LAST DAY,
AARDVARK-VANAHEIM, 2004

For *The Last Day*, Cerebus was confined to his bedroom for the entire book, so accuracy and consistency was very important. Here we see Gerhard's floor plan, complete with measurements, as well as two different views of the interior, each as a computer model and rendered tracing, with Cerebus positioned for scale.

◉ + ⬇ CEREBUS #139,
AARDVARK VANAHEIM, OCTOBER 1990

For *Melmoth*, Gerhard created a cardboard model of the exterior street scene, which was the setting for many of Dave Sim's stories.

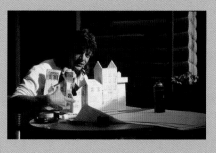

DESIGNING VEHICLES

The same rules used for location design apply when designing vehicles and other important props and objects. Good research is vital in order to create convincing cars, planes, boats, and spacecrafts.

Inspiration for futuristic craft can be found in science fiction and fantasy media, but this should never be a substitute for original design.

Animals and insects can often provide an interesting basis for futuristic craft, as can vintage vehicles and objects. Historical research of old designs can inspire modern "retro" versions, particularly for the steam punk genre.

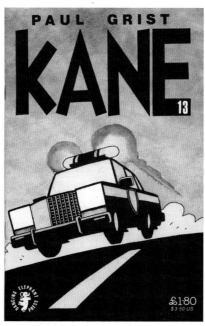

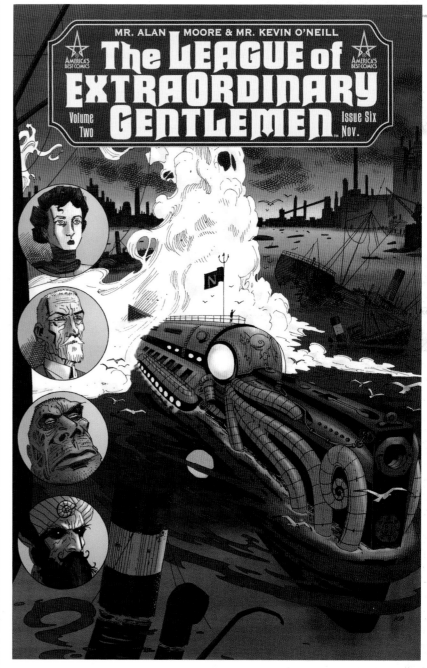

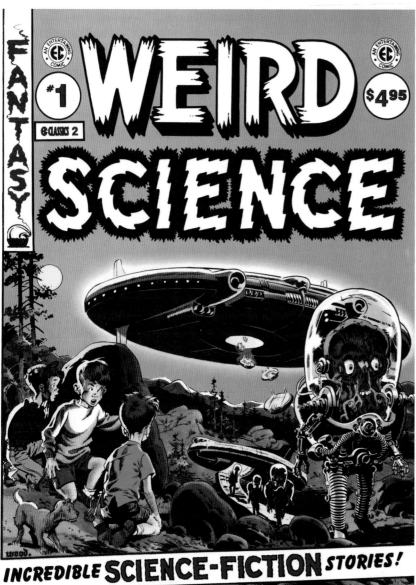

◑◑ KANE #13,
DANCING ELEPHANT PRESS, MAY 1996

To draw a real-world vehicle or object does not merely require that photographs, video, or models are gathered; the drawing style also has to be taken into account. Paul Grist's simple yet effective distillation of a police car remains consistent from whatever angle he draws it, as he has designed exactly how a police car should look in the *Kane* universe.

◐ WEIRD SCIENCE #16,
EC COMICS, NOVEMBER 1952

Wally Wood, inspired by the flying saucer phenomenon of the 1950s, gave these spacecraft the sheen and detailing of a Cadillac for his classic cover.

◔ THE LEAGUE OF EXTRAORDINARY GENTLEMEN VOLUME TWO #6,
AMERICA'S BEST COMICS, 2007

The octopus-inspired design of Captain Nemo's submarine the *Nautilus*, from the marvelous *League of Extraordinary Gentlemen* by Alan Moore and Kevin O'Neill.

Designer Spotlight: **Seth**

Canadian cartoonist and designer Seth—real name Gregory Gallant—established his reputation as an outstanding comics creator with the ongoing comic book series *Palooka-Ville*, which Drawn & Quarterly began publishing in 1991.

The emotional resonance and languid pace of his storytelling in conjunction with his organic, old-fashioned brushwork and perfectly balanced layouts has combined to produce a truly unique body of work.

Seth further developed his distinctive "*New Yorker*" art style with the faux-autobiographical award-winning graphic novel *It's a Good Life, If You Don't Weaken*, serialized in *Palooka-Ville*.

A nostalgic yearning for the early part of the Twentieth Century is apparent in all of Seth's work. He harbors a disdain for modern life, even habitually dressing in a vintage suit, tie, and fedora. He eschews the use of computer technology in favor of pencil, pen, and brush and even uses transparent overlays to define areas of his understated, muted color.

"The seemingly simple decisions about whether to use twenty-five panels on a page or five panels on a page actually turns out to be the most sophisticated area of the cartoonist's art. Sometimes just using a simple basic six-panel grid turns out to have the elegance that a big complicated layout cannot achieve."

His current magnum opus, *Clyde Fans,* has further extended his acclaim, as each issue of *Palooka-Ville* and the corresponding collected volumes are exquisitely designed with high production values.

As part of his preparation, Seth built an elaborate cardboard model of the fictional town Dominion, the setting for *Clyde Fans*, which was included as the centerpiece for a 2007 exhibition of the artist's work at the Phoenix Art Museum in Arizona.

"It really didn't have any practical purpose, I really wasn't planning on drawing from it or to use it as a lighting source or anything at all beyond just being fun."

Wimbledon Green, a stand-alone graphic novel about "the world's greatest comic collector" was produced as a cloth-bound hardcover volume with gold embossing, heavy paper stock with rounded corners, and an extravagant layout that transformed a mere book into an *object d'art*.

Seattle publisher Fantagraphics commissioned Seth as book designer for their comprehensive twenty-five volume series of Charles Schultz's classic *Peanuts*, collecting the strip chronologically for the first time. Most of the hard work was done in setting up a clear design system for the series, with unique elements like covers, title pages, and endpapers being created for each book. Each semi-annual collection takes about a month to design.

Seth's wife suggested the perfect metaphor for his role in designing the *Peanuts* books. "I am like a jeweller. Schulz's strips are the gems, but it is my job to create a beautiful setting for them."

The young Gallant studied at the Ontario College of Art before landing a job drawing *Mr. X* for Canadian publisher Vortex Comics. He moved on to freelance illustration while developing his ideas for *Palooka-Ville*.

Seth's work is recognized as that of one of the finest cartoonists working in comics today, and as a designer and illustrator he is in huge demand. He has provided the album cover for *Lost in Space* by Aimee Mann, illustrated and designed book jackets including the revised *Portable Dorothy Parker*, and covers for *The New Yorker* magazine, which is currently running his serial *George Sprott (1894–1975)*.

Seth has also designed a collection of pages from his sketchbook, *Vernacular Drawings,* and a memoir written by his father, *Bannock, Beans and Black Tea.*

"A well designed book is one of the most perfectly beautiful things in the world."

CLOCKWISE FROM TOP LEFT:
Palooka-Ville #19, Drawn & Quarterly, 2008

The Complete Peanuts 1951 to 1952, Fantagraphics, 2004

The Complete Peanuts 1951 to 1952, Fantagraphics, 2004

Clyde Fans, Drawn & Quarterly, 2004

Clyde Fans, Drawn & Quarterly, 2004

Clyde Fans, Drawn & Quarterly, 2004

Bannock, Beans and Black Tea, Drawn & Quarterly, 2004

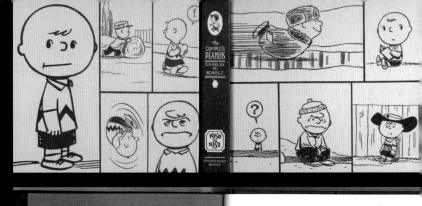

Chapter 2
Visual Storytelling and Panel Design

Introduction

The role of storytelling in comics is often overlooked, as it's the end result of a number of different skills and techniques, many of them intuitively performed by the artist.

The artist must devise a page layout that not only contains all the individual elements required to tell the story in a clear and concise fashion, but must also design the page as a whole to work as a single attractive composition.

There are a number of techniques available to the artist to achieve this. Pacing and rhythm can be controlled by modulating the size and frequency of the panels; by the arrangement of elements within each panel; by the positioning of dialogue balloons and captions; and by the placement of large areas of black, which guides the eye through the page in the desired sequence.

**◑ THE RING OF THE NIBELUNG
VOLUME 2,**
DARK HORSE COMICS, 2002

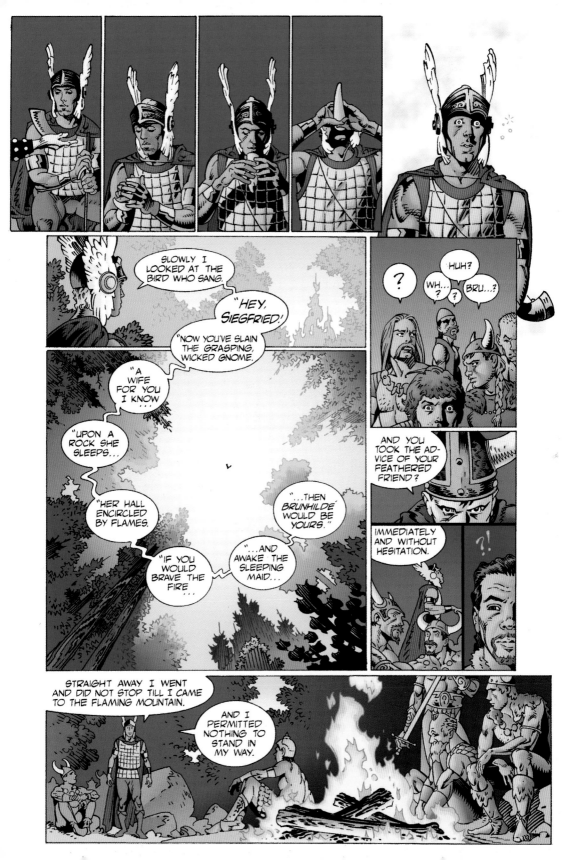

Writing and Visual Storytelling

In the best examples of sequential storytelling, art and story are so closely interwoven that they become inseparable elements of the finished article. Even though comics are ostensibly a visual medium, it's universally acknowledged that the art should first and foremost serve the story. Whether the writer is supplying a full script, or whether the artist is working from a basic plot, or indeed if a solo creator is laying out his own pages, storytelling is paramount.

For writer-artist collaborations, the two most common methods of working are: plot-first, or full script.

The plot-first method passes the responsibility for much of the storytelling process to the artist, who makes decisions about the pacing and rhythm of the story, page layout, and composition of individual panels.

With the full script method the writer breaks down the story page-by-page and panel-by-panel, often describing the composition, viewpoint, lighting, etc. in great detail, sometimes leaving the artist little room for his own interpretation.

Scripting for comics requires a visual sense of storytelling like no other form of writing. Perhaps unsurprisingly, many of the very best examples of comic book art have been created by single individuals; writing, drawing, lettering, and even coloring their own comics, creating works that blend words and pictures in a way that most collaborative teams simply cannot match.

A number of the current crop of successful comics writers started out as artists themselves. Brian Michael Bendis drew his crime noir creation *Jinx*; Ed Brubaker illustrated his slice-of-life *Lowlife*; Brian Wood kick-started his career drawing *Channel Zero*; and *Fables* writer Bill Willingham was the artist on his superhero creation *Elementals*.

One of the key elements of good storytelling is that when it's done well, the reader should not be aware of the process at all.

BREAKING DOWN THE STORY

The storytelling process begins with the writer or artist breaking the story down into the required number of pages.

A page can contain a single image as part of a sequence, but more often it is further broken down into a number of smaller individual units—called panels—creating a visual narrative.

A single panel usually represents one particular frozen moment in time. A sequence of panels typically indicate time passing. Each panel should advance the narrative to propel the story forward.

⊘ **AMAZING SPIDER-MAN #51,**
MARVEL COMICS, MAY 2003
A spectacular John Romita Jr. page from *Amazing Spider-Man*.

THE BASIC ELEMENTS OF A COMIC BOOK PAGE

① **Page**—The basic unit, this is the comic book artist's entire canvas

② **Bleed**—When the artwork extends up to the edge of the page

③ **Panel**—The unit that contains a single moment or image from the sequence

④ **Border**—The element that defines the edge of the panels

⑤ **Gutter**—The space that separates the panels from each other

⑥ **Margins**—The space that separates the artwork from the edge of the page

⑦ **Balloon**—A container for text indicating speech or thought

⑧ **Caption**—A container for text indicating narration or text other than speech

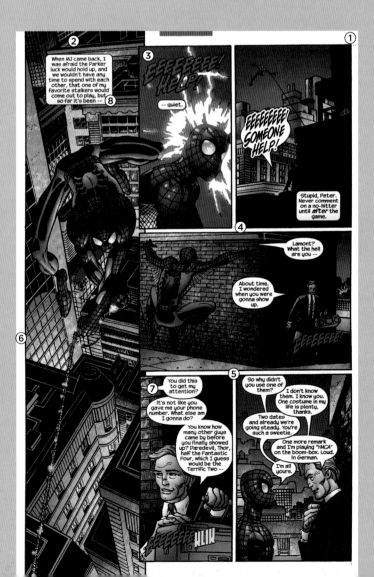

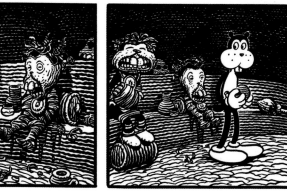

2

16

17

3

READING ORDER

The most important objective of page design is to guide the reader's eye across the page in the desired sequence. This can be achieved with a combination of simple panel layout, prominent areas of black, balloons and captions, and picture composition.

◆▶ **FRANK VOLUME 2 #4,**
FANTAGRAPHICS BOOKS, 1994

Comprehension of Jim Woodring's mind-bending surreal fantasy series, *Frank*, is aided by a simple panel layout. The reader's eye naturally follows a reading track from left to right and from top to bottom; this applies to comics in the same way that it applies to reading regular text. (Japanese manga is an obvious exception to this; many translated versions are published unmodified to read from back to front and from right to left.)

On a double-page spread, the left page is usually read in its entirety first, followed by the right page.

Despite this natural reading track, the eye immediately takes in the whole page—or the whole spread—at once, so it should always be designed with that in mind. There is no way that the artist can physically prevent the reader from looking or glancing at the last panel before the first; but the reader has a tacit agreement with the creator to read the page in order. Even so, any big change of scene, new chapter, surprise panel, or dramatic moment is usually placed after the turn of the page.

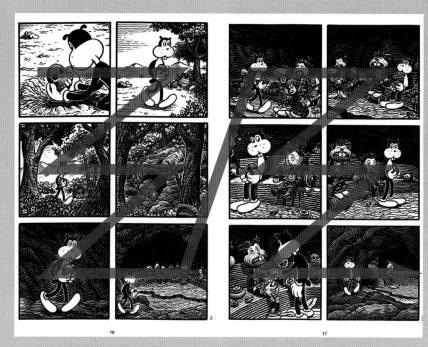

16

17

Comic Book Design

THUMBNAIL LAYOUTS

Almost all artists begin the process of drawing a script by making small, loose sketches of the page layout. These are called thumbnails, and they help the artist to visualize the script, deal with issues of pacing and composition, and make numerous design and storytelling decisions.

Panel sizes and shapes, cropping, framing and viewpoint, areas of black, and page flow can all be planned quickly by using thumbnail layouts, while details like anatomy and perspective are usually worked out at a later stage, typically on the final art board.

◗ After receiving the script for an issue of *Criminal* from writer Ed Brubaker, Sean Phillips breaks down the story into panels using a series of tiny, quickly sketched thumbnail roughs, complete with shapes for dialogue balloons and caption boxes.

Simple stick figures are usually sufficient to design the layout. Often several alternative versions of the same page will be roughed out until all the layout problems are solved. Some artists also quickly determine where their large areas of black should be laid at the thumbnail stage by blocking in areas using a thick, black marker.

Dialogue balloons and caption boxes for text are often integrated even at this initial stage of layout, as they will form part of the final page design. The reading order of balloons as well as the images is of the utmost importance.

Inexperienced artists can leave too little "dead space" for these essential elements, resulting in over-crowded pages, vital visual elements being covered up, a misleading reading order and overall poor page design.

◗ Phillips creates full-size layouts from his thumbnails onto the art board, prior to rendering the final illustrations. "The panel borders and lettering are done in Illustrator and printed out in cyan. The blue layouts are drawn directly onto those final boards with a pale blue marker while looking at my photo ref. Sometimes I'll drop in a photo background in cyan as well. Then I just go straight in with the inks."

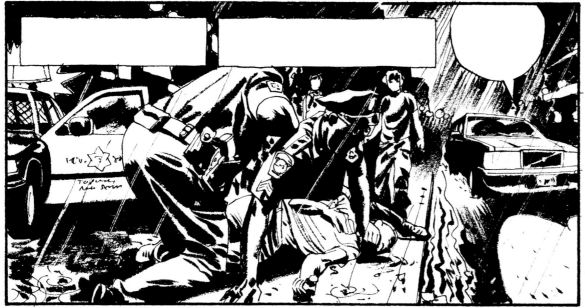

◁ The inked page is a beautifully balanced design, providing the reader with a comprehensible sequence of events, even prior to any dialogue being added.

◉ CRIMINAL, VOLUME 2, #4,
ICON/MARVEL, JULY 2008
The finished color page as published.

Pacing and Rhythm

Part of the artist's job in laying out a comic book is to control the speed of the reader's eye over the page, drawing attention to the most important and dramatic parts of the story and attempting to slow down and speed up the action as necessary.

The best comics usually have simple, easy-to-follow layouts. Overly elaborate and needlessly complex pages also have the potential to confuse and alienate the reader, detaching them from the thrust of the story. But the skilled comics artist can incorporate a number of different techniques to enhance the reader's experience, without sacrificing the overall narrative structure.

Some inexperienced artists' layouts can be little more than a series of pin-up pages with a minimum of inset panels. These often look very dramatic, but do not achieve the basic requirement of a comic: to tell an interesting story. "Splash pages" have their place, but are best used sparingly.

KEEPING THE BEAT

One method of controlling the speed of the reader is to vary the size and frequency of the panels. A rigid grid containing similar sized panels gives a metronome-like visual rhythm, with each panel representing an equal moment of time.

▶ IMPACT #1,
EC COMICS, 1955

A milestone in sequential art, *Master Race*, illustrated by Bernie Krigstein, demonstrates how even subtle variations in panel size can affect the pacing of a scene. In this cinematic sequence, the victim falls from the platform in a series of narrow panels, as the approaching train trundles inexorably closer.

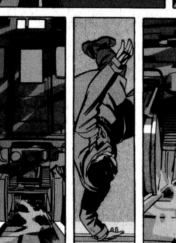

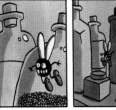

34 35

◀ LA MOUCHE,
LE SEUIL, 1995

Lewis Trondheim's sweet and very funny wordless graphic novel follows the adventures of a housefly. It consists entirely of pages split into nine equally-sized panels, giving the book an animated cartoon-like quality. We will look more closely at the use of various grid structures in Chapter Three.

Many artists liken panels to a series of musical beats. Large panels suggest slow, grander beats, suitable for dramatic scenes; smaller panels speed up the beat, useful for fast action sequences. Careful modulation of the size and number of panels holds interest and can control the speed of reading. Conventional wisdom has it that pages should contain around five to seven panels per page, but the resourceful artist has many more options available to him or her.

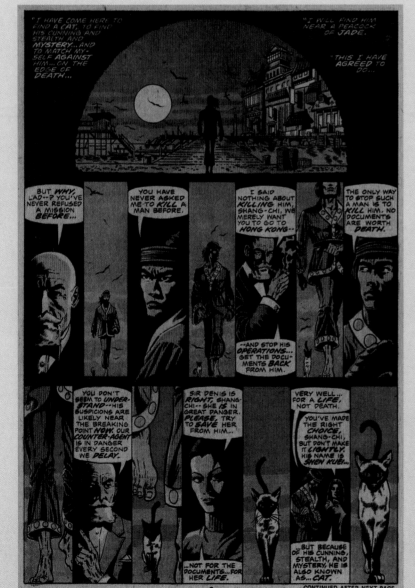

3 CONTINUED AFTER NEXT PAGE

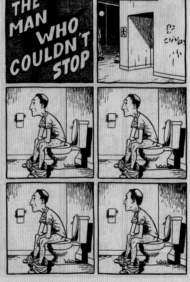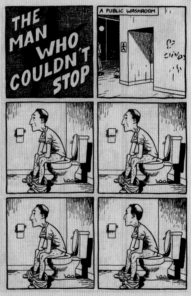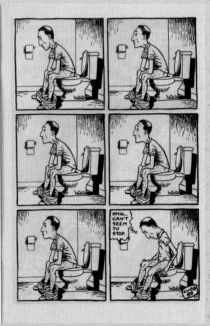

VARYING THE TEMPO

It's interesting to note the difference between a sequence of panels containing a series of similar images, and a succession switching between two different viewpoints. In the first instance (see above), the repeated panels convey a monotonous, relentless sequence, while the second, quick-cutting progression (see left) suggests a tense, staccato beat.

◀ MASTER OF KUNG FU #38,
MARVEL COMICS, MARCH 1976

The mood of tranquility in the first page-wide panel is broken by a number of tall, narrow, staccato panels. Paul Gulacy's highly detailed art switches between a series of conversation-heavy flashback panels and a silent sequence of hero Shang-Chi (and his cat) walking toward the reader's viewpoint.

▲ YUMMY FUR #3,
VORTEX COMICS, FEBRUARY 1987

In a seemingly unconnected episode from Chester Brown's surreal *Ed the Happy Clown* serial, the monotony of his character's daily ablutions is accentuated by keeping the same viewpoint in same size panels, with very little change in pose, setting up the final panel's punch line.

SLOWING THINGS DOWN

When the story requires that the reader is slowed down, there are various techniques that the artist has at his disposal.

Dropping out a single panel border on a page effectively slows down the pace, inviting the reader to pause and be immersed in the moment.

107

⬆ KINGDOM OF THE WICKED,
DARK HORSE BOOKS, 2004

In Ian Edginton and D'Israeli's gripping tale, the protagonist Christopher Grahame is shot in his unconscious mind as he lays on the operating table. This climactic moment is highlighted by a borderless, background-less panel in the center of a rigid three-tier layout. The crucial moment is frozen, inviting the eye to linger and take in the significance of the event.

As the eye follows a reading track from left to right, it's natural for figures or vehicles to move in the same direction. When the movement is reversed mid-flow, the momentum is stopped, which tends to slow the eye and encourage the reader to pause.

⬇ PERCY GLOOM,
FANTAGRAPHICS BOOKS, 2007

In Cathy Malkasian's delightful graphic novel, Percy Gloom's car drives toward the reader in the first three panels. When the viewpoint is switched to behind the vehicle in panel four, the momentum is halted, suggesting that Percy has stopped to take in the ominous scene ahead. The wide panel also slows down the reader, encouraging them to take in the view along with Percy.

40

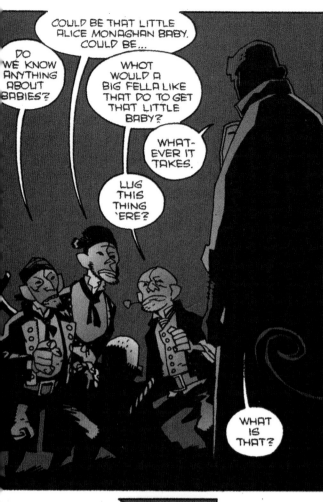

COULD BE THAT LITTLE ALICE MONAGHAN BABY. COULD BE...

DO WE KNOW ANYTHING ABOUT BABIES?

WHOT WOULD A BIG FELLA LIKE THAT DO TO GET THAT LITTLE BABY?

WHAT-EVER IT TAKES.

LUG THIS THING 'ERE?

WHAT IS THAT?

OH, THIS NOW, THIS IS ONE TAM O'CLANNIE FROM KILLARNEY.

AS FINE AND LOVELY A MAN AS EVER WAS.

WE LOVE 'IM.

NOT MUCH GOOD FOR WORK, WAS OUR TAMMIE, BUT 'E WAS A DRINKER AND A CARD PLAYER AND A WILD MAN FOR DANC-ING WITH PRETTY GIRLS...

BUT 'E'S ALL DANCED OUT NOW.

THE KING, 'E WAS FOND OF OL' TAMMIE AND SAYS TA US: 'YOU LADS GO AND LAY 'IM IN SUCH A PLACE AS 'E, BEIN' A CHRISTIAN, MIGHT LIKE.'

NOW, 'OW ARE WE TO DO A THING LIKE THAT? NO, SIR! BUT YOU NOW... MAYBE...

TAKE 'IM. GET 'IM BURIED AND WE'LL GET YOU THAT NICE BABY.

SORRY 'BOUT THAT STINK, BUT 'E'S GONE A BIT 'ROUND THE BEND, POOR TAMMIE.

DEAL.

NO KIDDING.

HEY!

UCK...

NOT SO TIGHT

OH, TAMMIE, 'E DON'T WANT TO FALL OFF.

HAWW HA!

BACKGROUND DETAILS

Excessive background detail can also ease the pace of storytelling. A beautifully rendered panorama invites the eye to slow down and linger over the scene, particularly over an initial establishing shot, helping the reader to immerse themselves in the story.

Conversely, dropping out backgrounds can increase the pace. It's also interesting to note that many artists limit background detail when there is a lot of dialogue or narration. This both speeds up and clarifies wordier panels. The reader's focus should be on the people talking, not on distracting background detail.

◁ HELLBOY: THE CORPSE,
DARK HORSE COMICS, 2004

In this unusually word-heavy sequence from *Hellboy*, Mike Mignola minimizes background detail, to enable the reader to focus on the dialogue and figure work.

Inserting and excluding backgrounds from panels to concentrate on figures or objects as part of the overall page composition is another unique aspect of comics. It's a technique that's not possible in any other sequential visual art form without becoming overtly stylized or hugely distracting.

41

Panel Borders and Gutters

BORDER CONTROL

The choice of panel borders is a design decision very much related to the style of the artwork. There are numerous choices available to the artist. Traditionally, borders have typically enclosed the image within the panel by way of a straight-edged ruled black line, with white gutters separating each panel.

But with the ever-increasing variety of styles of comics illustration and design, and the huge advances in computer design software, many more options are now available for the comic book creator. Freehand styles, curved corners, white borders, no gutters, and even no borders at all are among the choices for the imaginative artist.

◗ UNLIKELY,
TOP SHELF PRODUCTIONS, 2003

Freehand borders can be effective in reflecting the style of the artist. Jeffrey Brown's shaky panel borders and speech balloons match the scratchy artwork, conveying a sense of intimacy and honesty and in turn reflecting the highly personal subject matter of his strips.

Some artists simply divide their page into panels without gutters. In that instance, it's important that consideration be given to the layout of the entire page and to careful placement of blacks, to ensure that panels are distinct and separate from each other.

◗ FLUFFY,
JONATHAN CAPE, 2007

Simone Lia's delightful story about a single man and his white baby rabbit is told using a number of different page layouts and panel variations. On this page, Lia breaks up the square page canvas into a nine-panel grid without gutters, but the simplicity of her layout makes it easy to follow the correct sequence.

Beautifully rendered, fully painted or digitally colored comics often do away with panel borders altogether, and effectively rely on white gutters or thin white panel borders with no gutter.

◗ BIG NUMBERS #1,
MAD LOVE, APRIL 1990

Bill Sienkiewicz's innovative painted art style brings Alan Moore's ambitious but unfinished masterpiece *Big Numbers* to life, utilizing a straight-edged, thin white gutter to separate the panels. The center tier is a single image broken up according to a twelve-panel grid, suggesting a slow pan from left to right. Sienkiewicz's mixture of impressionistic and photo-realistic art with methodical pacing lends a cinematic quality to the storytelling.

◗◗ FANTASTIC FOUR #556,
MARVEL COMICS, JUNE 2008

The depth of Bryan Hitch's stunningly detailed art and Paul Mounts' spectacular colors are more than enough to hold the panel shapes together without the need for border lines.

It is also possible to do away with panel borders and gutters entirely and to design the page as what Will Eisner called a "meta-panel"—the page as one large composition. The borderless panel can suggest open space, freedom, and serenity.

◗ THE LITTLE MAN AND OTHER STORIES,
DRAWN & QUARTERLY, 1990

In *Showing Helder*, Chester Brown draws an autobiographical strip of himself creating page layouts by sticking down and rearranging separately drawn panels onto his art board. This page, unlike the page we observe him creating in the strip, has no panel borders and no grid structure.

Wavy or scalloped edges usually imply a dream sequence or flashback. No universally accepted convention exists, but obviously the technique should be consistent within the same narrative.

◗◗ SKIN DEEP,
FANTAGRAPHICS BOOKS, 1984

Charles Burns' creepy chiaroscuro vision from *A Marriage Made in Hell* clearly distinguishes flashback from present with a simple wavy line on three sides of the panel. These sequences can also be indicated by color, as we will see later.

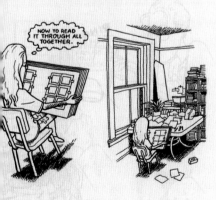

WHILE I WAS STATIONED IN THE PACIFIC OUR SHIP ENCOUNTERED AN ENEMY SNEAK ATTACK...

DURING THE BOMBING I HAD THE MISFORTUNE OF BEING NEAR A FUEL STORAGE TANK THAT EXPLODED...

WHEN I WOKE UP IN THE VETERANS HOSPITAL I FOUND OUT I HAD BEEN IN A COMA FOR EIGHTEEN MONTHS.

PANEL SHAPE

It's very common to compare the discipline of comics storytelling to that of directing a movie or TV show. There are similarities, but there are also many differences. One big distinction is the ability to change the size and even the shape of the panel. The comics artist can switch from a rectangular widescreen panoramic visual to a small close-up circular inset panel in adjacent frames if the story requires it.

▶ **AT HOME WITH RICK GEARY,**
FANTAGRAPHICS BOOKS, 1984

In *Journey to Outer Earth*, the ever-inventive Rick Geary shows here that it's possible to craft a panel sequence with an assortment of circular, rectangular, and diamond-shaped panels.

Jagged edged frames can be used to accentuate the content of the panel, which is especially useful for explosions or moments of high emotion and drama. Similarly, dripping frames can suggest tears or miserable, rainy weather.

▶▶ **DEATH JR. #3,** *IMAGE COMICS, 2005*

TV-shaped panels are a cute method for conveying exposition, as the shape is universally recognized. Frank Miller used this device heavily in his seminal *Batman: The Dark Knight Returns*. Here, Ted Naifeh applies the same the technique in this computer game adaptation.

▶ **LOST GIRLS,**
TOP SHELF PRODUCTIONS, 2007

Melinda Gebbie's extraordinary color artwork adds a sensual dimension to Alan Moore's erotic three-volume opus *Lost Girls*. This page, consisting of oval-shaped panels, is just one of the inventive layouts featured in the groundbreaking work.

▶▶ **KARLA IN KOMMIELAND,**
RAW VOLUME 2 #1, 1989

Kim Deitch's wild and irregularly shaped panel designs fully complement his surreal stories and bizarre cast of characters.

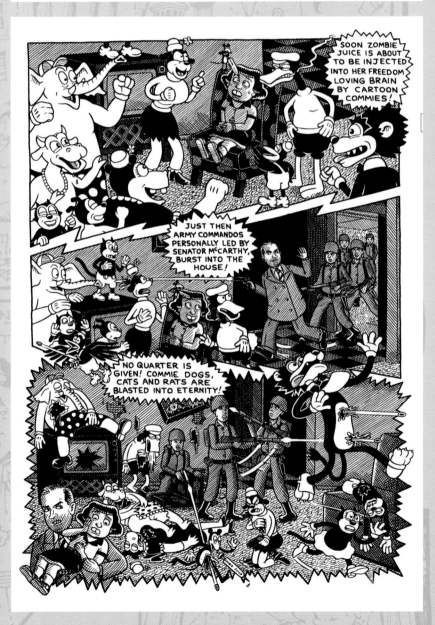

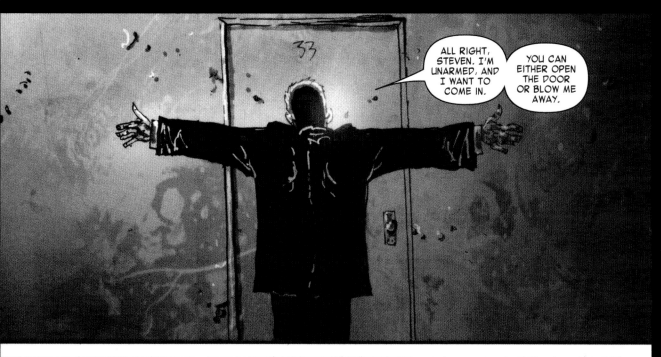

TO BLEED OR NOT TO BLEED

Bleed is a term denoting that the artwork extends beyond the trimmed edge of the page, rather than just being confined to panel borders.

Modern superhero comics often utilize "full bleed" on every page—that is, the art extends to all three edges and the gutter—which can sometimes be quite overwhelming, leaving no room for the artwork to breathe.

More restrained artists use bleed more sparingly, with occasional pages bleeding, or perhaps just the occasional panel on certain pages when additional impact is required to serve the story.

◁ **FELL #9,**
IMAGE COMICS, JANUARY 2008

For the Warren Ellis scripted comic *Fell*, Ben Templesmith adds an interesting kink to the nine-panel grid by allowing occasional full-tier widescreen panels to bleed off to each side of the page, while the middle tier panels retain their full complement of gutters.

▽ **FINDER: KING OF THE CATS,**
LIGHTSPEED PRESS, 2001

Carla Speed McNeil's epic fantasy *Finder* mixes a range of panel designs, here bleeding off all four edges of the page to maximize the expansive nature of the landscapes and wildlife scenes.

Composition and Design Within the Panel

PICTURE COMPOSITION

The primary function of the panel is communication. The various elements of the story should be arranged within the individual panel in a clearly communicative way. The artist must decide what the focus of the panel needs to be.

The artist also has to decide how to boil the composition down to the simplest, most effective way of conveying the information required for the story to progress.

Good design can both enhance readability and make the panel attractive. Comics are a visual medium, but decorative flourishes and eye candy should always come second to presenting a clear and unambiguous image. Ideally, the artist will aim to balance both, creating an aesthetically attractive and easily comprehensible picture in his own distinctive style.

A character placed symmetrically in the center of the panel can be very dramatic, but continual central placement can become boring and unimaginative very quickly. Varying the picture composition within the sequence sustains interest far more readily.

◒ THE GOLDEN SECTION AND THE RULE OF THIRDS

The Golden Section, known to artists of the Renaissance as the Divine Proportion, is a rectangle whose sides conform to the Golden Ratio, approximately 1:1.618.

If a square is drawn inside a rectangle of the Divine Proportion, a smaller rectangle is created with the exact proportions of the original. You can keep splitting the rectangles ad infinitum.

By arranging the elements of a picture in accordance with the Golden Section, the artist creates a harmonious, balanced composition.

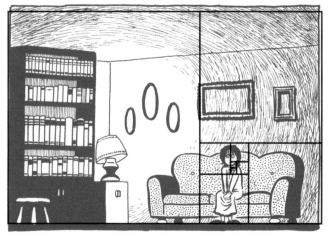

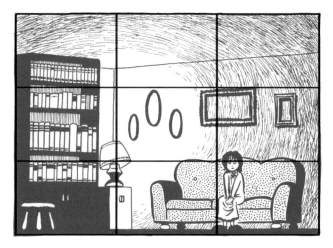

◒ LOVE & ROCKETS: HEARTBREAK SOUP, *FANTAGRAPHICS BOOKS, 1985*

In this panel from Gilbert Hernandez's seminal *Heartbreak Soup*, Carmen's loneliness is emphasized by the panel composition. By superimposing the Golden Rectangle, the panel shape conforms almost exactly with the Golden Ratio and Carmen's body and head are placed at the most harmonious positions possible.

The Golden Ratio appears frequently throughout nature, for example in the proportions of the human body, in DNA, and in the solar system, as well as having relationships to mathematics like the Fibonacci sequence and the pentagram. It has also often been used in music, art, and architecture. Unsurprisingly, therefore, the Golden Section has been imbued with a mystical quality.

Interestingly, the standard American comic book page conforms to the Golden Section: the typical three-tier grid structure divides the rectangular shape of the page at Golden Section proportions.

A rough-and-ready version of the Golden Section is the "Rule of Thirds"; a technique that suggests that a rectangle of any proportion can be divided into nine equal parts. Placing or aligning elements of the composition—such as figures or objects—within these sectors theoretically creates a pleasing, well-balanced composition.

◒◒ GARAGE BAND, *FIRST SECOND, 2007*

In Gipi's *Garage Band*, the composition in this panel is overlaid with a three-by-three grid. Many of the elements of the picture fit neatly into one or more of the sections, notably the balloons and captions.

◒ Jack Kirby's natural flair for design becomes apparent when analyzing his work. These panels, taken from *Fantastic Four* #87 (Marvel Comics, June 1969), show how neatly his compositions fit in with the Rule of Thirds.

◒ Splitting Gilbert Hernandez's panel into nine also makes for great analysis of the composition. Note how the table lamp balances the seated figure. It's possible to study almost any panel, picture, or photograph in this way.

This all may seem very involved and complicated, but of course much of this is accomplished intuitively by the artist's natural sense of composition and design.

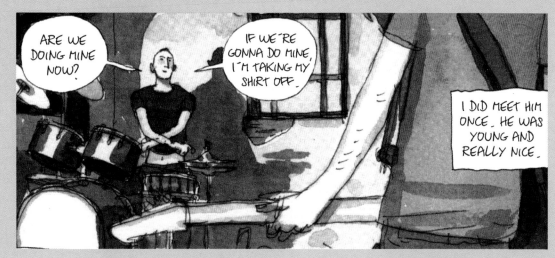

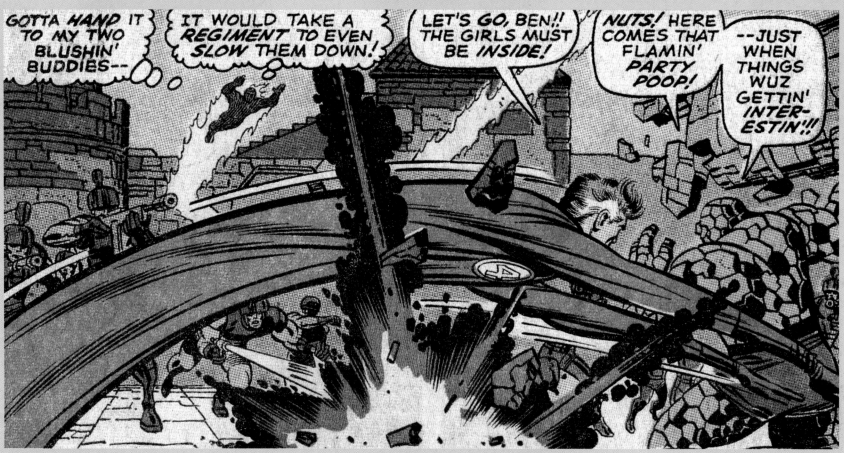

Viewpoint: Framing, Planes, and Camera Angles

The frame of the panel dictates the reader's viewpoint, forcing them to look at the scene in the way the artist intends. The artist controls the cropping, proximity, and angle of view. He also attempts to direct the eye to the focal point of the panel by using various compositional and framing devices.

FRAMING THE SHOT: CAMERA TERMINOLOGY

The reader viewpoint is usually described using camera terminology—close-up, long shot, and so on. Of course, movies and comics are different art forms and each have their own strengths and weaknesses. But at the risk of implying that comics are cinema's poorer cousin, and for the sake of clarity, the usual "camera shot" naming conventions have been followed here.

A single establishing shot at the start of a comic book, chapter, or page can "set the scene" and give the reader a sense of place, time, atmosphere, and environment.

Often this is an exterior scene, which then switches to a secondary, interior establishing shot that not only further identifies the location, but defines the relative position of the characters to their surroundings and to each other.

Once the reader has taken on board this information, the artist can safely progress to medium shots and close-ups having already established the spatial relationships between the characters.

A long shot naturally refers to a similarly wide or panoramic viewpoint, but is not necessarily placed at the start of a sequence. A long shot can be placed at any appropriate point in the narrative, perhaps showing action in context; or at the end of a sequence as the "camera" zooms out. Long shots can also imbue the scene with an air of detachment or remote observation.

A medium shot usually frames one or more characters at full figure, showing body language, pulling the reader closer into the action, and enabling an identification with the protagonist.

Close-ups can fill the panel with a character's head and shoulders; focus on a face, or perhaps even zoom in on just an eye. These are ideal for depicting facial expressions, immersing the reader in the emotional content of the story.

⦿ GARAGE BAND, *FIRST SECOND, 2007*

Establishing Shot
In the first panel, Gipi's evocative watercolor art immediately places the reader in an underprivileged tenement area.

Medium Shot
The second panel takes the viewer inside one of the apartments where three characters are introduced.

Close-up
The protagonist of the strip is seen close up, inviting the reader to identify with him.

⦿ FIRES,
CATALAN COMMUNICATIONS, 1984

A three panel sequence from Lorenzo Mattotti's near-abstract, painted tour-de-force *Fires*. The camera zooms in progressively from long shot to medium shot to close-up.

With judicious use of a variety of long shots, medium shots, and close-ups, the artist can create an infinitely more interesting page design.

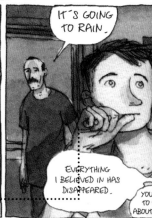
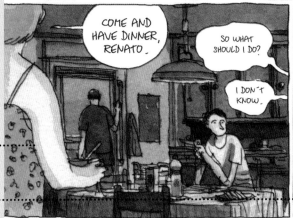

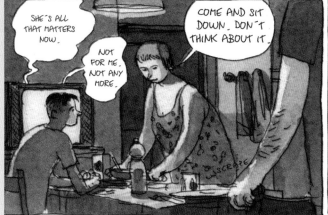

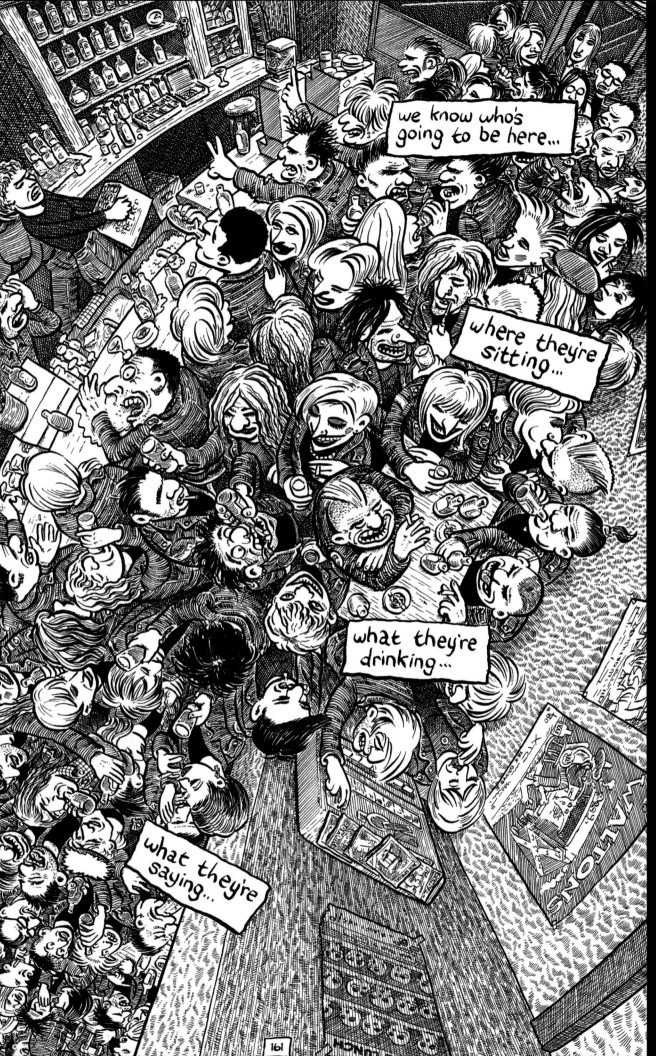

CAMERA ANGLES

The comics artist has potentially unlimited camera viewpoints available to him, altering the angle and zoom in every panel if desired. In practice, this is rarely effective, or even necessary.

Limiting the range of camera angles to the bare minimum often works best, and gives any dramatic change of viewpoint more impact when used sparingly.

A somber conversational scene for example, may be best served with a constant eye-level view, while dynamic action scenes can be enhanced by extreme variation of viewpoint.

Specific camera angles can highlight certain points in the story. A worm's eye view can emphasize the height of a giant monster or tall building, while a bird's-eye view is great for sweeping landscapes. Tilting the camera can create a feeling of unease and disorientation.

To avoid getting too carried away with close-ups and medium shots, Eddie Campbell suggests that artists "make sure to put a pair of feet on every page."

◀ **NOTES FROM A DEFEATIST,**
FANTAGRAPHICS BOOKS, 2003

Joe Sacco combines a distorted fisheye lens effect with a bird's-eye view to great effect, conveying the claustrophobic atmosphere of a crowded nightclub.

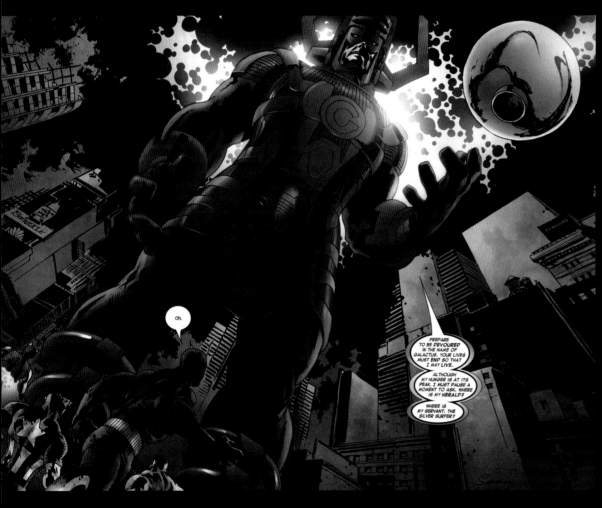

◬ MARVEL ZOMBIES #3,
MARVEL COMICS, APRIL 2006
This dramatic camera angle, illustrated by
Sean Phillips, accentuates the height of
Galactus who towers over the assembled
superhero zombies.

◗ CITIES OF THE FANTASTIC: BRUSEL,
NBM, 1992
A spectacular bird's-eye view of the city
below, exquisitely illustrated by François
Schuiten in this panel taken from his
graphic novel.

FOCUS: FRAMING DEVICES AND LEADING THE EYE

The reader's eye should be drawn to the focal point of the panel using a variety of techniques known as framing devices.

Framing, in this sense, should not be confused with the actual framing of the panel by camera angle and viewpoint, or indeed with the panel border.

The artist should always endeavor to have the reader's attention directed toward the most important part of the panel composition. Relatively straightforward panel designs can simply contain a close-up of the point of interest.

More complex layouts can contain elements that point to or surround the focal point in a way that leads the eye to it.

Framing devices including swirling capes, radiating perspective lines, windows and doorways, and even dialogue balloons can all grab the reader's attention and direct it to the main focus of the picture.

◁ **THE MAGICIAN'S WIFE,**
CATALAN COMMUNICATIONS, 1987
Radiating perspective lines lead the eye toward a mysterious figure seated on a park bench in this eerie panel from François Boucq and Jerome Charyn's graphic novel.

▽ **A SMALL KILLING,**
DARK HORSE COMICS, 1991
White sheets hanging from washing lines and blown by the wind lead the eye to the sad figure of Timothy Hole in this panel.

▽▽ **A CONTRACT WITH GOD,**
W. W. NORTON, 1978
Will Eisner literally frames two characters through the windows of a building. The window frames act as panels as well as framing devices.

51

Spotting Blacks

This curious term refers to the practice of placing areas of black on the page. This device is used to aid storytelling by simplifying complex compositions.

Solid blacks can establish the direction of light by indicating areas of shadow and give an illusion of depth. Bold shadows from a single light source help to give figures and objects shape and dimension.

Careful placement of blacks serves to define foreground and background elements, visually separate different figures, and lead the eye to the focal point.

The eye is naturally drawn to areas of the highest contrast and the artist can utilize this to his advantage, organizing black shapes in order to direct the reader's eye movement across the page.

Spotting blacks can also create mood and atmosphere, add balance and grounding, and act as a framing device by leading the eye to the focal point of the picture.

⊙ KICKBACK, *DARK HORSE, 2006*
© 2008 David Lloyd. www.lforlloyd.com

David Lloyd's use of blacks is evident in his works from his celebrated collaboration with Alan Moore, *V for Vendetta*, and his crime-noir graphic novel *Kickback*.

"Using blacks to help fortify a page composition is something I usually do only on b/w art, or on b/w art designed for color that may suffer in a later technical process, because it guarantees the page will work artistically whatever happens to it in someone else's hands. No such failsafe device was needed on this page, though, because the technical process of applying all of *Kickback*'s color was my responsibility. But old habits die hard."

Many artists rough in their blacks at the thumbnail stage, using thick markers to lay down solid areas. This ensures balance and solves storytelling issues by arranging the shapes to create a graphically satisfying pattern.

Well-designed pages can be analyzed for placement of blacks by simply squinting; allowing detail and rendering to be ignored. The main areas of black should become apparent, making the balance and design of the page as a whole more obvious.

CHIAROSCURO

Heavy blacks can provide a dramatic, noir feel to the scene. When taken to the extreme, the technique of using solid blacks and whites with little or no gray or shaded areas is called "chiaroscuro."

Originally devised by Renaissance artists including Rembrandt, high contrast dark and light is used to portray three dimensional objects with only the shape of solid shadows giving clues to form.

Many great comics artists have used this technique to their advantage, prime exponents being the great Alex Toth, Jose Munoz, Frank Miller, Paul Grist, and *Hellboy* creator Mike Mignola.

⊙⊙ TORPEDO 1936,
CATALAN COMMUNICATIONS, 1984

Alex Toth's use of black and white is legendary. In this six-panel sequence, without the benefit of color or rendering (other than a few short dashes), only black ink is used to suggest shadow or form. Despite this, every panel composition is clear and unambiguous, the design is attractive and well-balanced, and the storytelling is easily comprehensible.

⊙ EPILEPTIC, *PANTHEON, 2002*

David B's mammoth 350-page autobiography uses an appropriately dark chiaroscuro art style to track his family's struggle with his brother's illness, as the author himself withdraws into a surreal, fantasy dream world.

Storytelling Tricks and Techniques

Many creators are fond of adapting various cinematic techniques to the comic art form, other than those that have already been discussed. These include tracking and panning; split panels; and passage of time.

TRACKING AND PANNING

Tracking and panning is a technique which imitates the movement of a camera, for example, following a character walking across the page from left to right, or simply panning across a landscape.

◗ CAPTAIN AMERICA #111, *MARVEL COMICS, FEBRUARY 1969*

Jim Steranko was an innovator in the comics industry in the late 1960s. His stylish designs, influenced by contemporary filmmaking techniques and advertising trends, were a breath of fresh air to the comics industry.

As Captain America takes Bucky for superhero training, Steranko splits the bottom tier into four panels to suggest movement in Cap's gymnastic display.

It's suggested to the reader that the "camera"—the viewpoint defined by the frame of the panel—tracks the figure of Rogers from left to right as he vaults the horse and performs a somersault.

Note that the way the various poses of Captain America are not simply confined to a single panel, but overlap into adjacent panels creating a smooth transition and the illusion of movement.

◗◗ THE ADVENTURES OF LUTHER ARKWRIGHT, *DARK HORSE COMICS, 1989*

In his first major work, Bryan Talbot was already experimenting with cinematic technique. In this page from his *Luther Arkwright* series, the protagonist walks from left to right in successive panels, but the background remains constant. Although this mimics the way a camera would track the figure's movement, the effect of seeing all three panels at the same time gives a graphically unified effect, somewhat different when compared to cinema.

SPLIT-PANEL TECHNIQUES

This technique involves splitting a panel into a number of sections, often with a character moving across the page (almost certainly from left to right), giving the impression of the camera panning and following the figure.

In these interesting examples, the "camera" tracks the movement of the characters in more than one direction, in space as well as in time; the reader is offered a choice of which panels to read first, or indeed, to take in the whole page as a single composition. This is something that simply cannot be achieved with film.

◉ GASOLINE ALLEY, *1934*

Frank King's Sunday pages were often experimental, and here a number of kids walk up to and climb on to the roof of a house. The sequence reads from left to right, but anticipates a degree of commitment from the reader as the elapsed time between panels varies greatly; three minutes between the first and second panels for example.

◉ PALOOKA-VILLE #19,
DRAWN & QUARTERLY, 2008

Clearly influenced by King, Seth takes a similar isometric point of view. The panels on this page are a simpler sequence to follow as it only features one character that progresses through the page in a more logical manner, but it's nonetheless beautifully designed.

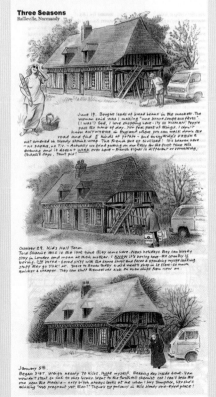

PASSAGE OF TIME

The elapsed time between two adjacent panels may be a split second, a minute, a few days, or even several years.

◉◉ A SHORT HISTORY OF AMERICA,
KITCHEN SINK PRESS, 1979

Robert Crumb uses the same technique in his beautifully conceived and drawn comic strip about the changing face of small town America. In this case, many years elapse between each panel.

◉ GEMMA BOVERY, *PANTHEON, 2005*

In this example, from Posy Simmonds' *Gemma Bovery*, the viewpoint is repeated but the seasons change, indicating that many months have passed between one panel and the next.

REPEATED VIEWPOINT

The repetition of the same panel produces a relentless, metronomic beat, often giving greater emphasis to relatively subtle changes in each panel's composition.

⊘ FUN HOME,
HOUGHTON MIFFLIN, 2006

In this episode of Alison Bechdel's autobiographical account of her relationship with her father, she has a revealing conversation with him during a car journey to the theater. This same viewpoint is repeated over two pages, focusing the reader's attention on the dialogue, subtle changes of expression, and body language.

In this rigid arrangement, the silent panels are as effective as those with dialogue, suggesting moments of awkwardness and deep thought for the characters.

⊘ KANE #13,
DANCING ELEPHANT PRESS, MAY 1996

Always formally experimental yet playful, Paul Grist took the repeated viewpoint technique to extreme lengths in an issue of *Kane*, in which the entire story was told from the same point of view—the back seat of a police car.

ZOOMING

From the same reader viewpoint, the camera movement "zooms" toward (or away from) the subject over a sequence of panels with only one or two minor changes to the content of the scene.

SILHOUETTE

Silhouettes can help separate background from foreground, heighten drama and impact, and bring a strong sense of graphic design to the comic page.

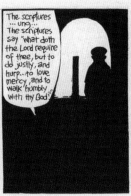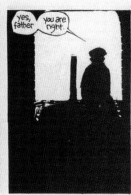
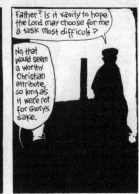

⬥ **THE ARRIVAL,**
ARTHUR A. LEVINE, 2007

From Shaun Tan's stunningly rendered and atmospheric silent story about a migrant seeking a better life for his family in a strange foreign land; the camera slowly zooms out from a photograph of the traveler's folks until we see the ship in which he is making his voyage, emphasizing his loneliness and isolation.

⬥ **FROM HELL,**
TOP SHELF PRODUCTIONS, 1999

Eddie Campbell combines the repeated panel motif with the power of the silhouette. In this sequence, the canal boat gradually approaches the end of a tunnel before emerging into bright daylight.

Designer Spotlight: **Matt Kindt**

Matt Kindt's design sensibility and technical virtuosity has earned him a deserved reputation as an extraordinary up-and-coming designer in the comic book field. He is also recognized as being a prolific and accomplished cartoonist and storyteller.

His *Pistolwhip* collaborations with Jason Hall early in the new millennium were low-profile but critically acclaimed, the first of which made *Time*'s Ten Best Graphic Novels of 2001.

Today his accolades continue to grow for his serialized web comic, *Super Spy*, formatted as downloadable content for the PSP Playstation Portable, and collected in an elegant print edition by Top Shelf.

Although much of his comics works are evocative period pieces, his design and attention to production values are entirely contemporary.

"I think the design of books gets overlooked a lot of times and it shouldn't. The design and feel of the book is really integral to the book's message.

"The 336-page *2 Sisters* graphic novel was designed to be read from cover to cover. The front cover is really the first panel of the story and the back cover is the last panel—even the inside covers are panels in the story."

Kindt obtained a degree in fine art from Webster University in St. Louis in 1995 but had already long been producing his own copy-shop zines.

After working as a graphic artist for local companies, including a stint as art director at *The Sporting News*, Kindt supplied freelance design and illustrations for Random House and *St. Louis Magazine*.

Kindt now does less illustration and design work in favor of creating more of his own comics, but still teaches a class on drawing comics in his home town, St. Louis, and says that he will never give up designing his own books.

"I can't imagine spending a year on a book and then handing the art over to someone else to put together and package into who-knows-what. It's such a part of the process to me that I don't think I could ever give it up. I really think the entire package should be part of the experience."

Kindt, along with Top Shelf publisher Brett Warnock, won a Harvey award for their design work on the lavish three-volume slipcased edition of Alan Moore and Melinda Gebbie's *Lost Girls*.

Each of the elaborate 112-page oversized volumes has an individual dust jacket, cloth binding, and luxurious cream-colored stock. In keeping with Moore and Gebbie's concept, Kindt designed the set to look like an old-fashioned children's storybook, scanning in parts of vintage books to create textures for added authenticity.

"For the cover of *Super Spy*, I really just did two sketches and then picked the one. Sometimes I do a ton of concepts but I didn't feel like I needed more."

The distressed look of the fake dust jacket, the yellowed, stained, and cracked interior pages, and muted color give the book the convincing impression of a real, aged document. A variety of full color, single color, and monochrome schemes are used for the different segments of the book, along with various page layouts, but Kindt's drawing style and the antique design hold the book together superbly.

Typical of Kindt's love of detail are the inside covers of the paperback edition of *Super Spy*. Drawings of skeletons, which, when held up to a bright light, are revealed in x-ray style, to be the bones of the figures on the outer covers. There is also a hidden message on the inside front cover as red letters spell out a secret message.

ABOVE
Super Spy, Top Shelf Productions, 2007

FACING PAGE
CLOCKWISE FROM TOP LEFT:

2 Sisters, Top Shelf Productions, 2004

Super Spy, Top Shelf Productions, 2007

Pistolwhip: Yellow Menace, Top Shelf Productions, 2003

Super Spy, Top Shelf Productions, 2007

Super Spy, Top Shelf Productions, 2007

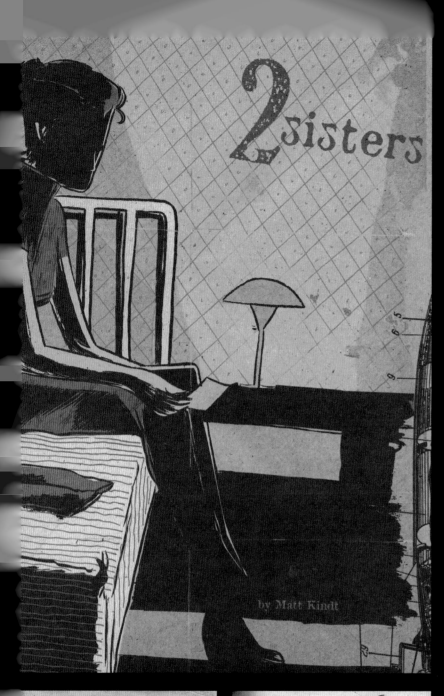

2 sisters

by Matt Kindt

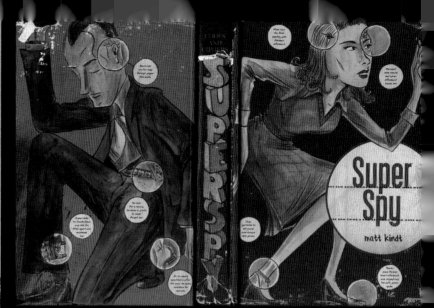

Super Spy

matt kindt

PISTOLWHIP
The
Yellow Menace

Chapter 3
Page Layout and Design

Introduction

The page, rather than the panel, is the basic unit of the comic book or graphic novel. In the context of a single-page newspaper strip, or an epic graphic novel, the reader views a page (or perhaps a double-page spread) at a time.

One thing unique to the comic art form that no other medium can offer is that all the various storytelling elements (images, balloons, text, sound effects) can be arranged as a sequence of separate panels, and viewed at once as a single unified design.

A potentially confusing array of differing images and text is avoided when the whole page is designed correctly, the reader being able to follow the reading track sequentially across and down the page, viewing each panel at their own pace.

More adventurous page layouts may contain any number of different-sized interlocking panels, even making use of irregular shapes, overlapping panels, or angled panels with diagonal gutters. Figures may even break out of the grid for additional impact.

Despite the wide range of alternatives available to the creator, panel arrangements should never be arbitrary. Narrative flow is the prime concern when laying out a page. Clear, logical page layouts are crucial if the reader is going to be able to follow the story.

OMEGA THE UNKNOWN #2,
MARVEL COMICS, JANUARY 2008

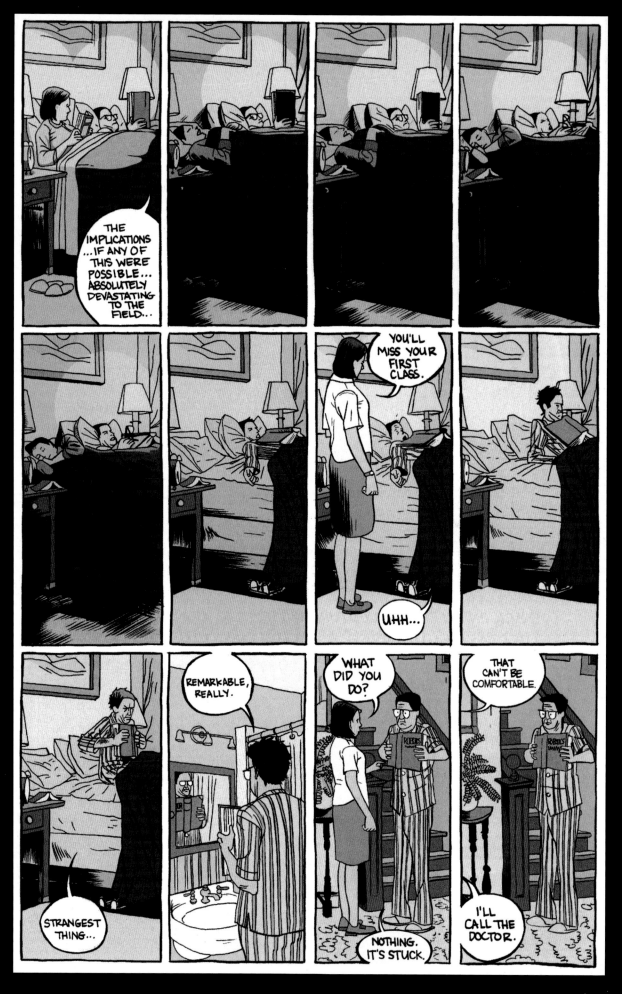

Grid Layout Systems

It's essential that the panels that form the narrative on each page are arranged to be read in a specific sequence. This allows the reader to focus on the panel content rather than trying to decipher the reading order.

One of the most effective and common ways of achieving ease of readability is through the use of a grid system. The overall page is divided into smaller units, split horizontally and vertically, resulting in a number of equally sized panels arranged in rows and columns. Typically, grids contain nine or six panels, although four, eight, and twelve grid systems are not uncommon either.

The eye tends to read from left to right across the top tier of the page, reading each panel in sequence then dropping down to the next tier, and so on down to the bottom tier.

The use of a grid structure ensures that the page is readable, understandable, and easy-to-follow, and the same grid applied throughout the comic book gives a consistent visual coherence. This allows the reader to immerse themselves in the content rather than concerning themselves with form.

THE NINE-PANEL GRID

One of the most versatile fixed grid structures is the nine-panel grid. It has been adapted for use in myriad comic books across the full spectrum of genres, popularized by EC Comics in the 1950s and Steve Ditko during the 1960s on such titles as *Amazing Spider-Man* and *Dr. Strange*. It was famously exploited by Alan Moore and Dave Gibbons in their seminal 1986 series *Watchmen*, with every page being based on the nine-panel grid.

The three-by-three layout remains an excellent storytelling solution, as borne out by its continued popularity with creators from all corners of comic art from superhero to art comics. The "live area" of the page —the space that remains in the center of the page after the margins have been added, containing the artwork and text—is divided equally into a matrix of three columns and three rows.

Adherence to the grid maintains a metronome-like visual rhythm and a simple, effective, and flexible framework on which the creator can hang his stories.

▶ **AMAZING SPIDER-MAN #24,**
MARVEL COMICS, MAY 1965

This page from a Steve Ditko-era *Spider-Man* story is typically densely packed with narration, dialogue, and illustrations. There are three separate scenes packed into this single page, as we cut from Peter Parker and Betty Brant, to Spider-Man, to the offices of the Daily Bugle and J. Jonah Jameson. The large amount of information is easily digestible and comprehensible thanks to the rigid, easy-to-follow grid format.

Like much of Jack Kirby's classic 1960s Marvel work, Ditko varies his layouts on a page-by-page basis. Quieter moments, or scenes with lots of exposition, are well suited to a nine-panel grid, with more action-oriented pages usually containing fewer panels.

Any nine-panel grid, by default, no matter to which page proportions it is applied, creates a layout that conforms to the rule of thirds. As noted in the previous chapter, the dimensions of the American comic book page correspond precisely to the Golden Section ratio.

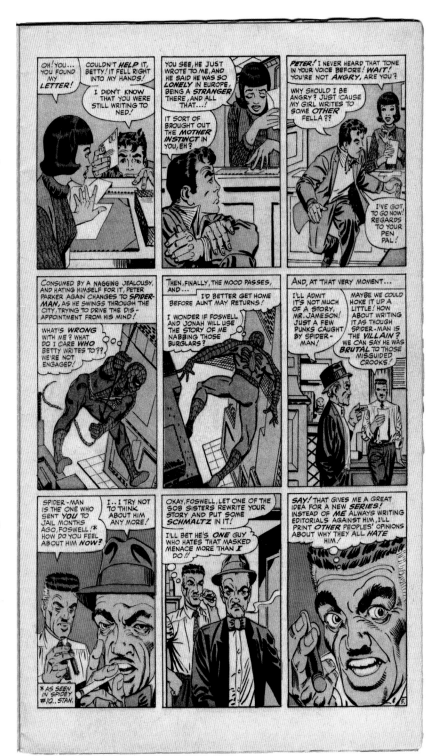

▶ INCREDIBLE HULK #36,
MARVEL COMICS, MARCH 2002

The nine-panel grid is as fresh today as it was in the 1960s. In this page from *Incredible Hulk*, John Romita Jr. and Tom Palmer create tension and anxiety by the use of the wordless regular grid, reinforced by the inclusion of the clock motif. The somber mood and inevitability of death by lethal injection is perfectly conveyed by layout and color.

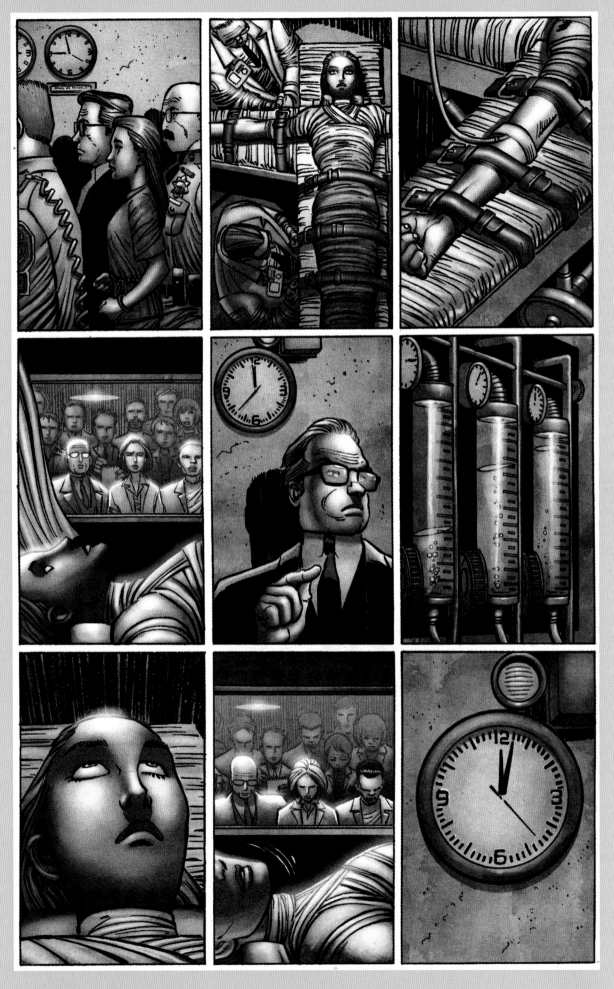

JOINING GRIDS

Of course, the content of each panel as dictated by the story does not always fit comfortably into these strict divisions.

The story will often call for larger panels for important events, action scenes, panoramas, and other moments where the required composition simply won't fit into the available shape. By joining two or more panels together, larger panels can be accommodated without breaking the overall grid pattern.

The nine-panel grid allows the artist a large number of potential page layouts and panel sizes. Here are some of the options.

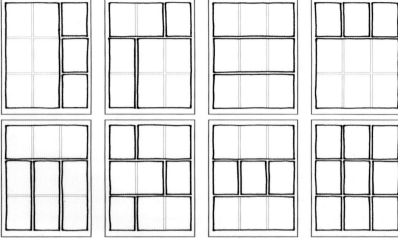

PERSEPOLIS,
PANTHEON, 2004

Marjane Satrapi's autobiographical coming-of-age story *Persepolis* employs the nine-panel grid throughout. Her graphic woodcutlike art style and straightforward page layouts make this story of a young girl growing up in Iran a breeze to read, and has also contributed to its huge commercial and critical success.

By joining the bottom six panels of the grid together, Satrapi creates a much larger canvas, allowing her more space and freedom to create powerful, metaphorical imagery. Here, the terror of hearing about an outbreak of car bomb attacks is visually portrayed by Satrapi's simple but effective style.

The large frame breaks the constant rhythm of the grid and invites the reader to pause and identify with the gravity of the situation.

FROM HELL,
TOP SHELF PRODUCTIONS, 1999

In Alan Moore and Eddie Campbell's masterpiece *From Hell*, every one of its 600 pages is based on the nine-panel grid. Campbell's scratchy dip-pen style perfectly encapsulates the spirit of the time. Here, as Jack the Ripper's victim is lured into the carriage, Campbell joins the bottom tier of three panels to create room for the chilling denouement of the scene.

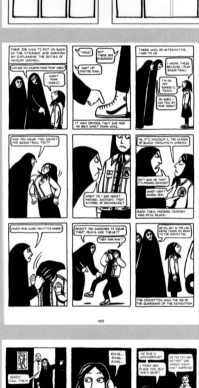

UNDERLYING GRID STRUCTURES

Even though the page may be based on a somewhat rigid grid structure, this can be disguised or softened somewhat by various techniques.

CARICATURE,
FANTAGRAPHICS BOOKS, 1998

The nine-panel grid used for this page in Dan Clowes' graphic novel *Caricature* is evident but not entirely obvious. The narrated captions are not enclosed by the panel borders, resulting in each panel being a slightly different height and shape, breaking up the rigidity of the grid. The circular center panel creates a focal point for the whole page. Clowes' stunning use of spotted blacks, gray tones, and negative space balance the page with a variety of unusual and unexpected methods.

OMEGA THE UNKNOWN #6,
MARVEL COMICS, MAY 2008

Grid structure can be interpreted in a less rigid fashion, with panels and gutters not being precisely measured, but roughly drawn with uneven borders. This takes advantage of a familiar grid structure without exact measurements, giving the page a structured, easily readable, but looser and more relaxed sensibility.

Farel Dalrymple makes excellent use of the grid system with his artwork for the revived *Omega the Unknown* series, brilliantly manipulating different grid layouts.

SIX-PANEL GRIDS

Dividing the regular American comic book page into three rows and two columns (allowing for the usual borders and gutters) creates six identically sized square panels, giving the page a great sense of balance.

This is another extremely popular grid, often utilized by the great Jack Kirby, and it continues to be extremely popular with independent and art comics creators such as Jim Woodring, Jeffrey Brown, Kevin Huizenga, and Chester Brown.

Like the nine-panel grid, the page is divided into three tiers, and again the overall shape conforms to the Golden Rectangle. The easy-to-follow structure allows for greater complexity in composition for each individual panel as the reading track is obvious and straightforward.

▶ **FANTASTIC FOUR #99,**
MARVEL COMICS, JUNE 1970

Kirby's dynamic panel compositions are barely contained by a simple grid, and often he would mix variations of four- and six-panel grids, less regular grid layouts, and full-page images in one story.

His three-by-two grids would frequently have one full-width panel, usually across the top. The panels mixing medium shots with close-ups are action-packed, filled with numerous expressive characters in the trademark Kirby style, but always superbly balanced and designed.

Despite the complexity of the design of the first panel here, each character has their own space to express themselves through their actions and body language, and yet the image remains clear and uncluttered.

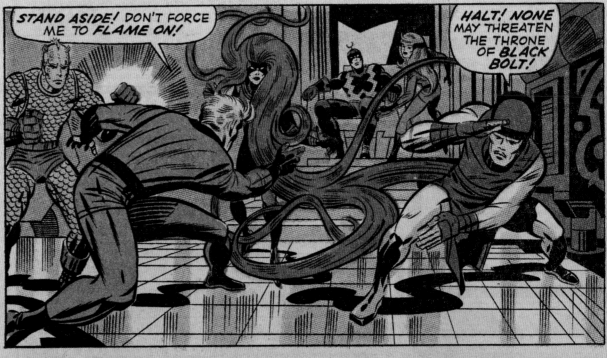

◭ BLACK HOLE,
PANTHEON, 2008

The page layouts for Charles Burns' teen plague horror graphic novel *Black Hole* modulate between different grids, usually based on a three-tier page. As the narrative progresses, the layouts become less structured and more fragmented.

This disturbing six-panel sequence is beautifully depicted by Burns' chiaroscuro brushwork, with superbly balanced spotted blacks.

FOUR- AND EIGHT-PANEL GRIDS

Pages containing four and eight same-sized panels are less common, but each can be equally effective as part of the overall design of the story.

Four-panel grids are great for powerful action sequences, and can carry the reader through the scene very quickly. This layout is often popular in small-sized publications where space and legibility is an issue.

◑ TINY BUBBLES,
HIGHWATER BOOKS, 1998

Only James Kochalka can create an entire graphic novel about a minor skin problem. The four-panel grid, used throughout the book, speeds the reader through his memoir of discomfort. Kochalka's simple, naïve, yet attractive drawing style has won him many fans across the world.

◑ THE ORIGINALS,
VERTIGO/DC COMICS, 2004

In his self-scripted, retro-futuristic graphic novel, Dave Gibbons tells the story of rival bike gangs, recalling the bygone era of the Mods and Rockers of 1960s Britain.

A stylish eight-panel grid is used consistently throughout the book, giving an altogether different panel shape compared to his work on the seminal *Watchmen*. This grid turns out to be remarkably flexible in Gibbons' hands, with a large variety of panel shapes possible without interrupting the flow of the story.

GRIDS OF MANY PANELS

Pages with more than eight panels arranged in a regular grid pattern are usually quite rare, the typical exception being for oversized formats. Sixteen panels is a comfortable maximum when designing for these larger layouts.

High numbers of panels per page is usually a solution for a narratively dense story, so care has to be taken to avoid making the page look too crowded and unattractive. Balloons and captions should be kept to a minimum and panel content should be accordingly simple, in terms of drawing style, background detail, and composition.

◗ SIGNAL TO NOISE,
DARK HORSE COMICS, 1992

Neil Gaiman's poignant tale of a dying film director is vividly brought to life by Dave McKean's sensational use of photography, drawing, painting, and collage. McKean divides the sixteen equally-sized panels with a thin white gutter, often using split panel and repeated panel techniques to great effect.

◖ BERLIN #14,
DRAWN & QUARTERLY, DECEMBER 2007

Jason Lutes' masterful story about pre-war Germany utilizes a sixteen-panel grid throughout, giving options for a variety of panel sizes.

Lutes limits most of his background rendering to the four-panel-sized establishing shot. In all but one of the panels containing dialogue, background detail is dropped out completely in favor of a solid black.

Note how the pipes on the ceiling in the initial panel draw the reader into the page. The arched curve above the bar subtly leads the eye toward the second panel.

◐ ELEKTRA LIVES AGAIN,
EPIC COMICS, 1990

Frank Miller showcases the variety of his storytelling chops in an oversized hardcover format that boasts a range of virtuoso panel layouts. Each page of this sequel to his fan-favorite *Daredevil* spin-off character Elektra is based around a sixteen-panel grid, but combining these to produce two-panel pages, splash pages, floating panels, borderless panels, and yet more inventive and surprising layouts.

Miller tightly controls the tempo here with eleven panels of varying size, suggesting to the reader that the figure falls to the floor in slow motion.

◑ STUCK RUBBER BABY,
PARADOX PRESS, 1995

Howard Cruse's unusual five-by-three grid is just one of the many innovative and tightly packed panel layouts in his award-winning tale of civil rights in 1960s America. Despite packing in fifteen panels on this page, the storytelling is never compromised. The graphic novel is digest-sized, making it a rare and densely packed treat.

◑ MISTER O,
NBM PUBLISHING, 2004

Master French cartoonist Lewis Trondheim manages to divide each and every page of this graphic album up into no less than sixty panels. In a series of animation-like single page adventures, his stick-figure character Mister O comically fails on each disastrous attempt to cross from one cliff edge to the other side.

The minimalist drawings and simple, fixed viewpoint ensure that the reader is never confused. The cliff itself provides a de facto panel separator along which the eye is led.

Comic Book Design

LARGE AND UNUSUAL PAGE SIZES

Page layouts are, of course, forced to fit the physical page dimensions dictated by the book or publication in which they appear.

Many of the grid formats discussed in this chapter relate to the standard American comic book size—approximately ten by six-and-a-half inches—which is the standard format for most superhero and mainstream comics and graphic novels.

American magazine size, a little wider and of proportionally squarer shape, is a less favored format, but notably used for *Love & Rockets*. The recent boom in translated manga has seen the rise in popularity of digest or pocket-sized editions, while the advent of the graphic novel has seen many variations of shape and size.

The size of the canvas available to the artist with oversized, newspaper, and tabloid formats allows a much greater scope for inventive layouts. From Herriman's *Krazy Kat* to Chris Ware's *Acme Novelty Library*, large formats have often inspired artists to more experimental and ambitious designs.

◗ KRAZY KAT,
SUNDAY NEWSPAPER STRIP, AUGUST 1940

Regarded by many as the finest ever comic, George Herriman's sublime newspaper strip really came alive on the full canvas of the Sunday page. Always sweet, funny, and incredibly inventive, Herriman's tale of a love triangle between a cat, dog, and mouse has become an all-time classic. Backgrounds changed from panel to panel, and page layouts ranged from the quirky to the surreal, rarely repeating the formula two weeks in a row.

In this example, the decorative circular panels are part of the narrative and the display title of the strip is characteristically unusual.

We'll look at the diversity of formats again in Chapter Six.

PARIS, GARE DE LYON.

HEY! YOU THERE!

SO, SCUM, YOU'RE DEAF!

STILL KICKING, YOU DIRTY ARAB?!!

⑩

EUROPEAN-STYLE PANEL LAYOUTS

In Europe, specifically France, the hardcover album is the default format for comic books, or *bande dessinée* as they are known locally. This is somewhat larger than the standard American comic book and notably taller than the typical US magazine size. Recently, as in the US, mainstream French formats are becoming more diverse.

Often the strips themselves have appeared as serials in magazines and other periodicals, although unlike American comics, the stories have historically been conceived for eventual collection into albums.

○ THE ROAD TO AMERICA,
DRAWN & QUARTERLY, 2002

Using a four-tier, twelve-panel grid, Baru's gorgeously fluid line work bring to life the story of Algeria's fight for independence from France through the eyes of a young boxer.

From the photo-realistic establishing shot, the lines of the train tracks lead the eye to the second panel, where Baru's cartooning skills take over. Superb panel composition and expressive body language, along with the muted tones of colorist Daniel Ledran, together create a wonderful example of

○ ○ ASTERIX IN BRITAIN,
ORION, 1966

○ THE BLUE LOTUS,
LITTLE, BROWN, 1946

Both *Asterix* and *Tintin* are hugely popular, long-running, multi-volume examples of the traditional French album format. The four-tier layout is very common due to the larger page size and the fact that some of these stories were serialized weekly in half-page installments.

Creator Hergé, who pioneered the *ligne claire*—or clear line—technique, painstakingly researched and illustrated each book to very high standards. Encompassing a variety of genres, the adventures of young detective Tintin span a total of twenty-three volumes.

Asterix the Gaul and his sidekick Obelix have been entertaining French readers since 1961 and have been translated into over 100 languages, including Latin. Since the death of René Goscinny, artist Albert Uderzo has continued the series, with every panel of his big foot (and big nose!) cartooning always exquisitely composed.

Grid Variations

Mixing and Combining Grids

It's not always desirable to have the same grid structure used throughout a comic book or graphic novel. Many creators switch between a number of different grids from page to page according to the needs of pacing and layout. The characteristics of different grids can even be mixed together on a single page, certainly if they have the same number of regularly spaced tiers.

A nine-panel grid and a six-panel grid both have three rows of panels. Each row can be then divided equally into either two or three panels.

This modulation allows the artist greater flexibility in the size of the panels without sacrificing the easy-to-follow grid patterns.

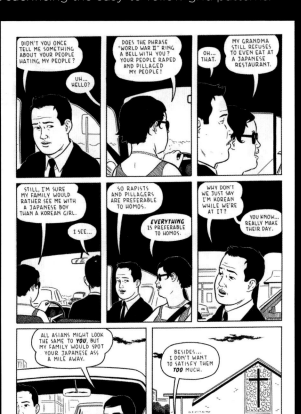

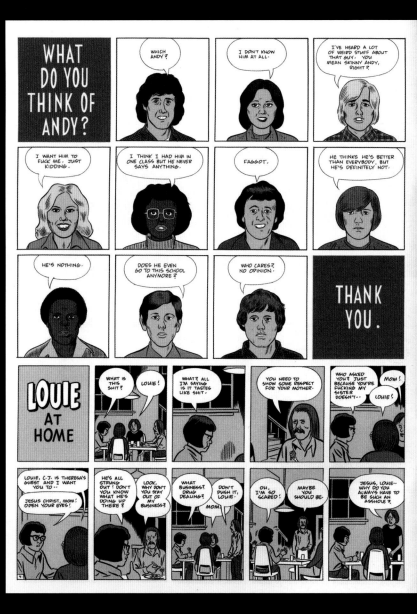

◀ **OPTIC NERVE #9,**
DRAWN & QUARTERLY, JANUARY 2004

Adrian Tomine frequently combines nine- and six-panel grids throughout his work, three tiers of either two or three panels as the pacing or composition requires. In this page from his *Shortcomings* storyline, he spins the viewpoint of the reader around to create a variety of images in a static environment, but keeps the camera at eye level to maintain the appropriate mood.

Entirely different grid types can even be used to define separate narrative strands in more complex stories.

◢ **EIGHTBALL #23,**
FANTAGRAPHICS BOOKS, 2004

Dan Clowes breaks up the page into two different areas and utilizes two separate grid patterns to differentiate between sequences. Even though the layout implies that these are two unconnected strips, they are parts of a single, fragmented narrative.

THE DAY BEFORE, THAT MAN FROM THE UNITED STATES TOLD HER SHE WAS POSSIBLY THE FASTEST WOMAN SPRINTER IN THE WORLD...

THIS IS THE REASON DIANA VILLASEÑOR IS UP SO EARLY ON A SATURDAY MORNING, A DAY WHEN HER OLDER SISTER TONANTZIN USUALLY ALLOWS HER TO SLEEP IN.

UP UNTIL LAST NIGHT, THE ONLY ACTIVITY DIANA LOVED MORE THAN RUNNING WAS SLEEPING. THAT HAS NOW CHANGED.

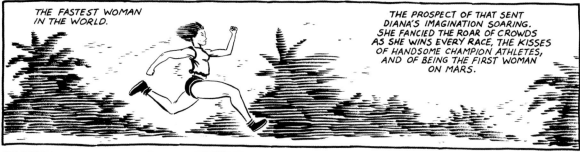

THE FASTEST WOMAN IN THE WORLD.

THE PROSPECT OF THAT SENT DIANA'S IMAGINATION SOARING. SHE FANCIED THE ROAR OF CROWDS AS SHE WINS EVERY RACE, THE KISSES OF HANDSOME CHAMPION ATHLETES, AND OF BEING THE FIRST WOMAN ON MARS.

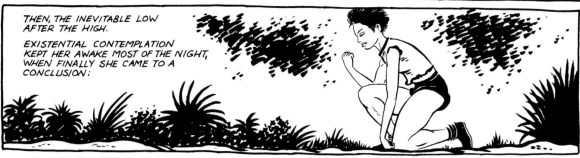

THEN, THE INEVITABLE LOW AFTER THE HIGH.

EXISTENTIAL CONTEMPLATION KEPT HER AWAKE MOST OF THE NIGHT, WHEN FINALLY SHE CAME TO A CONCLUSION:

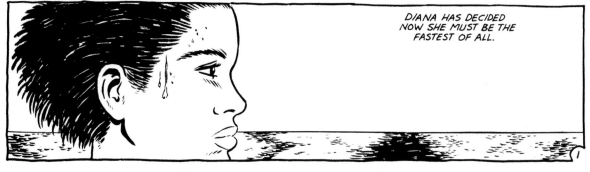

DIANA HAS DECIDED NOW SHE MUST BE THE FASTEST OF ALL.

191

HORIZONTAL AND VERTICAL PANELS

Individual panels in a grid structure can be joined either horizontally or vertically in order to provide varied page layouts.

Alternatively, when there are a series of panels stretching from side to side (or from top to bottom), a more flexible approach can be taken, modulating the panel widths to suit the panel content. As the eye naturally follows the panels either from left to right, or from top to bottom, comprehension is straightforward.

A page layout containing only horizontal panels is great for sweeping action scenes or a series of panoramic visuals. Vertical-only panel structure is more rarely seen. The field of view of human binocular vision is perceived as horizontal, so restricting the panel frame to a long, thin shape is unusual and dramatic. A series of vertical panels gives a fragmented viewpoint, perhaps impressing the sense of spying on a scene through a crack in a door, creating a tension and anxiety in the reader.

◁ LOVE & ROCKETS,
FANTAGRAPHICS BOOKS, 1985

Gilbert Hernandez uses the full width of the page to portray Diana Villaseñor's attempts to become the fastest woman in the world. This is an elegantly designed and superbly balanced page; the long narrow panels emphasize the length of the beach, and the speed of Diana's running and the composition of the panels complement each other perfectly.

Breaking the Grid

Of course, adherence to a strict grid is not the only way to build a page.

Breaking out of a deliberately restrictive grid structure at the appropriate part of the narrative can underline a moment of action or high drama. The expected rhythm of rectangles broken with a slanted, borderless, larger-sized, or differently shaped panel will highlight its content. It's also not unusual to have page layouts containing irregularly shaped panels, angled page structures, overlapping, and "floating" panels, or even no panels whatsoever as part of a single-page "meta-panel" design.

But it must be remembered that clear panel arrangement is essential for the reader to be able to follow the sequence of images, especially when the narrative is complex.

NO FIXED GRID

Fixed-panel grids can be dispensed with entirely if desired. Variation of tier height offers the artist a much greater flexibility; interlocking panels of varying size can be designed to contain the required content of each panel, to create the desired impact for each image, and to control pacing. This may make the reading track less obvious, so greater care has to be taken with the layout of the page as a whole.

Having horizontal rows of panels helps to control the movement of the reader's eye across the page, although the further the layout deviates from the regular grid, the more important other factors like caption and balloon placement, spotted blacks, and composition become.

Panel arrangements should always be designed with a purpose in mind, never simply arbitrary.

⊙ KICKBACK,
DARK HORSE, 2006
© 2008 David Lloyd. www.lforllloyd.com

This page from David Lloyd's crime noir graphic novel contains four panels of different sizes not arranged to any grid system. Lloyd says, "Using these two horizontals stretching across the page gave me room for a wide low-angle composition that is perfectly suited to depicting the main subject of the panel and also demonstrates the volume of space around the characters. The third frame's thin vertical emphasizes the depth of the viewpoint."

⊙ SECRET INVASION #1,
MARVEL COMICS, 2008

Lenil Yu's excellently designed panel compositions for Marvel's hit series use a combination of one vertical image and five horizontal panels of differing sizes. As the eye reads from left to right, it's natural that first views the vertical panel, then proceed down the stack of horizontal panels.

If the vertical panel was on the right-hand side of the page, it could cause some reader confusion about which order the panels should be read.

BREAKING OUT

Sometimes, the artist may want to draw extra attention to a character or object by bringing it to the foreground of the entire page, literally bursting out of panel borders. Figures overlapping other panels give an illusion of depth and create a focal point for the whole page design.

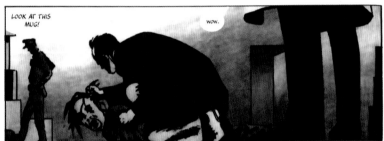
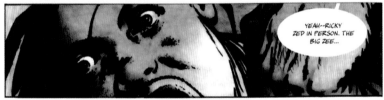

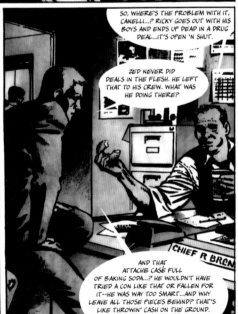

◐ AMERICAN FLAGG! HARD TIMES,
FIRST COMICS, 1985

Howard Chaykin's boldly graphic and design-conscious series, published by First Comics in the mid 1980s, was famous for its "poster page" layouts. Chaykin's experimental panel arrangements and integrated display lettering by Ken Bruzenak produced a comic book like no other. "Papa papa ooo mow mow" indeed.

◓ WHEN THE WIND BLOWS,
PENGUIN, 1982

To break up the relentless arrangement of tiny panels that characterizes Raymond Briggs' shocking and funny anti-nuclear fantasy, the figure of a Russian soldier is inserted into the narrative. The size of the character and the borderless, bleed-off image is in stark contrast to the rest of the page. The open panel is neatly incorporated into the design as James leans back in fear.

◒ MELMOTH,
AARDVARK-VANAHEIM, 1991

From Dave Sim's hugely influential and long-running epic, the title character Cerebus stands free of panel borders in this full-page design.

Sim's unparalleled innovation in page layout, lettering, and storytelling techniques is a constant delight. Here, even the panel borders are composed of a pre-printed, self-adhesive tape, which Sim used extensively to speed up production time.

MONTAGE

Experienced creators may even decide to do away with panel borders altogether, arranging images intuitively to create a page-sized free-flowing composition.

The montage is a page designed to be swallowed whole. The entire page is a single unit with no obvious individual panels, yet contains a sequence of images.

▶ **ELEKTRA LIVES AGAIN,**
EPIC COMICS, 1990

Apart from two floated panels in the top left corner, Frank Miller portrays Matt "Daredevil" Murdoch getting up, putting on his gown, and walking down the staircase all in one panel. Despite the continuous background and the lack of panel borders, the reader is in no doubt about the sequence of movement.

The eye is attracted by the high contrast shadow of the blinds in the first panel, leading us to Murdoch's head. The reader should then look at the second panel, then across to the figure of Murdoch as he gets out of bed.

This layout is so successful that, by the time the eye has followed Murdoch all the way down to the bottom of the staircase, the eye is actually moving from right to left.

MINOR MIRACLES,
W. W. NORTON, 2000

Will Eisner was perhaps the greatest and most frequent proponent of what he described as the "meta-panel." Indeed, starting with his collection of short stories *A Contract with God*, he abandoned the panel border and conventional page layouts altogether in favor of the montage.

This page illustrates the ink wash technique that he used to great effect in his later years, mixing montage with floating panels and other characteristic storytelling devices.

With images bleeding into each other without the benefit of any panel division, it's important that the different images are clear enough to be discerned as separate by the reader. Balloons and captions are an excellent way of leading the reader through a complex layout.

WARLOCK,
MARVEL COMICS GROUP, 1973

Soliloquy is often difficult to make visually interesting. To compensate, the character could be engaged in a mundane activity while speaking, camera angles could be varied, or the text could be broken up over a number of small panels focusing on the character's expressions.

On this page of his cult *Warlock* series, Jim Starlin decides to create a meta-panel with the title character striking various poses on a rock floating in space, the camera zooming in. Note how the dialogue balloons lead the eye in the correct sequence; and how the images and the balloons themselves balance the page as part of an integrated composition.

KANE VOL. 5,
IMAGE COMICS, 2005

Paul Grist's "soft boiled" detective series constantly uses montage. His marvelous application of chiaroscuro combined with an excellent compositional sense makes it easy to follow the narrative despite the lack of panel borders. Note the way the light from the window frames Kate Felix in the second panel.

ALICE IN SUNDERLAND,
DARK HORSE, 2007

Bryan Talbot's astonishing mix of art styles for his *Alice in Sunderland* book led him to experiment with Photoshop, creating many borderless montages.

FLOATING PANELS

Floating panels refer to panels inset into a larger image. These types of panels can add a great variety to the page layout and create visual interest while maintaining the reading track. This can be facilitated if the placement of the superimposed panels corresponds to an underlying grid pattern.

Panels juxtaposed against each other without a gutter to separate them have to be very carefully composed. The main areas of color or black and white have to be meticulously planned so that individual panels are not confused with each other. The reader must be able to see where one panel ends and the next begins.

◗ **THE UMBRELLA ACADEMY #1,**
DARK HORSE COMICS, 2007

Gabriel Ba's excellent placement of two floating panels cleverly balances with the main image, effortlessly packing in three distinct events on one page without diminishing the effect of the explosive third panel. Ba's distinctive artwork is enhanced by Dave Stewart's subtle colors, which use a limited palette to create a clear separation between the main image and the floating panels.

◗◗ **DEAD SHE SAID #1,**
IDW PUBLISHING, MAY 2008

Steve Niles' mixture of detective and horror genres is evocatively illustrated by comics legend Bernie Wrightson, who floats four panels over the main image to create an integrated and harmonious page composition. The pacing of the storytelling is immaculate, as Coogan pours himself a drink, lights a cigarette, and looks out through the blind.

◗ **INVASION OF THE ELVIS ZOMBIES,**
RAW BOOKS, 1984

Gary Panter's main, crudely effective image of a zombie Elvis is inset with panels drawn in a cleaner style and a typeset caption. Ever inventive, Panter mixes drawing and storytelling techniques into his signature grunge style, creating a compulsive narrative with unique visuals.

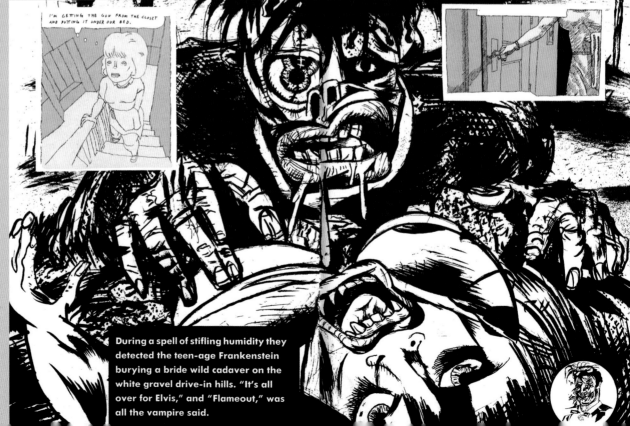

NEGATIVE SPACE

Artwork does not have to fill every spare inch of the canvas. Space, as in individual panels, can help the artwork breathe, and helps the artist to draw attention to a certain element—in this case a panel, or series of panels.

◐ SUPER SPY,
TOP SHELF PRODUCTIONS, 2007

Matt Kindt's distressed style design of his *Super Spy* graphic novel includes the illusion of yellow, stained, and creased paper. He uses this as a backdrop, contrasting a number of small, dark images across the center tier, evoking a quiet atmosphere of reflection and contemplation.

◐ THE TICKING,
TOP SHELF PRODUCTIONS, 2005

Placing just one or two panels on each delicately penciled page of her surreal graphic novel, Renee French applies the negative space to draw attention to the isolation of a disfigured child.

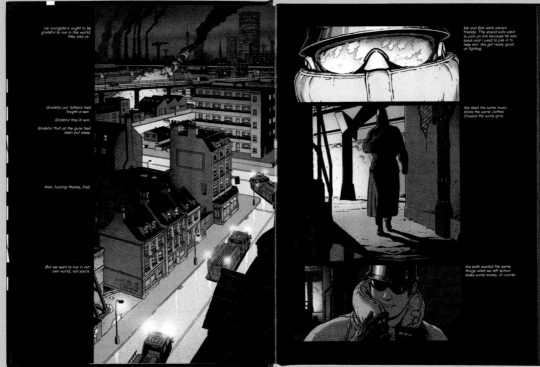

◐ THE ORIGINALS,
VERTIGO/DC COMICS, 2004

On some pages of Dave Gibbons' graphic novel *The Originals*, the artist utilizes negative space to place small chunks of narration, normally contained in caption boxes, onto the artwork. This is a stylish and effective solution when integrated into the overall design of the book.

Exotic and Unusual Page Layouts

Despite the emphasis of this chapter being on an assortment of grid structures, there is nothing wrong with unorthodox, elaborate, or experimental page layouts.

Effective comics can be created without the use of a rigid grid layout, but a clear and obvious reading track is essential. If the reader does not know which part of the page to look at next, he is pulled out of the story. Even when comics layouts are at their most experimental, reader comprehension should always be considered of the utmost importance.

IRREGULAR PANELS

More elaborate page layouts may not adhere to a grid system, but may nevertheless have a consistent structure using differently shaped panels.

Oddly-shaped, irregular panels can be used to enhance a particular page if the narrative requires a fractious, fragmented arrangement. As always, extreme and unusual page designs should be used sparingly and are most effective when they provide a sudden contrast to the usual layout.

◀ STUCK RUBBER BABY,
PARADOX PRESS, 1995
Howard Cruse's *Stuck Rubber Baby* is a tour-de-force of detailed illustration and masterful storytelling. In one of Cruse's most complex page layouts, the standard rectangular frames suddenly become irregularly shaped floating panels. The

distorted panels and modulating camera angles convey a sense of confusion, fear, and anxiety as Ku Klux Klan members invade a domestic home.

◢ PALESTINE,
FANTAGRAPHICS BOOKS, 2001

Joe Sacco's unique reportage-style comics contain assorted page layouts depending on the information he wants to impart, from regular grids of many panels to free-flowing, chaotic page designs like this page from his celebrated *Palestine* book.

The erratic panel shapes and captions floating above the frenzied crowd scene amplify feelings of fear and paranoia as Sacco navigates through the Arab market in Jerusalem.

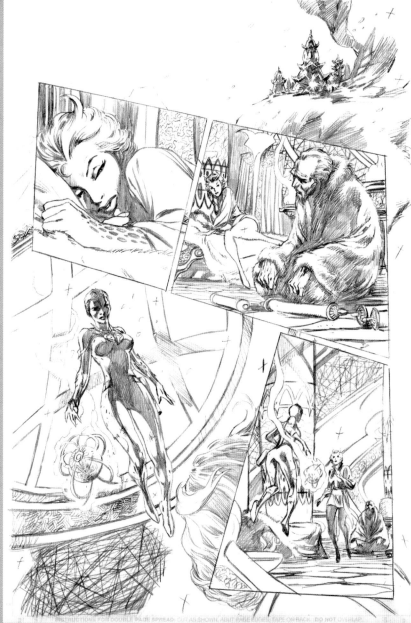

DIAGONAL PANELS

⬟ **X-MEN #58,**
MARVEL COMICS, JULY 1969

Neal Adams' innovative use of photo-realism in the late 1960s was a revelation to comics' faithful readership. Not only did he bring anatomical accuracy and extremely detailed rendering to Marvel's slightly stale titles, but also innovative page design.

As the Beast is knocked out of a window, Adams indicates the mutant character's fall via a diagonal split-panel layout. As a piece of design it's breathtaking, but storytelling-wise, it's less successful. Chronologically, the first panel in the sequence is bottom left, but the eye naturally starts at the top of the page and follows the Beast's fall until the third or fourth panel, when the other two panels (top right and bottom left) become more apparent.

It could be argued that the page is meant to be taken in at once as a single design, for the reader then to pick out the correct order. Even so, it's not clear where the top right panel fits into the sequence.

⬟+⬟+⬟⬟ **FANTASTIC FOUR: THE END #5,**
MARVEL COMICS, APRIL 2007

Alan Davis makes use of an unusual diagonal page layout system throughout his self-scripted *Fantastic Four* mini-series. Full bleeds and floating panels make this page (and many of the others in the work) extremely complex and credit must be given to Davis for maintaining clarity of storytelling.

Despite the potential distractions, there is no confusion over the correct reading sequence. Davis' anatomy and panel composition, along with Mark Farmer's fluid inks and John Kalisz's coloring, result in a beautiful example of superhero comic art.

"The conceit that comics are like movies is misleading because a reader can't help but be aware of an entire page or spread," says Davis. "Angular panels have an inherent abstract excitement but are also a more economical use of space and can be far more effective in directing the reader's eye around the page/across a spread/through the story than a 'cinematic' grid."

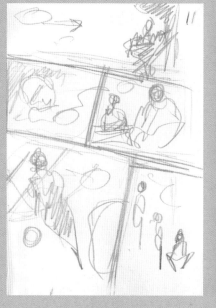

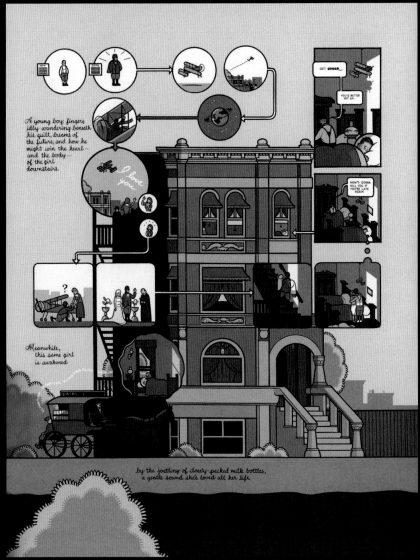

DECORATIVE LAYOUTS

◭ CAPTAIN AMERICA #113,
MARVEL COMICS, MAY 1969

This page from Jim Steranko's golden era is a typical example of his excellent eye for comic design. There is no doubt that the page is intended to be viewed as a single composition, inviting the reader to admire the beauty of the entire page design before reading the individual panels.

The small inset second panel is highlighted with a red background, drawing the eye to the next panel in the sequence. The fragmented panels depicting Madame Hydra's face are not so much a sequence of images, but more of an aesthetic arrangement. The small and varied size of these creates anxiety and conveys the character's high emotional state. The page culminates in a final borderless panel; Hydra's arm framed by the graphic representation of the broken mirror.

◭ ACME NOVELTY LIBRARY #18,
DRAWN & QUARTERLY, 2007

This page serves as a good example of Chris Ware's typically innovative use of the comics medium, published as part of his *Building Stories* series. Based around the repeated motif of an exterior shot of a building, the inset panels follow a convoluted anti-clockwise sequence, relating the life story of one of the building's residents.

In addition to the main flow of the narrative, there is a cutaway of the building showing another character in the interior of one of the rooms. The various panels and captions can be read in a number of different sequences, the overall effect being extraordinarily inventive.

Normally, the use of arrows in panel continuity is considered bad practice—a substitute for poor storytelling where the reading order isn't obvious. But when conceived as part of the intended design, as Ware does here, they can be extremely effective.

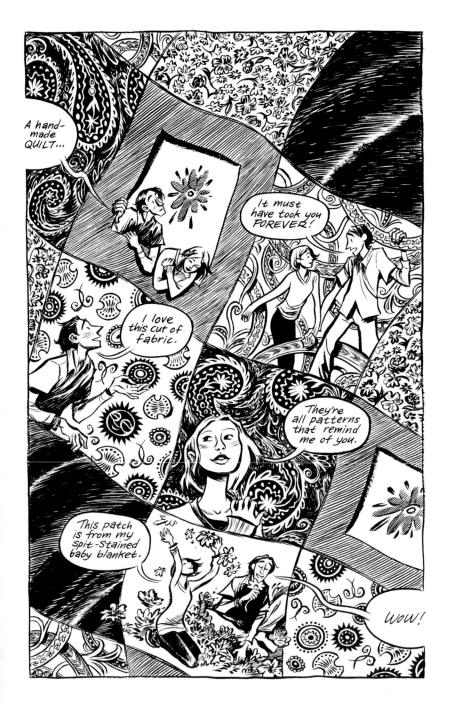

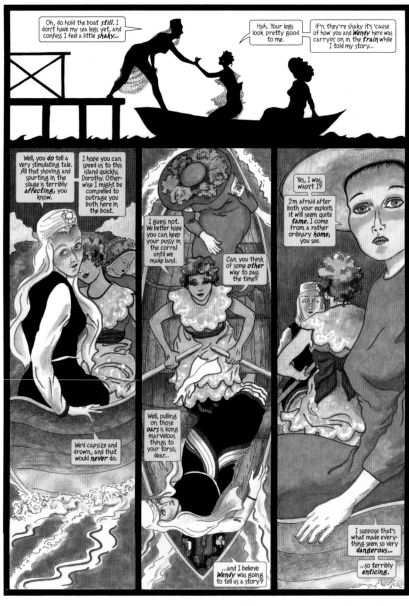

⬢ BLANKETS,
TOP SHELF PRODUCTIONS, 2003

Craig Thompson's acclaimed graphic novel is not only an emotionally charged, heart-rending story of first love, but also a catalog of ingenious and experimental page layouts, rendered with effortlessly fluid brushstrokes.

This page uses the squares of a patchwork quilt as panel borders that contain a sequence where Craig and Raina hold a discussion about the quilt itself.

⬢ LOST GIRLS,
TOP SHELF PRODUCTIONS, 2007

Alan Moore and Melinda Gebbie's pornographic masterpiece, *Lost Girls*, is full of structurally methodical grids, which contain Gebbie's delicate and sensual artwork. Page layout varies depending on from whose perspective the story is being told.

Each page from this chapter is arranged in the same four-panel arrangement with a wide horizontal panel at the top containing a silhouette design. Other chapters in the book follow a number of fixed—but different—layout and art styles, switching between styles influenced by popular artists of the period in which the book is set, including Schiele, Mucha, and Beardsley.

Splash Pages

Splash pages are pages containing a single image or panel, sometimes expanding to fill an entire two-page spread.

Traditionally, the term "splash page" referred to the very first page of a comic book, a dramatic single illustration either depicting a scene from later on in the comic (to whet the reader's appetite) or to establish a frame of reference; a seductive introduction to the story. This initial page also often included the story title, continuing story recap, creator credits, and publishing indicia.

More recently, however, the term has evolved to mean a full-page illustration at any position in the comic, perhaps to denote a chapter break, or simply for when the story requires a strong visual impact. The full-page image used within a story has the effect of encouraging the reader to pause and to take in its overall meaning. To be most effective, splash pages are best used sparingly; for a panorama, a large crowd scene, a dramatic moment, or otherwise important part of the story.

Occasionally, a comic book has experimented with an "all splash page" issue. John Byrne did this in an issue of the *Incredible Hulk*; Walt Simonson repeated the trick during his run on *Thor*; and Dan Jurgens utilized it in the celebrated *Death of Superman* issue. These have novelty value but are usually rather unsatisfying reads.

⊙ FANTASTIC FOUR #83,
MARVEL COMICS, FEBRUARY 1968
This typically dramatic Kirby splash page from *Fantastic Four* sets the mood for the comic book, as well as providing a story recap for the reader.

⊙⊙ THE ROCKETEER,
ECLIPSE BOOKS, 1985
Dave Stevens' retro rocket-powered superhero the Rocketeer accidentally crashes a photography session, allowing the artist to show off his command of the female form. Almost every element in the image leads the reader's attention to Betty, who is neatly framed by the yellow curtain.

GARAGE BAND,
FIRST SECOND, 2007

Italian artist Gipi makes full use of negative space for this understated yet beautiful landscape splash for his graphic novel *Garage Band*.

The wide open sky and Gipi's subtle watercolor technique perfectly convey the peaceful atmosphere of this village scene, as the gently curving lines converge towards the horizon, drawing the reader into the picture.

DOUBLE-PAGE SPLASHES

ARZACH,
IBOOKS, 1977

Splash pages can also be extended over a two-page spread for maximum impact.

This sensational panorama by French master Moebius portrays his fantasy character Arzach riding on his pterodactyl-like flying steed over a bloody alien landscape. Arzach and his flying creature are picked out from the background by the superb use of color, giving a tremendous illusion of depth.

DOUBLE-PAGE SPREADS: DESIGNING LAYOUTS ACROSS FACING PAGES

Occasionally the artist may want to take advantage of the size and shape of a double-page spread and design across both pages, converting his canvas from portrait proportions to a landscape shape.

This can cause a number of additional design problems for the artist, as the reader has been conditioned to read each whole page in sequence. The eye follows the sequence of panels across the first tier of the left-hand page and when it reaches the central gutter or fold, it will naturally move down to the next tier on the same page.

To get the reader's eye to move across the central gutter, the top tier must very obviously and emphatically straddle the page division. This is especially important when the comic is of the full-bleed type, where the artwork extends to the edge of every page as well as the central gutter.

The double-page spread works best over centerfolds in saddle stitched (i.e. folded and stapled) comic books, as the artwork is unbroken. When the spread is placed elsewhere, there are sometimes registration problems when the two halves of the same image don't match up accurately.

It should also be noted that when the comic is collected into a square bound book, part of the page is lost in the binding. It's therefore extremely important that any text is kept a safe distance from the center gutter as it can otherwise be rendered unreadable.

⤢ FANTASTIC FOUR #557,
MARVEL COMICS, JULY 2008

In this stunning Bryan Hitch double-page spread from his run on *Fantastic Four*, the reading track actually takes a vertical route down the left-hand side of the page, then from left to right across three panels along the bottom of the page leading into the main splash image.

Despite this unusual layout the storytelling is not compromised and the panel sequence is clear. The inset panel at the bottom right neatly directs the eye to the next page, maintaining a smooth flow for the reader.

▶ LEVIATHAN,
REBELLION, 2006

D'Israeli's climactic double-page spread from Ian Edginton's script for *Leviathan*, originally serialized in *2000 AD*.

To begin with, D'Israeli's layouts were roughed out with a gray line in Adobe Illustrator, then tightened up with a thinner line in black. An old postcard of New York served as reference for the cityscape. "I decided it would be better in terms of storytelling to have the ship moving from left to right on the bottom panel, so I flipped that panel in Photoshop."

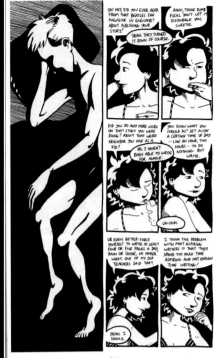

368 369

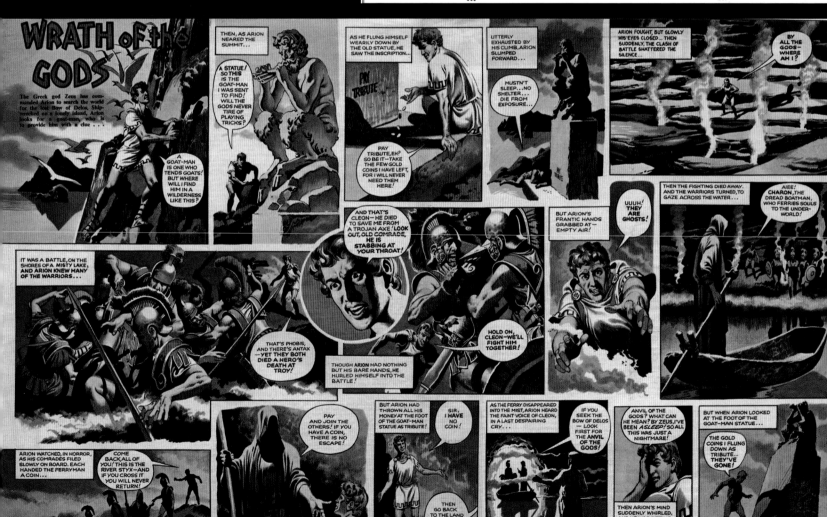

Designer Spotlight: **Chris Ware**

Chris Ware is one of the foremost proponents of experimental design working in comics today. His innovative publications are a precisely measured combination of complex storytelling, illustration, calligraphy, and graphic design.

The format of the *Acme Novelty Library* series is reinvented by Ware with almost every issue, and each subsequent release becomes more elaborate and ambitious in production value and content.

Compact, digest-sized pamphlets alternate with tabloid formats, and more recent volumes are presented as sophisticated, cloth-bound hard covers. Appropriate square, landscape, and portrait shapes are chosen to complement the material.

While the content also changes with each issue, it was the bleak *Jimmy Corrigan* strip that brought Ware to the attention of the art comics scene. Originally published in Chicago's arts weekly *New City* prior to being presented in *Acme Novelty Library, Jimmy Corrigan* is a cheerless story of childhood alienation and loneliness spanning four generations.

Ware's iconic, geometric art style placed within intricate and complex panel layouts looks digitally generated, but is entirely hand drawn using traditional techniques with only the evocative muted hues added by computer.

His innovative use of type as a design element within the page, juxtaposed against the starkly graphic imagery created a new, diagrammatic approach to comics storytelling.

Ware said that, "I try to use the rules of typography to govern the way that I 'draw,' which keeps me at a sensible distance from the story as well as being a visual analog to the way we remember and conceptualize the world."

The page layout of a typical Chris Ware page is often deliberately convoluted and obscure, with clues to the correct panel sequence being provided in the form of arrows, lettering, and other subtle techniques, but the end result is invariably a beautiful piece of comic book design.

Ware's finely crafted pages can resemble some kind of complex board game, densely packed panels sometimes rotated ninety degrees or upside-down, some containing images, some containing miniscule type, and together creating an almost musical rhythm.

Acme Novelty Library also features other serialized comics as well as more esoteric material. Early issues featured the odd, unnamed potato-headed man, *Quimby the Mouse*, and *Big Tex* in short, often single page episodes.

There are also pages devoted to mock advertisements written in Ware's hilariously convoluted, Edwardian style as well as cut-out and assemble paper models. If a reader was willing to mutilate such

a beautiful artefact, he might build a number of kinetic sculptures, miniature houses, and cardboard robots.

More recent projects featured in the publication include the self-contained single-page series *Building Stories* and a longer, divergent narrative about the pathetic action figure collector Rusty Brown.

Ware's stunning covers are predominantly a mixture of typography and design rather than straightforward illustration. Taking inspiration from vintage novelty catalogs, wallpaper, board games, school books, cigar labels, cosmetics packaging, and even a child's wristwatch, his covers are enhanced with elaborate borders and baroque flourishes.

The extensively redesigned collected edition of *Jimmy Corrigan: the Smartest Kid on Earth*, a 380-page landscape format hardcover book, was the first comic to win the prestigious *Guardian* First Book Award. This has led to handsome oversized collections of his earlier *Acme* work.

In addition, Drawn & Quarterly have published sketchbook compilations in two volumes of *The Acme Novelty Datebook*. They contain exquisite doodles, sensitive life drawings, and marvelously loose cartoons, demonstrating Ware's artistic versatility and facility, as well as his ruthless self-depreciation.

Ware's design work on publications other than his own is no less groundbreaking and beautiful. Notable among these are his illustrations for *Lost Buildings*, a book and DVD set.

Every volume of Fantagraphics Books' collected *Krazy Kat* archive, *Krazy and Ignatz,* boasts an all-new cover and interior design by Ware; he has also been commissioned by Drawn & Quarterly to design the *Gasoline Alley* compilations *Walt & Skeezix*.

The all-comics volume 13 of *McSweeney's Quarterly Concern* was designed and edited by Ware and included another extraordinarily elaborate fold-out dust jacket with several mini-comics retained in place by the intricate folds of the cover.

Ware attended The School Of The Art Institute Of Chicago in the early 1990s where he produced his first self-published photocopied 'zine, *Lonely Comics and Stories*.

He found a sympathetic ally in Seattle-based Fantagraphics Books, who published *Acme Novelty Library* for over ten years and fifteen issues, after which, Ware decided to take over publishing duties himself and raised comic book design to the level of fine art.

As an enthusiast of ragtime music and himself an excellent banjo player and pianist, Ware also publishes an annual journal entitled *The Ragtime Ephemeralist*. He has designed various album covers and posters for ragtime performers and other musicians, as well as creating book covers, movie poster art, and short animations

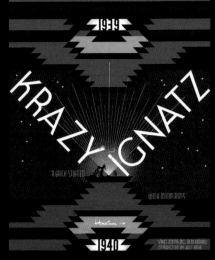

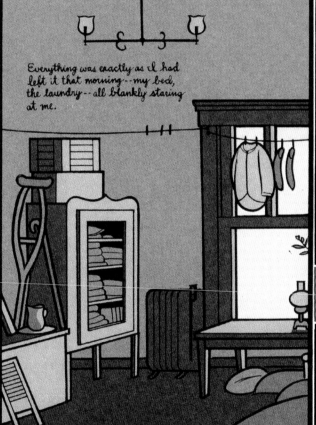

Chapter 4
Lettering and Balloons

Introduction

Captions, dialogue balloons, and the lettering contained within are an essential part of the storytelling process—as crucial in their own way as every other aspect of comics design. Indeed, comics are often described as a combination of words and pictures, but the importance of lettering is often overlooked.

The printed format of comic books and graphic novels does not give the creator the luxury of dimensionality, movement, or sound. But all these elements can be conveyed to the reader through various ingenious techniques; in the case of sound, it's represented by caption boxes, dialogue balloons, expressive fonts, and sound effect lettering.

Not every comic book uses balloons and captions, and indeed there are many fine examples of wordless "silent" comics stories—but the majority rely on them as integral to the storytelling process.

Making use of traditional techniques or by using computer software, the comic book letterer must make vital decisions about choice of fonts, size of lettering, placement and style of balloons, and captions.

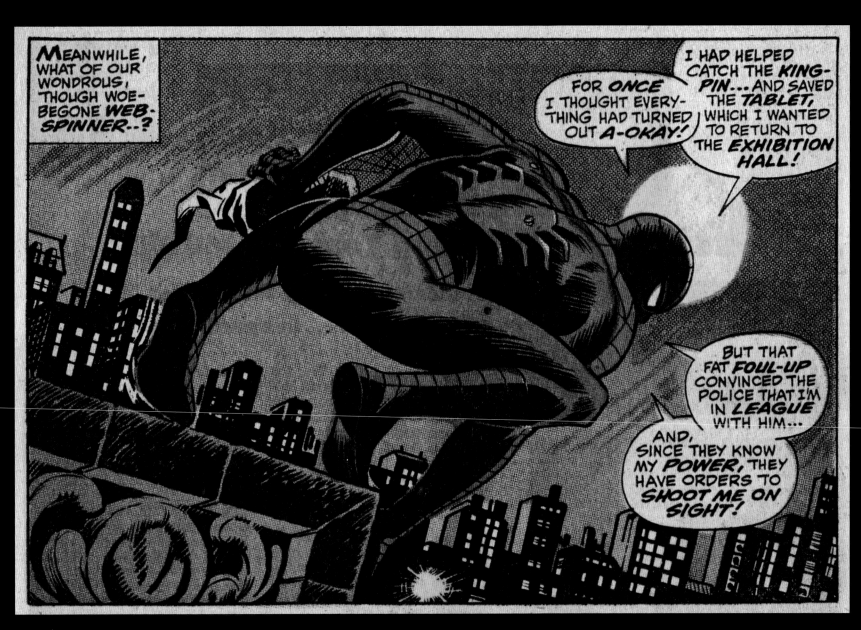

⬥ AMAZING SPIDER-MAN #70,
MARVEL COMICS, MARCH 1973

Page Mark-Up

LETTERING PLACEMENT GUIDE

The first stage of lettering a comic book page is to create a placement guide. A photocopy or printout of the unlettered artwork should be used in conjunction with the script to figure out the optimum positioning for the balloons and captions. Often a numbering system is utilized, with numbers relating to captions and balloons as indicated in the script, corresponding with numbers marked on the placement guide.

Balloons should be placed over the least intrusive areas of the art and arranged in such a way that the reader is pulled through the page in the desired sequence.

Experienced comics artists will already have designated areas for the lettering to be placed, leaving plenty of "dead space" and perhaps even indicating the position for the lettering themselves.

Traditionally, hand lettering was directly applied onto the artwork at the pencil stage of drawing. The lettering, balloons, and panel borders were completed in black India ink, before the page was passed on to the inking stage. The artwork was then embellished by an "inker," transforming the penciled art into a finished, camera-ready, fully-inked page.

Today, it is more usual for lettering to be created in computer software programs, laying over fully completed (and even already colored) artwork.

◄ OR ELSE #1,
DRAWN & QUARTERLY, OCTOBER 2004
Kevin Huizenga dispenses with the typical balloon tail and replaces it with a simple line pointed toward the speaker, perfectly complementing the drawing style for his excellent *Glenn Ganges* strips.

▲ HEART OF EMPIRE,
DARK HORSE COMICS, 2001
For his sequel to *The Adventures of Luther Arkwright*, Bryan Talbot produced placement guides for letterer Ellie De Ville. The text and balloons were lettered by hand, cut out, and pasted onto the inked artwork.

DEAD SPACE

Dead space in the artwork is not always merely part of the panel composition; more often than not it's a way of allowing space for lettering. Sufficient space for captions and balloons should ideally be incorporated into panel design at the start of the artist's page layouts, rather than squeezed in by the letterer at a later stage and potentially covering vital parts of the artwork, unbalancing the composition, and forcing an unnatural reading order.

Placement of balloons over minor elements of the background is perfectly acceptable, but positioning them directly over characters has to be avoided where possible, especially hands, feet, and, of course, the head. Once the balloon placement has been nailed down to the letterer's satisfaction, the lettering can be applied, either by hand or by computer.

In the case of many solo creators, particularly in alternative art comics, the lettering is done by the artist, often lettered directly on the art board similar to the traditional method. This ensures that the style of lettering and balloon outlines integrate with the artwork comfortably, often as part of the panel composition.

ASTRO CITY: THE DARK AGE BOOK TWO #4, *WILDSTORM PRODUCTIONS, NOVEMBER 2007*

◐ In this sample page of Kurt Busiek's script for his *Astro City* series, each balloon is numbered to aid the letterer.

◐◐ Letterer J. G. Roshell first works out the approximate positioning of the dialogue balloons on a reduced-size printout of Brent Anderson's pencil artwork utilizing Busiek's numbering system. Here, reading order and other considerations can be checked and finalized.

◐ Roshell letters the page on computer using Comicraft's "Chatterbox" font for a 1960s/1970s Marvel look. Balloon shapes are created in Adobe Illustrator, and the page is proofed.

◐ Finally, the page is colored by Alex Sinclair.

BALLOON PLACEMENT
AND READING ORDER

As with panel composition, spotted blacks, the arrangement of panels on the page, and the placement of balloons and captions is another way of directing the reader's eye through the page in the desired sequence.

The western reader naturally scans text from left to right, starting at the top of the page, dropping down to the next line when the end of each row has been reached. The comic book reader does the same, usually taking an initial glance at the entire page (or spread) first. Starting with the balloon or caption closest to the top left of the page, all the text is read before proceeding to the next balloon in the panel, then to the next panel, and so on.

Care must be taken to lead the reader's eye to the next balloon in the sequence, working in tandem with the other elements of the panel and page design, so that there is no ambiguity as to which caption is to be read next.

◐ + ◑ TELLOS: RELUCTANT HEROES,
IMAGE COMICS 2001

This page from Todd Dezago and Mike Wieringo's all-ages fantasy adventure series *Tellos,* provides a straightforward and unambiguous track for the reader to follow.

Captions and balloons are characteristically placed at the top of each panel, where there tends to be the most dead space, and where the balloon tail is in close proximity to the speaker's head. This is a logical solution that creates an obvious path for the reader, but can also become a rather pedestrian, monotonous layout.

BREAKING UP

Large blocks of text in comics usually interrupt the flow of the reading experience and tend to be difficult to integrate with the artwork. Shorter, bite-size pieces of dialogue are easier to digest. This can be achieved by breaking up wordy monologues into two or more overlapping balloons, or balloons connected by "joins." This little trick can also indicate phrasing, hesitations, pauses, and other verbal characteristics, as well as creating a trail of white ovals with which to lead the eye to the next caption or panel.

◑ KANE: THE UNTOUCHABLE RIO COSTAS, *IMAGE COMICS, 2005*

In this fantastic example of reading order manipulation, Paul Grist forces the reader to follow a chain of balloons counter to the natural reading sequence. The balloon trail affects the way in which this montage is read, with Officer Munroe entering the panel at the top right of the page, walking down the stairs, around and in front of the seated Officer Marylyn, and down the second flight to the left of the page.

The balloon at the top of the page is the first to attract the eye and by following the sequence of balloons the reader can't help but be pulled along the path Grist has laid out.

◑ AMERICAN FLAGG! HARD TIMES, *FIRST COMICS, 1985*

Letterer Ken Bruzenak breaks up Howard Chaykin's dialogue-heavy text into easily digestible chunks with the placement of balloons and joins, creating an obvious reading trail.

SPEAKER ORDER

Often a panel will contain one speech balloon per character. Assuming that the speakers are standing in the order in which they will talk, this will cause no problem for the letterer.

Badly designed panels, with the characters standing in the wrong order, can prove more of a challenge, and the placement of balloons becomes essential for the story to be understood as the writer intends. One mistaken solution that should be avoided wherever possible is the crossing of tails, which some consider to be a lettering sin of the highest order!

Sometimes it's possible to overlap panel borders with the balloon in order to force the correct reading sequence.

◑ OMEGA THE UNKNOWN #3, *MARVEL COMICS, FEBRUARY 2008*

In the first two panels of this sequence in Jonathan Lethem and Farel Dalrymple's *Omega the Unknown*, the characters are positioned in the order in which they are speaking. In the third, the character on the right is speaking first, a problem that the letterer simply overcomes by moving the second balloon to the bottom of the panel.

TALK AND RESPONSE

Panels will also often contain more than one piece of dialogue by the characters, but it's still possible to incorporate a whole conversation between two or more people by the use of an overlapping chain of balloons. This can reduce the number of "talking head panels."

◑ SAME DIFFERENCE & OTHER STORIES, *TOP SHELF PRODUCTIONS, 2004*

Derek Kirk Kim forces the reader to follow the conversation in vertical columns, stacking the two characters' exchange of views in a space-saving, unambiguous reading order.

Hand Lettering

Before the advent of computer technology all comic book lettering was done by hand, with the exception of some experimentation with pasted typesetting, most notably by the celebrated line of EC comics. Hand lettering still persists today, especially utilized by alternative, art comics creators, who prefer a more personal, organic approach. The assembly line style of production favored by the major comics companies generally favors computer software-based solutions.

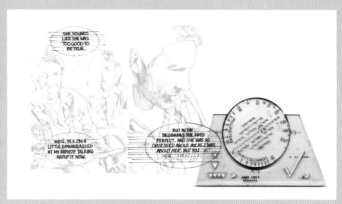

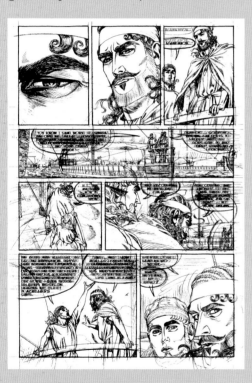 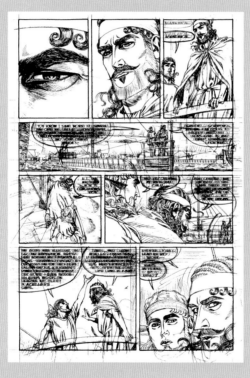

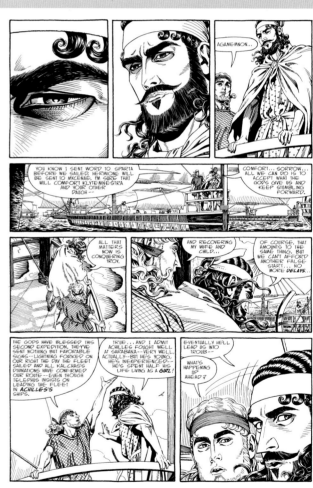

◐◑ THE LETTERING GUIDE

The tool for creating classic comic book lettering is the Ames guide. It's a rather ingenious piece of plastic that allows the letterer to rule any number of perfectly spaced guidelines for creating comic book lettering. It's operated by simply setting a width using the single adjustment, placing a pencil in the appropriate hole, and sliding it along a T-square for each line required.

The tool has fallen out of fashion due to the major companies' reliance on computer lettering and the more relaxed, lettered-by-eye style preferred by art comics creators.

AGE OF BRONZE: BETRAYAL,
IMAGE COMICS, 2007

◗ For the creation of his epic series *Age of Bronze*, Eric Shanower continues to use traditional methods. His tight, highly rendered penciled artwork is overlaid with ruled lines using the Ames guide, and the lettering is lightly roughed in.

◭ The text, balloons, and panel borders are inked in using various sizes of Rotring rapidograph technical pens, a French curve, and ellipse templates.

◓ The artwork itself is then inked using a Hunt dip pen and Pelican ink, with a brush to fill large, flat areas of black. Finally, the art is cleaned up with an eraser and white acrylic paint.

Age of Bronze TM and © 2008 Eric Shanower. All rights reserved.

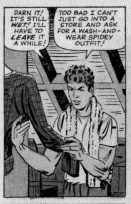

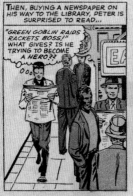
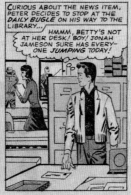
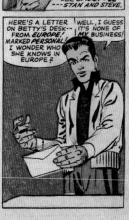
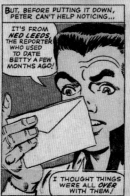

CONTINUED AFTER NEXT PAGE

LOWERCASE AND UPPERCASE

Production limitations in the first half of the Twentieth Century—for example poor print quality—forced comics publishers to make exclusive use of all-uppercase lettering. This is a default style that persisted in almost all comics until relatively recently.

Today, there really is no rule for the use of lower and uppercase lettering. It's acceptable for all-ages, juvenile, mainstream superhero, alternative, independent, and art comics creators to use any method as they see fit.

◔ AMAZING SPIDER-MAN #23,
MARVEL COMICS, APRIL 1956

The all-capitals approach can make a page look more traditionally "comic-booky" but many people find a block of text consisting of the uniform size and shape of solely capitals much harder to read.

◔ AMAZING SPIDERMAN #492,
MARVEL COMICS, MAY 2003

Since the introduction of computer lettering, many comics, including mainstream superhero comics, now use lowercase fonts as well as all-capitals, but this is an aesthetic choice by the creators and editorial team.

◑ FUN HOME,
HOUGHTON MIFFLIN, 2006

Alison Bechdel's celebrated memoir *Fun Home* is a flagship title for alternative creators but ironically makes use of traditional uppercase lettering. On this page Bechdel deploys the caption box in an innovative and economical way, adding arrows to point out various luxurious materials in the living room of her family home.

TYPOGRAPHICAL TERMS

Correct spacing is essential for readability. Following ruled lines drawn by the Ames guide automatically creates a consistent space between lines of text, which is called "leading" in typographic circles. The spacing between words and individual letters (called "kerning") has to be judged by the letterer's eye.

Lettering that is either too loosely spaced or too closely bunched will be difficult to read.

◗ **AMERICAN FLAGG! HARD TIMES,**
FIRST COMICS, 1985

Stressing certain words, particularly in the all-uppercase style, is useful for adding some variety and inflection to otherwise samey blocks of text, through the judicious use of bold and italicized lettering. Care must be taken, though, as excessive use of these type variations can be worse than none at all.

◗ **FROM HELL,**
TOP SHELF PRODUCTIONS, 1999

The tradition of all-capitals was broken by independent creators in the 1980s such as Eddie Campbell in *From Hell*, his groundbreaking collaboration with Alan Moore. Campbell's extraordinary spidery lowercase lettering perfectly suited his scratchy, etched visual interpretation of Victorian London.

◗ **GOODBYE CHUNKY RICE,**
TOP SHELF PRODUCTIONS, 1999

Independent art comics creators often deploy unique and distinctive handwritten styles. Craig Thompson's stunning debut graphic novel, *Goodbye Chunky Rice*, sported a charming and fluid lettering style that beautifully complements the creator's art and the bittersweet story.

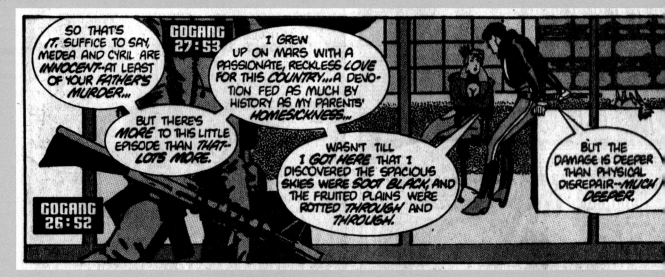

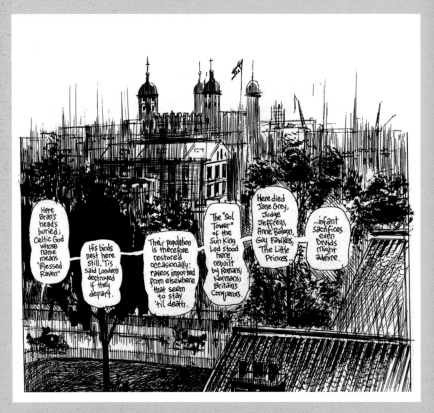

Most of the time, the lettering style will remain consistent throughout a comic book story. Even so, specific narrative voices can be indicated by a significantly different type.

Captions containing journal entries as a narrative device can be represented by use of a handwritten or typewriter style, while wobbly lettering can imply nervousness or intoxication. Mechanical lettering can suggest a robotic monotone; a Cyrillic style implies a Russian accent; and meaningless symbols can create the impression of an extraterrestrial language.

⦾ DEAR JULIA,
TOP SHELF PRODUCTIONS, 2000

Brian Biggs' haunting story of a man who is desperate to fly is told as a letter to his ex-girlfriend with the text transcribed in a handwritten style.

⦿⦿ A.L.I.E.E.E.N.,
FIRST SECOND, 2006

Lewis Trondheim's curious "discovered" extraterrestrial comic book is rendered entirely in an alien language, represented by shapes and symbols.

Type variations are now much easier to incorporate thanks to specialized comics lettering-style computer fonts. But too many different contrasting styles can be difficult to read, distract from the story and artwork, and can look untidy. It's important that lettering—whether done by hand or computer—always be clear and legible.

⦾ SHOCK SUSPENSTORIES #6,
EC COMICS, DECEMBER 1953

Attempts to lend the comic book a certain maturity included typeset text in place of hand lettering, as with the EC comics of the 1950s. This was not generally successful, as the mechanical type did not blend well with the artwork and lacked character and personality. However, EC's place in comics folklore was cemented by the array of brilliant artists who worked on their titles. Wally Wood's detailed inking style perfectly complemented the typically moralistic story, *Under Cover*.

From SHOCK SUSPENSTORIES #6, copyright ©1952 by Tiny Tot Comics, Inc., renewed by William M. Gaines.

Computer Lettering

As in most other walks of life, computer technology now plays a big part in comic book lettering. There is still a place for hand lettering among independent creators who may use it to express their own personal style, but computer fonts and software-generated lettering has become the predominant choice for major publishers.

The lettering style should always attempt to match the drawing style as much as possible so that the two are "read" together as a single entity, helping to immerse the reader further in the story.

Well-designed modern computer fonts are now used to create comic book lettering that is very similar to hand lettering. Some fonts even incorporate different versions of the same letter to add variation and prevent the text from becoming too uniform.

Compared to hand lettering, computer lettering offers certain advantages; a greater consistency, straightforward corrections and language changes, the option to automatically spell-check, and much more. In a deadline crunch, different letterers using the same fonts can work on the same strip, even at the same time. More elaborately designed fonts, colored and reversed-out lettering, and floating text are all relatively simple to implement.

Computer lettering is superimposed onto scanned artwork in a vector drawing program, Adobe Illustrator being the generally favored option. It's also possible to use bitmap-based software like Photoshop, although the printed result may look less sharp.

Lettering and balloons are kept on separate layers from the artwork to allow for easy correction and positional readjustment.

There are now a huge variety of fonts especially designed for comic book lettering available online from companies like Comicraft and Blambot. These include fonts based on specific artists' lettering styles, sound effects lettering, and display fonts.

Fonts can also be custom designed in programs like Fontographer or FontLab, although this option is not for the beginner. You can even arrange to have your own hand lettering style converted into a computer font commercially—although of course it is best to gain some experience in lettering by hand first.

◉ HULK #1, MARVEL COMICS, *MARCH 2008*
Comicraft's lettering over a page of Ed McGuinness and Dexter Vines' artwork from the revamped *Hulk* title. Note Iron Man's dialogue is not only in a bespoke shaped balloon and in a color tint, but is also all italics.

◀ The full character set of a font called "Monologous" designed by the Comicraft team, containing bold and italic variations of each alphabet set. There are also alternatives for each letter in its alphabet (in place of a lowercase alphabet) to avoid the text becoming too uniform.

Some software programs can automatically create "faux" bold and italic versions of fonts, but these approximations of style do not always produce predictable results and can cause errors in production.

SUNDERLAND
THE LOOKING GLASS
AABBCCDDEEFFGGHHIIJJKKLL
MMNNOOPPQQRRSSTTUUVVWWXX
YYZZOI23456789-=!@#$%^¢£
*()_+_+[]÷\|;:'",./()?÷"'\/·®©™

SUNDERLAND
THE LOOKING GLASS
AABBCCDDEEFFGGHHIIJJKKLL
MMNNOOPPQQRRSSTTUUVVWWXX
YYZZOI23456789-=!@#$%^¢£
*()_+_+[]÷\|;:'",./()?÷"'\/·®©™

SUNDERLAND
THE LOOKING GLASS
AABBCCDDEEFFGGHHIIJJKKLL
MMNNOOPPQQRRSSTTUUVVWWXX
YYZZOI23456789-=!@#$%^¢£
*()_+_+[]÷\|;:'",./()?÷"'\/·®©™

☍ + △ ALICE IN SUNDERLAND,
DARK HORSE COMICS, 2007

Bryan Talbot's distinctive lowercase lettering was converted into a computer font by Comicraft and made available to purchase online. Talbot used the computer font to letter his graphic novel tour-de-force *Alice in Sunderland*.

◁ CASTLE WAITING: THE LUCKY ROAD,
CARTOON BOOKS, 2000

Linda Medley's enchanting fairytale series, *Castle Waiting*, is digitally lettered by Todd Klein. The unusually baroque font fits well with the weight and softness of Medley's inked line.

◑◑ FANTASTIC FOUR: FIRST FAMILY #5,
MARVEL COMICS, SEPTEMBER 2006

Poor Ben Grimm has been trapped inside the rocky orange hide of his cosmically altered body for almost half a century, but with the advent of computer lettering techniques the visual representation of his voice now matches his rough exterior.

◑ Blambot offer a number of free downloads as part of their font range. Nate Piekos designed this all-caps font called "Crimefighter," which can be used for independent comic books and non-profit purposes without charge.

CRIMEFIGHTER FONT
ABCDEFGHIJKLMNOP
QRSTUVWXYZ
1234567890!@#$%^&*()
_-+=≥≤[]÷;'''<>,.?/\~

CRIMEFIGHTER FONT
ABCDEFGHIJKLMNOP
QRSTUVWXYZ
1234567890!@#$%^&*()
_-+=≥≤[]÷;'''<>,.?/\~

Speech Balloons and Captions

Speech balloons have virtually become a representative symbol of the comic book. With the sole exception of the single panel cartoon, they are characteristic of, and virtually unique to, the medium. The shape of the standard word balloon is generally understood—even by most non-comic book readers—to contain dialogue spoken by the character indicated by the balloon's tail.

Often, standard ellipse shapes can waste space, covering too much of the artwork and also proving an uncomfortable fit for the arrangement of the text. Because of this, it's not unusual to see slightly "flattened" ellipses, irregularly hand drawn shapes, rectangles, and other variations of speech balloons used with success. Whatever the style, it should always blend with the artwork itself, and of course remain consistent within the same comic book.

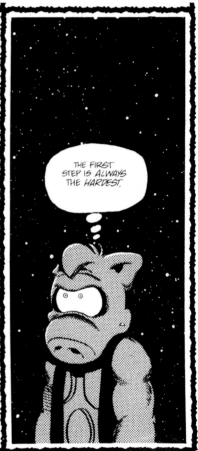

◐ THE ORIGINALS,
VERTIGO/DC COMICS, 2004

Throughout Dave Gibbons' graphic novel *The Originals*, balloon shapes are unusually rectangular with curved tails. The computer lettering is a font converted from Comicraft by Dave's own hand lettering.

◑ FIRES,
CATALAN COMMUNICATIONS, 1984

Lorenzo Mattotti's geometrically shaped balloons mirror the abstract, cubist nature of his painted artwork, as seen here in his groundbreaking painted graphic novel.

BALLOON SHAPES

A variety of balloon shapes (sometimes in conjunction with the font style) can be used to suggest different character "voices" or to convey emotions, exclamations, whispers, and even private inner thoughts.

Jagged edged balloons, often used in conjunction with larger text, can suggest exclamations, shouting, and screaming.

◐ BONE: OUT FROM BONEVILLE,
SCHOLASTIC BOOKS, 2005

Wavy edged balloons can indicate weakness, fear, infirmity, or just plain spookiness. Jeff Smith uses a hugely expressive style of balloons and lettering, deftly tailored to communicate to the reader an exacting degree of emotions.

◐◐ TELLOS: RELUCTANT HEROES,
IMAGE COMICS, 2001

In conjunction with reduced lettering size, balloon shapes with dotted lines can be used to indicate a soft whisper. This from Todd Dezago and Mike Wieringo's swashbuckling fantasy series *Tellos*.

THOUGHT BUBBLES

Traditionally, a character's private thoughts have been represented by cloudlike balloons with smaller bubbles in place of a tail. These "thought balloons" have become somewhat outmoded in recent years, particularly in American mainstream comics, where narrative "voiceover" captions have largely replaced them, although there are still some practitioners using them successfully.

THE SPACE BETWEEN

Exactly how much space to leave between the lettering and the edges of the balloons is a matter of judgment. Too little can make the balloons appear crowded and difficult to read; too much can distract from the artwork, or cover up too much of the panel.

◐ CEREBUS #194,
AARDVARK-VANAHEIM, MAY 1995

Dave Sim always letters his own work and prefers to leave plenty of white space to allow the lettering to "breathe." As Sim's aardvark protagonist considers his destiny, the reader is privy to his inner thoughts via the magic of the thought bubble.

CREATING BALLOONS BY COMPUTER

Balloons are usually created in computer "vector drawing" programs like Adobe Illustrator or CorelDraw, as perfect sharpness is often required when overlaying balloons on hard-edged line art. Photoshop can also be used with a degree of success where sharpness is not critical, for example on grayscale or full color artwork.

Lettering and balloons are always kept separate from the artwork by use of the "layers." Sometimes each balloon has its own layer, which helps facilitate any corrections or alterations that are required at a later date. This also gives flexibility for color effects or foreign translations of the work.

◓ KINGDOM OF THE WICKED,
DARK HORSE BOOKS, 2004

Reversing out—i.e. creating white text in black balloons by computer—is a much easier process than traditional photographic methods or attempting to letter by hand.

In this eerie scene from Ian Edginton and D'Israeli's meshing of reality and nightmare, Christopher Grahame confronts his inner demon, whose voice is characterized by a jittery balloon shape and reversed out text. Lettering by Woodrow Phoenix.

BLENDING COMPUTER TEXT

Computer-generated balloons and text can clash with more organic-looking artwork, particularly on painted or highly rendered color art. This can create an undesirable and uncomfortable contrast between the organic art and mechanical balloon, distracting the reader and pulling them out of the story.

◓◓◓ LOST GIRLS,
TOP SHELF PRODUCTIONS, 2006

Todd Klein's delicate computer lettering, combined with pastel-colored balloons and subtle edges, help the dialogue to "sit" in the panel and aid the storytelling process rather than distract from it.

◔ GROO: HELL ON EARTH #4,
DARK HORSE COMICS, APRIL 2008

Sergio Aragones includes a number of different solutions for Mark Evanier's dialogue in one single panel of the long-running barbarian humor series. The minstrel's singing is denoted by lowercase and an irregular balloon, while Groo's dog Rufferto's inner thoughts are depicted in a thought bubble, and the soldiers shout with a slightly spiked balloon.

◖ ETERNALS #1,
MARVEL COMICS, AUGUST 2006

Balloon shapes with scalloped edges and zigzagged tails are used for dialogue heard through a speaker of some kind; radio or television, walkie-talkie, or tannoy to name a few.

◓ BONE #25,
IMAGE COMICS, AUGUST 1996

Phoney Bone's expression of suppressed anger is complemented by the frosty speech balloons, clearly expressing the meaning of his dialogue.

CAPTIONS

Caption boxes that contain narrative text or character "voiceovers" are generally rectangular in shape. Because they are not directly associated with any particular object within the panel, they can be placed more freely, so long as they contribute to the overall composition and reader flow.

◖ TOMB OF DRACULA #68,
MARVEL COMICS, FEBRUARY 1979

This panel of Gene Colan and Tom Palmer Sr.'s atmospheric artwork for the classic monster series allows for an interesting placement of caption boxes.

Comic Book Design

FLOATING CAPTIONS

Sometimes a borderless caption can simply "float" over an appropriate blank area of the artwork, rather than being confined within a rectangle.

▶ THE SPECTACULAR SPIDER-MAN #263,
MARVEL COMICS, NOVEMBER 1998

Writer Howard Mackie provided the original lettering placement guide for this splash page, with the title of the story intended for the empty black area. The sheer number and weight of the captions placed where suggested actually obscures much of artist's artwork and is a daunting chunk of text for the reader to navigate.

▶▶ The solution provided by letterer Richard Starkings was to use a clever combination of captions and floated text, leading the reader through the page without covering up too much artwork and allowing for the repositioning of the title at the bottom of the page. Not only does the floated text provide rhythm and visual variety, but also does not have to be forced into rectangular shapes.

WORKING WITHOUT BALLOONS

Not all comics creators are big fans of speech balloon conventions and some have experimented with alternatives. None of these options have proved so successful that they have been adopted by the majority of comics creators, but certain methods can complement and reinforce a creator's unique style.

▶ AT HOME WITH RICK GEARY,
FANTAGRAPHICS BOOKS, 1985

In some of Rick Geary's delightfully surreal short strips, the technique of confining all text to captions beneath the panels has been used. This was very popular in the developmental years of the comic book, particularly in early British comics.

This can work with certain methods of juvenile storytelling, but when dialogue is required it creates a kind of hybrid picture book that does not take full advantage of the tremendous possibilities offered by the comics art form.

▶▶ STREAK OF CHALK,
NBM PUBLISHING, 1994

In an effort to avoid covering up too much of his beautiful color pastel artwork, this Miguelanxo Prado graphic novel makes use of semi transparent dialogue and narrative boxes, allowing the art to show through. Occasionally a very dark background can cause the text to be hard to decipher.

▶▶ THE COWBOY WALLY SHOW,
DOUBLEDAY, 1988

Kyle Baker carefully arranges the characters in his panels to make sure that they are placed in the order they speak. Their dialogue simply floats in white space above or adjacent to their heads. This method can be restricting in terms of panel composition and also limits the complexity of any backgrounds.

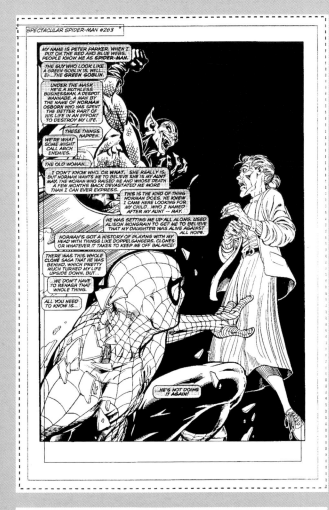

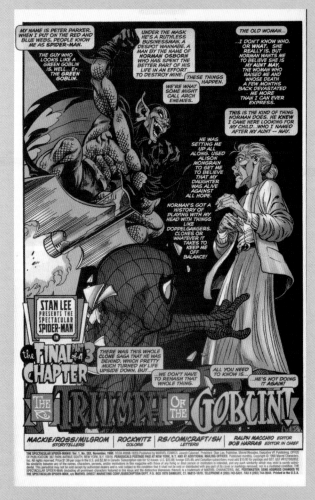

's true, you don't see much of Nicholas Hardiman. Thankfully he keeps to
s shed in the garden, a place I never go near. It's where he spends all day
andering to popular taste," as he puts it. The times we do meet I want to kick him
ard in the butt. He practically curtsies to me, like I'm Henry James. So fucking
nic, Americans don't get that stuff, do they? *Asshole.*

Take the other night. Nicholas doesn't often join us for dinner, but when there's
crime-writing weekend, he appears. He kept making these dumb statements
nd every time I disagreed he drowned me out with the electric carving knife.
nd then he talked, non-stop. Horse shit, total horse shit.

...sure you'll agree, Glen...
MAD expanding them,
isn't it? **Too** many
students in the universities,
who'd be much better
suited to vocational
courses...

... I think the real secret
of being a writer is learning
to be a convincing liar... I mean,
that's what we are: story
tellers... *liars*....

Next he turned to the state of journalistic writing.

...*every* other word is "I"...
and the **clichés!!**.."a girl's
gotta do what a girl's gotta do"
...... I ask you!

And this is typical : a glamorous
by-line photo above a load of
self-deprecation...about how god-
awful she looks in the morning...
"I need a leper's bell to warn people"
...etc, etc ... **Eurchh yuk!!**

Could you
give us, p
few tips o
style?

Oh, come on, Nick...it's
not meant to be
Shakespeare!...
Everyone writes
drivel at some
stage...

It was Tamara's column he was trashing. (Actually I agree with him pretty much
about that.) But Nicholas is a jerk. Why Beth took him back I don't know, she's
so indulgent. But I guess I have to be glad she did. Without his payroll Stonefield
couldn't exist, and then where would I be?

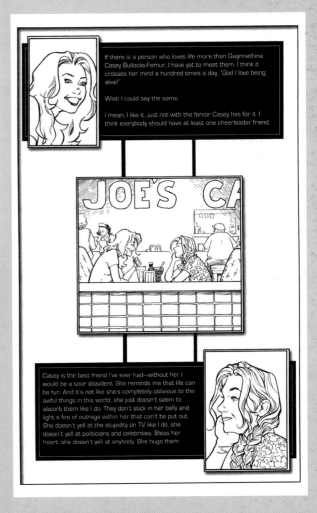

INCORPORATING TYPOGRAPHY

Creators who have found themselves with
large amounts of information or long
sequences of dialogue have occasionally
resorted to including pages containing
large blocks of mechanical text as part
of a longer comics work.

⊙ TAMARA DREWE,
JONATHAN CAPE, 2007

Posy Simmonds' recent graphic novel
Tamara Drewe typifies her mastery of
the medium. She often mixes a number
of what she calls "typographical voices,"
incorporating handwritten journals,
typeset narration, and beautifully
hand-lettered dialogue balloons.

⊙ CEREBUS #193,
AARDVARK VANAHEIM, APRIL 1995

Notably, Dave Sim's massive *Cerebus*
series included many sequences that
were simply illustrated texts.

⊙ STRANGERS IN PARADISE #75,
ABSTRACT STUDIO, JULY 2005

Terry Moore's long-running *Strangers
in Paradise* incorporated infrequent
sequences of text-only pages, lyrics
and even sheet music.

These are obviously all valid means of
artistic expression, although some critics
have complained about their inclusion in
what are ostensibly comic book series.

Sound Effects and Display Lettering

Sound effects are another element that typify comics. Unfortunately, however, the superimposed "Smash! Wham!" effects used in the famously campy 1960s *Batman* TV show did much to discourage their use for more serious works. Even in these relatively enlightened times newspaper headline writers still resort to the "Biff! Pow! Comics Have Grown Up" clichéd headline, even on stories about the most mature graphic novels.

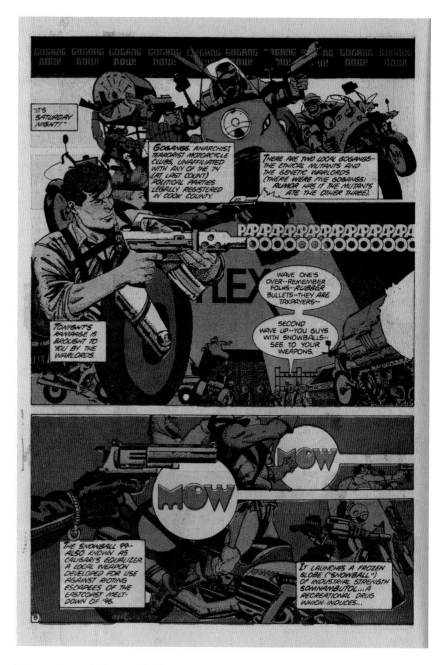

The use of sound effects varies from creator to creator. While sometimes the writer actually suggests the sound effect itself—sometimes a literal "boom," other times an onomatopoeic equivalent—it's down to the artist or letterer to make decisions about placement, size, font, and other design considerations. The font choice is also often informed by the sound effect itself; wet and drippy, jagged and explosive, soft and feathery.

Many comics stories with an adult tone do not require sound effects lettering at all, but it can be argued that an image of the firing of a gun is inevitably more dramatic when combined with a "bang!"

Some, like Bryan Talbot, prefer not to use any kind of sound effect, letting images tell the story cinematically. Without the prop of special effects, the artwork and storytelling must carry the additional burden of creating a soundtrack in the mind of the reader.

◁ THE TALE OF ONE BAD RAT, *DARK HORSE BOOKS, 1996*

In this scene from Talbot's affecting graphic novel, the drama of a car crash is conveyed without the additional crutch of visual sound effect lettering.

Others believe that comics creators should use every technique available to them in order to immerse the reader as much as possible in the story, allowing the sound effects to become part of the panel composition themselves.

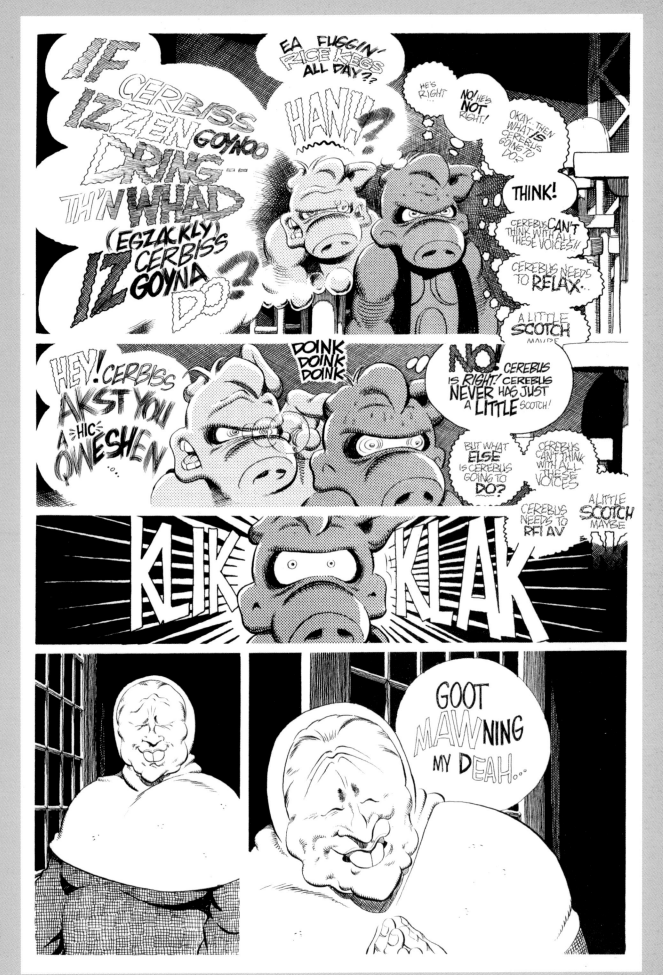

AMERICAN FLAGG! HARD TIMES,
FIRST COMICS, 1985

Ken Bruzenak revolutionized comic book lettering on Howard Chaykin's *American Flagg!* series. His deliberately prominent display lettering and sound effects complemented Chaykin's graphical approach to his storytelling, accentuating the clean-line, futuristic tone of the book.

CEREBUS #214,
AARDVARK VANAHEIM, JANUARY 1997

Dave Sim has won many industry awards for his prominent use of innovative and expressive lettering. His ingenious use of graphic sound effects and display lettering within his characters' speech balloons is unrivaled. Speech patterns and accents, internal dialogue, and emotional content are deliberately and meaningfully conveyed.

CREATING SOUND EFFECTS

Like standard comic book lettering, sound effects lettering is regularly created using both traditional hand drawn methods and with the aid of computer technology. In the assembly line production system of major publishers, it's the letterer's job to add sound effects alongside the balloons, captions, and lettering. For more independent creators, it's often the artist that incorporates the effects into their own work as part of the overall page design.

A wide range of special effects display fonts for computers are available from online specialists like Comicraft.

In software packages like Adobe Illustrator, the sound effects can be colored, stretched and distorted, converted to outlines so that that the background shows through, and other techniques to make it fit the requirements of the panel.

⊙ FINDER: KING OF THE CATS,
LIGHTSPEED PRESS, 2001

Carla Speed McNeil converts dialogue into display lettering in this page from her self-published *Finder* series. In this dream sequence, the loud hysterical laughter of Ganesh is expanded to create an effective graphical backdrop, creating an ominous and nightmarish mood.

In the last panel, McNeil uses shadow and reversed out lettering to beautifully balance the composition against the heavily rendered figure in the bottom right.

❷ FANTASTIC FOUR #55,
MARVEL COMICS, OCTOBER 1966

Superhero comics are the natural home for sound effects. Here, Sam Rosen's lettering, Jack Kirby's dynamic pencils, and Joe Sinnott's inks combine to result in a powerful composition.

❸ GROO: HELL ON EARTH #3,
DARK HORSE COMICS, JANUARY 2008

Sound effects still work amazingly well in humor comics. Sergio Aragones' comic timing and brilliant cartooning makes his collaboration with Mark Evanier on *Groo* always well worth a look.

❹ BONE: OUT FROM BONEVILLE,
SCHOLASTIC BOOKS, 2005

Alternative creators such as Jeff Smith integrate elements like sound effects and speech balloons as a major part of the panel composition. This gives the artist much greater control over storytelling aspects like energy and movement as well as the emotional content of the scene.

COLOR EFFECTS AND BALLOONS

Sound effects are often filled with a single or gradated color (a "grad"), but thought should always be given to the overall color scheme. Sometimes white display lettering against a highly rendered and colorful background can be the best choice.

▷ NEW AVENGERS #1,
MARVEL COMICS, JANUARY 2005

Sound effects and display fonts can be styled as outlines so that the artwork is allowed to show through.

Colored text or speech bubbles are not usually necessary. Color should be used sparingly, perhaps for a particular character's "voice," or as part of the color design—for example, when a balloon is laid over a plain white background.

Caption boxes in modern comics are sometimes filled with a color to distinguish between narrators. Black type and white balloons are frequently the best choice.

▷ COMPLETELY PIP AND NORTON VOLUME 1,
DARK HORSE COMICS, 2002

Dave Cooper's imaginative worlds and bizarre characters are matched by expressive and opulent lettering. Here, Cooper's richly colored balloons and text are seamlessly integrated into his frenetic cartoonlike art.

▷▷ MAD MAGAZINE #20,
EC COMICS, FEBRUARY 1955

This page from the classic strip *Sound Effects!*, beautifully illustrated by Wally Wood, brilliantly parodies the use of visual sound effects in comics by using them to tell a story without dialogue.

▷ THE SPIRIT, NEWSPAPER SUPPLEMENT,
JANUARY 1950

Even before the Second World War, Will Eisner was making innovative use of lettering, ingeniously incorporating the title of his character The Spirit into many of his splash pages. The logo has been stretched like rubber, composed of pieces of trash in a gutter, a design on a net curtain, road signs, and billboards, and here it's made from bricks.

As with everything else in comics design, the choice of lettering style should work with the artwork and subject matter, and should always be considered as an integral element in the overall design of the panel and the page.

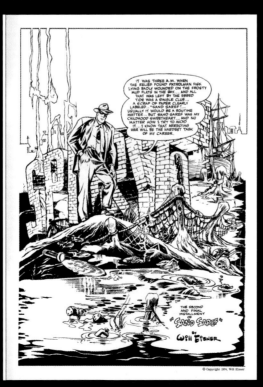

Brian Wood's groundbreaking scriptwriting output for various comics publishers, his gritty design-heavy comics illustration, and his experience in website design and computer game packaging make him one of the comics industry's most prolific and original stand-out talents.

His grungy, highly distinctive mix of illustration, photography, and typography has been one of the most refreshing developments in comic book cover design in recent years.

Rejecting lucrative opportunities to write corporate-owned superhero books, the majority of Wood's works are creator-owned, which makes him one of the most important comics creators of his generation.

New Yorker Wood announced his arrival on the comic book world in the late 1990s with *Channel Zero,* which he wrote, drew, and designed.

The stunning graphic imagery of his covers of the Image Comics series made an immediate impact, while design-heavy page layouts perfectly complemented the political nature of the story.

Public Domain, Wood's 145-page collection of behind-the-scenes material for *Channel Zero* was deliberately "very old school and low-fi, using mostly a photocopier and a glue stick, the results being grainy and choppy and, in my mind, an accurate representation of how I used to work when I first started making comics."

His growing reputation was such that Warren Ellis requested his cover design skills for his Vertigo series *Global Frequency*, where Wood mixed photography and typography to create original, eye-catching covers.

Wood spent four years being "very well trained" in illustration and graphic design at Parsons School of Design in New York City and worked as a website designer during the dot com boom of the 1990s.

Taking design inspiration from outside the insular world of comic books, Wood has also worked his graphic design magic in other media, including the video game industry for Rock Star Games. There he worked on packaging for *Grand Theft Auto*, *Manhunt*, and *Midnight Club*, as well as creating T-shirt designs and game booklet artwork. It was an experience that Wood has likened to boot camp, although he claims that it did instil in him, "a pretty severe work ethic."

His illustrations have appeared in various magazines and short films for Nike, and his logo designs have adorned many comics related websites.

Wood, as a writer and designer, says that he has "so many ideas" that he rarely gets time to draw full-length comics anymore, although he still enjoys creating covers for the majority of the series that he writes.

That has included the Vertigo series *Fight for Tomorrow* and *DMZ*, *The Couriers*, *Demo,* and *Couscous Express* from AiT/Planetlar, *Supermarket* from IDW, and *Pounded* and *Local* from Oni Press.

ABOVE
Channel Zero (sketch)

FACING PAGE
CLOCKWISE FROM TOP LEFT:

Channel Zero, AiT/Planet Lar, 2000

DMZ # 16, DC/Vertigo, 2008

DMZ # 25, DC/Vertigo, 2008

Channel Zero #1, Image Comics, 1998

Global Frequency #2, Wildstorm ,2002

Supermarket, IDW, 2006

"Brian Wood is a writer on a mission" *PUNK PLANET*

Special interest groups have bullied the government into passing the Clean Act, effectively killing freedom of expression and smothering the country into submission. Television and God become one and the same as America wages a holy war against itself.

Meet Jennie 2.5, self-styled media activist and symbol of resistance and change in an imprisoned society. Armed with only a camera and a determination to secure a place for herself in the history books, she takes the battle to the streets, using the tools of the enemy in an all-out effort to snap the population out of its apathy and restore free will and self-expression.

Hailed internationally as ground-breaking work in the field of sequential art, Channel Zero challenges and tests the limits of the medium, combining current events and no-future shock into a dark, paranoid, deep-ambient visual narrative. First appearing in serial form in 1997, Channel Zero has retained its energy and relevance in the face of rapidly changing times.

"surprising and fresh... beautifully stark" *WIRED*
"your handbook for the media revolution" *EYEBALL MAGAZINE*
"dramatic" *I.D. MAGAZINE*
"a seemingly endless barrage of powerful art" *NEWTYPE USA*
"Someone's remembered what comics are for. Meet Brian Wood" *WARREN ELLIS*
"fascinating... this is a paranoid future Grant Morrison could not conceive of" *COMICS INTERNATIONAL*
"one of the most visually exciting and politically daring books on the shelves today" *SEQUENTIAL TART*
"brilliant... icewater in the putridly tepid stream of comic books" *STEVEN GRANT*
"strangely prescient... lucid and sharp" *ARTBOMB.NET*
"...a cold, hard slap in the face of the Big Brother generation." *NINTH ART*
"Anytime I get stumped drawing comics, I just look for my copy of Channel Zero and trace over Brian's drawings." *DAVE CHOE*

BRIAN WOOD

BRIAN WOOD · CHANNEL ZERO

CHANNEL ZERO
CREATED, WRITTEN AND ILLUSTRATED BY BRIAN WOOD
INTRODUCTION BY WARREN ELLIS

VERTIGO · PUBLIC WORKS 4/5
DMZ
BRIAN WOOD & RICCARDO BURCHIELLI
DIRECT SALES · No. 16 · APR 07 · 2.99

DMZ
VERTIGO
BRIAN WOOD · DANIJEL · ZEZELJ
25 JAN 08 · 2.99 · DIRECT SALES

image · CHANNEL ZERO · 1 · $2.95
CHANNEL ZERO
channel zero
AD SPACE
DIRECT SALES
BRIAN WOOD

SUPERMARKET

BRIAN WOOD · KRISTIAN

convenience 24 · BEER

PELLA

24 · IDW

$3.99 ISSUE NO.1

kristian cover

WILDSTORM
WS
#2 of 12 JAN

ARE YOU ON THE
GLOBAL FREQUENCY

$2.95 US / $4.95 CAN
DIRECT SALES
wildstorm.com

ELLIS · FABRY · SHARP · BARON

Chapter 5
Designing with Color

Introduction

Color can have a huge impact on the comic book page. It's potentially as important a part of the comic book design process as any other part; enhancing all aspects of storytelling, evoking mood and atmosphere, and complementing the style of the artwork.

Comic book color has evolved from a limited range of mechanical tones to the enormous digital palettes and special effects used in modern superhero books. As technology advanced, the reproduction of fully painted comics became feasible, and today almost anything is possible.

Of course, not all comics use color, even these days. Many independent comics are published in black and white due to simple economics; others choose monochrome for artistic reasons. There is also a trend for alternative comics to use black plus one or two spot colors.

**⊙ MARVEL MONSTERS:
WHERE MONSTERS DWELL #1,**
MARVEL COMICS, DECEMBER 2005

Keith Giffen and Mike Allred's 1950s monster pastiche, complete with exaggerated printing screen, beloved of Roy Lichtenstein.

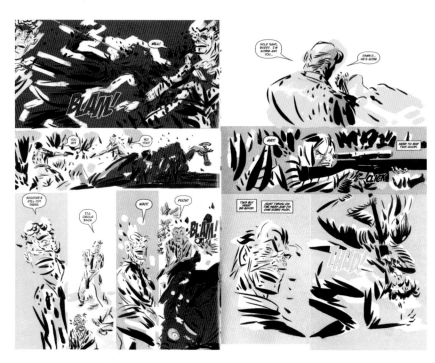

The Development of Color in Comics

Even during the embryonic years of the comic art form, many Sunday newspaper strips were produced in color, despite the high expense. Innovators like Winsor McKay quickly adapted to the new opportunities that color printing offered to create stunning Sunday pages.

In Europe, black-and-white line illustration was initially the norm for comics weeklies, and the earliest comic books in America were only partially in color. By the time Superman was launched in 1939, garish four-color newsprint comics became the standard format.

Specialized colorists used a limited palette to add color to the artist's black outlines—filling in the space in between the lines like a coloring book. Up until the 1970s, the colorist had a maximum of sixty-four colors to work with. Photostats were colored with Dr. Martin dyes and then laboriously annotated with alphanumeric codes for each specific color. Hand separations were then created by the printer's staff by painting various dilutions of a brown paint onto acetate sheets. These separations were then used to create the printing plates. There was no way to check the accuracy of the colorist or separators' work (without expensive and time-consuming proofing) until the book actually rolled off the presses.

Apart from an expensive color process called photogravure, most comics remained colored by this crude method until the mid 1970s, and some publishers still used the process into the 1990s. As technology progressed, a wider range of colors became available and the European "blue line" coloring technique was adopted by some publishers. Fully painted comics were photographically separated, notably for *Heavy Metal* magazine.

More recently, with the advent of digital coloring techniques, millions of colors have now become available to the colorist at the click of a mouse. Adobe's Photoshop made hand separations obsolete, as separations are created automatically within the software. Computer coloring now less often apes the traditional "flat" method of coloring, but adds digital flourishes, airbrushed highlights, textures, and special effects. Digital paint techniques

can also be used to create eye-popping painterly effects using only the artist's pencil artwork as a starting point.

With so many options available, it's all too easy to end up with artwork that can be overpowering or too perfectly shaded and modeled. Today's comic book colorist needs to exercise some restraint and implement the right style of rendering to enhance the artwork.

And of course, there are many exceptions and much scope for unusual color schemes, depending on the subject and style.

◯ KILLING GIRL #1,
IMAGE COMICS, AUGUST 2007
Frank Espinosa's expressive, fluid brushwork is complemented by his bold, primary color scheme, creating a highly original and arresting comic page design. Note how blocks of color are used to form the actual panel structure itself.

◔ FELL #7,
IMAGE COMICS, JANUARY 2007
Ben Templesmith's stunning cover painting mixes a mass of primary colors, framing the silhouette of Detective Richard Fell. Templesmith creates the main artwork in monochrome using ink and paint, then adds bespoke textures and color in Photoshop. "It's about eighty percent drawn and twenty percent computer. I use Photoshop as a composition and layering tool, everything else is created in the real world."

Lost Girls · Chapter 1 · Page 1

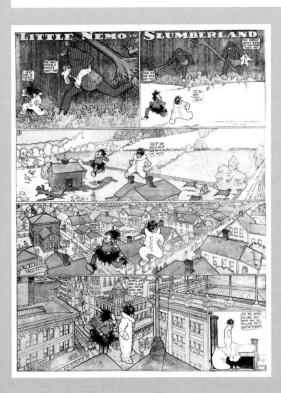

⚉ CAPTAIN AMERICA #111,
MARVEL COMICS, MARCH 1969

The hustle and bustle of the amusement arcade is perfectly portrayed, not only by Jim Steranko's intricate panel arrangement, but also by his full use of the limited color palette.

The technique of coloring a group of characters or objects in a single flat color, often used for background elements, is called "knocking out." This was regularly used in the days of hand separations, but is less seen today, probably due to the speed and facility afforded by computer coloring software.

⚉ LOST GIRLS,
TOP SHELF PRODUCTIONS, 2006

Melinda Gebbie's stunning multi-media artwork for the groundbreaking *Lost Girls* books sets a high standard in this beautiful first page. Six equally sized panels from the same mirror-reflected viewpoint, but with radically different color schemes.

⚉ LITTLE NEMO,
NEWSPAPER STRIP, 1907

Winsor McKay's beautiful Sunday pages set the standard in comics coloring, with its imaginative stories, perspective, and innovative page design.

The modern computer coloring method for comic books typically consists of two stages: "flatting" and "rendering." The universal choice of software for comics coloring is Adobe's Photoshop. Working from a scan of the original black-and-white line art, colors are added on separate layers to allow for easy adjustment and correction

◭ The main shapes of the artwork are filled with areas of flat color in order to check that the color design works. Sometimes the artist or the writer may have indicated a general color scheme, or a certain element to be a specific color where it's important to the story. If a particular color is not working against another, appropriate changes can be made at this stage.

According to *League* colorist Ben Dimagmaliw, "The flats stage is also useful in monitoring overall ink percentage of the page. I try to make sure that there is at least a 10% difference in ink density between two adjacent colors. The reason for this is that when the book gets printed, ink densities that are too close to one another ultimately end up looking 'muddy' and indistinct."

◮ Once the colorist is happy with the color "flats" he will then move on to "rendering" or "modeling" the color to add areas of highlights and shadows, dimensionality for figures and objects, and any necessary special effects.

Ben Dimagmaliw's coloring philosophy is simple: he just tries to tell a story. "I think it's my job to help the artist tell the story through color and lighting that conveys the mood, emotion, and place in the same way that a soundtrack 'colors' a film. The reader may not be consciously aware of the colors, but I hope that they subconsciously feel their effect."

Color Schemes

Print and Screen

Although many of today's comics are colored on computer, it should be noted that colors behave differently on a computer screen compared to print on paper. It's therefore important to prepare digital color files in the correct format, depending on whether their ultimate destination is for the web or for books, magazines, and comics.

primary analogous hue

secondary complementary tint

intermediate split complementary tint

CMYK

In print, color is reflected from the ink on the paper, and four colors are overprinted to create "full process color"—cyan (light blue), magenta (pink), yellow, and black, or CMYK for short. This is known as subtractive color; the more colors that are added, the darker it becomes. The process is used to create everything from cheap pulpy comics to glossy art books.

Most comics and graphic novels have traditionally been produced via offset lithography using CMYK, although short-run projects are now often printed digitally (sometimes from RGB files) as print-on-demand (POD). Reproduction from this new "plateless" technology is usually of lower quality than traditional print, although it is improving all the time.

RGB

Computer monitors display colors as pixels of colored light; the more colors that are added together, the lighter it becomes. This is known as additive color. All the millions of available colors are made up of red, green, and blue—RGB—and mixing all three together creates white.

⬡ + ⬡ THE COLOR WHEEL

The color wheel is a staple of art instruction books, but it can be very useful for designing specific color schemes and palettes for particular moods or effects.

Monochromatic is essentially using just one color in varying shades of brightness in order to color an entire scene. For example, blue is very often used alone to give the impression of night or darkness.

Analogous is the use of three adjacent colors on the color wheel.

Complimentary means the use of opposite colors—such as green and red. It's also interesting to note that bright is the opposite to dull, so the opposite, complimentary to bright green is dull red.

Clash colors are the colors adjacent to the first color's complimentary.

Neutral colors have little color saturation and are therefore mostly gray, giving a muted, downbeat atmosphere to the scene.

Primary colors are bright, pure hues of red, yellow, and blue and will give a garish palette most suited to juvenile or pop art material.

Secondary colors are simple mixes of the primary colors; green, violet, and orange.

Tertiary colors are intermediate mixtures of primary and secondary colors. Tertiary triad color schemes are sets of three tertiary colors that are equidistant from each other on the color wheel; there are, in fact, only two combinations: red-orange, yellow-green, and blue-violet; or blue-green, yellow-orange, and red-violet.

Hue, Tone, and Saturation

Hue is another name for the actual color. Red, blue, orange, and purple are all hues.

Tone is the lightness or darkness of the hue.

Saturation (sometimes called "chroma") is the strength or intensity of the color.

Color can greatly alter or enhance the atmosphere of the artwork, and can have all kinds of unconscious associations.

Color Temperature

The blue and violet part of the color wheel often invokes an impression of coolness, darkness, and nighttime. The opposite side of the chart—red and orange—implies heat, fire, cosiness, and energy.

Dark colors often make a scene oppressive, gloomy and miserable, while bright, vivid colors create a feeling of excitement.

Creating Depth with Color

It's interesting to note that the warm, rich colors appear to advance toward the reader, while cooler, less intense colors tend to recede. This can be extremely useful when landscapes are rendered, helping the colorist to create the illusion of depth in the picture. Darker colors also appear heavier, while lighter colors tend to look . . . well, lighter.

Color Associations

Color also has less intuitive, more cultural associations. Yellow implies a sign of warning and red means danger. Black is traditionally a color of mourning in the western world, while green suggests the environment.

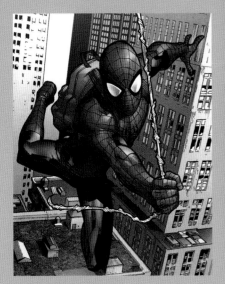

ULTIMATE SPIDER-MAN #111,
MARVEL COMICS, JULY 2007

NEW AVENGERS #1,
MARVEL COMICS, JANUARY 2005

The comics colorist must take into consideration a number of aspects prior to coloring a page.

First of all there is the actual, basic color of any element in the picture he is about to work on—for example, Spider-Man's costume is red and blue. But environmental considerations like time of day, weather conditions, and direction of light may also have a big impact on color, as will more esoteric decisions like mood and atmosphere, and any direction given by the writer or artist.

Any or all of these may affect the various constituent parts of the picture—for example, Spider-Man at night may not be colored the same way as he would be during the day.

The colorist should also be aware of the main focus of each panel and will aim to draw the readers' eye toward the appropriate area by using color contrast. The colorist may also decide to use a different color palette to give each separate scene a distinctive and consistent look.

The style of the art should also be taken into account. All-action modern superhero comics often benefit from a glitzy, highlighted, and airbrushed coloring method, while juvenile or humor comics usually look better with a simple flat color approach.

HELLBOY: THE CORPSE,
DARK HORSE COMICS, 2004

The style of the coloring should always complement the artist's style.

Mike Mignola's hard-edged, chiaroscuro graphical imagery for *Hellboy* benefits from simple, flat colors with a limited palette. Highly rendered, airbrushed coloring would look out of place and not be appropriate for Mignola's drawing style.

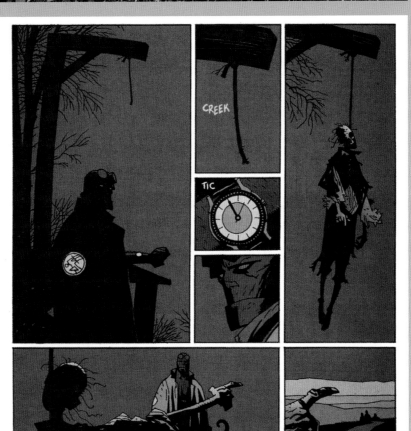

By using a predominantly neutral blue palette, darkness and cold are implied, with the contrasting red color of Hellboy making him the obvious focal point of each panel. It's also interesting to study the panel arrangement. There is no obvious reading order, but it's apparent that it's not that important. All but the last and first panel can be read in any order.

THE LEFT BANK GANG,
FANTAGRAPHICS BOOKS, 2006

In Jason's bizarre anthropomorphic tale of a gang of cartoonists turned bank robbers, the artist cleverly changes the whole palette from blue-gray to red-orange when there is gunfire in each of two panels.

X-MEN #50, MARVEL COMICS,
NOVEMBER 1968

Jim Steranko's stunning cover artwork utilizes a slightly extended analogous palette of green, yellow, and orange, completely independent of the actual colors of the characters and their costumes.

Steranko also designed the iconic X-Men logo, used here for the first time.

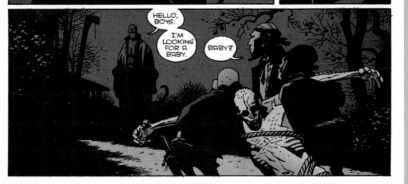

SETTING MOOD

In comics design, color is an important instrument in suggesting mood and atmosphere. Sometimes this can be achieved by the artist using black and white alone, but the experienced creator will leave the artwork "open" for the colorist to work their magic.

⬤ WEAPON X,
MARVEL COMICS, 1994

Barry Windsor Smith's beautiful sinewy artwork on his Wolverine story arc from *Marvel Comics Presents* is enhanced by his somber, neutral color scheme. Cool blues, flesh tones, and even the splashes of blood red are subdued by the addition of gray.

Note also, that the captions containing the off-panel voices of scientists who are observing Wolverine fighting, are color-coded to distinguish between speakers.

⬤ THE MAGICIAN'S WIFE,
CATALAN COMMUNICATIONS, 1987

François Boucq's evocative watercolor art for Jerome Charyn's enchanting story is awash with atmosphere. This beautiful page combines complimentary tones of autumnal reddish browns with chilly bluish purples.

FLASHBACKS AND DREAM SEQUENCES

Dream sequences and flashbacks can be indicated by using different panel border styles, contextual clues, or from narrative captions. Alternatively, choosing a neutral, monochromatic, or analogous color scheme as a contrast to the way the rest of the comic is colored, makes it more obviously a different sequence.

⊘ **ELEPHANTMEN #8,**
IMAGE COMICS, MARCH 2007

Moritat's smooth switch between monochromatic palettes signifies the transporting of the zebra character Trench from the dusty gray "present" to the sepia-toned flashback war sequence.

⊘ **TAMARA DREWE,**
JONATHAN CAPE, 2007

Andy stands admiring the peaceful countryside while his mind drifts back to an incident involving Tamara Drewe, in this page from Posy Simmonds' superb graphic novel. The flashback is clearly indicated by the soft blue monochrome panels within a huge thought balloon, contrasting with the earthy green and brown tones of the main image at the bottom of the page.

⊘ **DRAWN & QUARTERLY**
VOLUME 5, 2003

In this translated page from Dupuy and Berberian's excellent *Monsieur Jean* series, the title character's mind flits back to his experiences while traveling. By simple use of an analogous palette the sequence is marked out as separate from the main narrative. Even the dialogue balloons are colored!

Limited Palettes and Other Techniques

Using a Limited Palette

Monochromatic palettes are useful for suggesting strong lighting effects. Blue is frequently used for darkness and nighttime, but there are often other circumstances where a single color scheme is appropriate.

▶ **THE WAR OF THE WORLDS,**
DARK HORSE, 2006

D'Israeli's stunning monochrome color scheme from this page of Ian Edginton's adaptation of H. G. Wells' classic novel communicates the anxiety of the protagonist's situation. The sequence is also enhanced by the use and placement of sound effects.

▶ ▶ **THE 'NAM #2,**
MARVEL COMICS, JANUARY 1997

Phil Felix's atmospheric coloring over Mike Golden's exquisite artwork was a brave and successful experiment for the opening sequence of the second issue of a new Marvel Comics series in 1997. The limited palette of blues and grays perfectly captures the mood of nighttime in the jungles of Vietnam.

▶ **SECRET INVASION #1,**
MARVEL COMICS, JUNE 2008

An otherworldly two-page spread illustrated by Lenil Yu is beautifully colored in a limited range of pinks and purples by Laura Martin, accentuating the extraterrestrial nature of this alien planet.

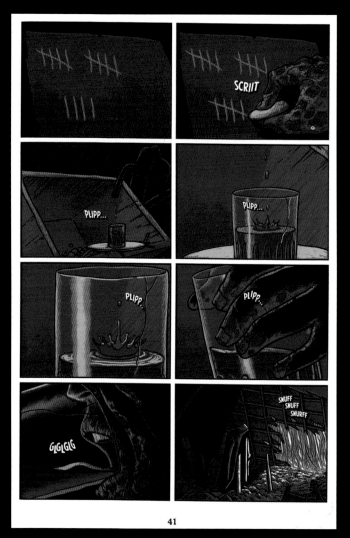

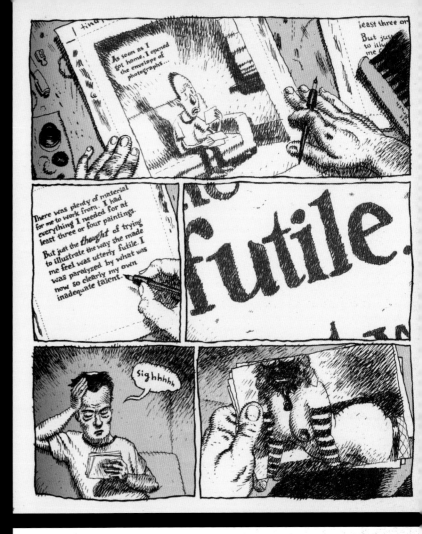

SPOT COLOR

Black and white is still popular with many independent art comics creators, such as Charles Burns, Dave Sim, and the Hernandez brothers, all of whom turn the limitations of monochrome to their advantage. Many great works continue to be created without the use of color. However, other alternative creators, like Jordan Crane, Alison Bechdel, and Dan Clowes are increasingly taking advantage of new print technologies and making use of two-color or spot color techniques.

The second color is most typically applied in Photoshop as a separate layer. Many traditional methods, such as applying ink onto a translucent overlay, are still practiced by some creators, like Canadian cartoonist Seth.

◗ THE LAST LONELY SATURDAY,
RED INK, 2000

In Jordan Crane's bittersweet graphic novel, two colors were used with great effect, red for the line work and a yellow hue for backgrounds, evoking Crane's skill as silkscreen artist.

◗◗ RIPPLE,
FANTAGRAPHICS BOOKS, 2003

For the graphic novel collection of Dave Cooper's story of sexual obsession, the artwork was printed in two colors—red and blue—onto a yellow-colored stock.

◗ GHOST WORLD,
FANTAGRAPHICS BOOKS, 2001

In Dan Clowes' celebrated graphic novel about the lives of two teenage girls, each page of his precise line work is overlaid with a pale blue second color. This particular hue was chosen by Clowes because he wanted to suggest the ghostly atmosphere that reflected blue light from television screens creates in dark living rooms.

◗ YIKES! VOLUME 2 #2,
ALTERNATIVE PRESS, MAY 1998

Inventive use of a second peach color from Steven Weissman's superb series about a gang of kids with extraordinary talents.

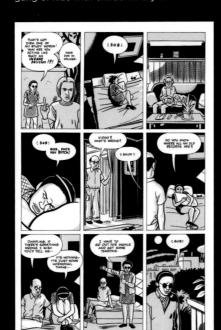

OLDS

"...old" simply means changing a
...rea of black line work into color.
...to be achieved by the artist
...nto a separate overlay where the
...equired. In the digital age, it is a
...simple task to select any part of
...line work and change it into a

...F RED #1,
...OMICS, 2005

...am's meticulous artwork makes
...se of a second color, incorporating
...chniques and color holds in
...ensities.

...GHT #1,
...APHICS BOOKS, 2006

...ane's background in screen-
...apparent in the design for this
...is comic book series *Uptight*.
...lor hold for the line work and
...green and orange, combining
...oduce a murky brown creates
...l and haunting image.

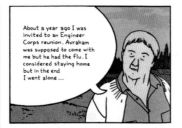

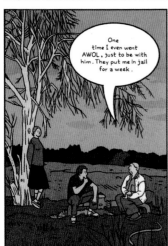

◄ **EXIT WOUNDS,**
DRAWN & QUARTERLY, 2007

Color holds can be extremely useful
for giving the illusion of depth—for
example, softening the hard line of a
range of mountains or cityscape in
the background of a panel. In this
example, Israeli artist Rutu Modan uses
the technique to draw attention to
the small figures in the background
by reducing the contrast on the line

ISOLATION

Another interesting effect can be achieved by dropping the color saturation to zero in certain parts of the image.

◆ DEMO #1,
AIT/PLANET LAR, NOVEMBER 2003

Becky Cloonan's cover for the first issue of Brian Wood's *Demo* series features a crowd scene; attention is drawn to the two central characters by rendering all the other figures in monochrome gray.

◇ ALISA'S TALE,
NOT YET PUBLISHED, 2008

In Al Davison's graphic novel about dwarfism, the central character Alisa is initially depicted in gray tones in a world of color to highlight the isolation she experiences from the rest of society. As she gains confidence by having positive experiences she gains color incrementally.

Original pencil art

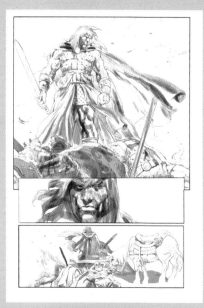

Transition layer

Flat color

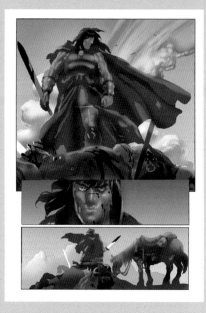

Rendering

Digital Painting

Modern, experimental comics creators can express themselves by using all kinds of media to create their artwork. These can include oil and water-based paints, colored pencils and pastels, collage, photography, and even sculpture. High-quality photographic techniques and modern scanners can both produce excellent reproductions of virtually any medium in which the artist chooses to work.

Skillful practitioners of computer programs such as Adobe Photoshop and Corel Painter can now produce convincing imitations of traditional painting techniques without getting their hands dirty.

These programs offer many different digital brushes, which can provide close approximations of real world styles. Used in conjunction with pressure-sensitive digital drawing tablets, breathtakingly authentic-looking paintings can be created.

▶ CONAN THE CIMMERIAN #0,
DARK HORSE COMICS, JUNE 2008
This recent adaptation of Robert E. Howard's barbarian hero utilizes the latest in modern digital painting techniques. Photographer and color artist José Villarrubia says, "Each coloring project requires a different approach, depending on the style of the artist, their technique, the subject matter of the story, and also the editorial input." Scans of Tomas Giorello's penciled artwork are imported into Photoshop as grayscale TIFF files, where Villarrubia tweaks the levels to increase the contrast between the paper and the pencil marks.

Photoshop's pencil, lasso, and bucket tools are used to create areas of flat color on one layer underneath the drawing. On a separate layer, rendering is applied with standard and custom-made brushes.

"To create the painted look of these pages, I added an extra layer on top of the rest that partially would cover the line art, so there would be softer transitions between the color and the black areas of the drawing. I also add scanned watercolor textures on top."

The last stage is to flatten the files and save as a CMYK TIFF file.

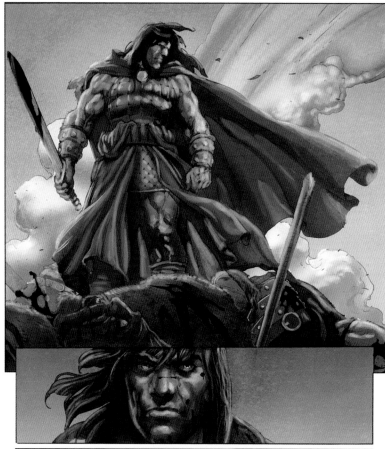

Final flattened color

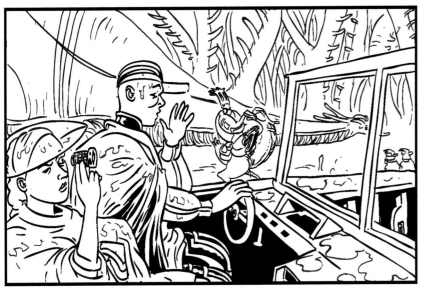

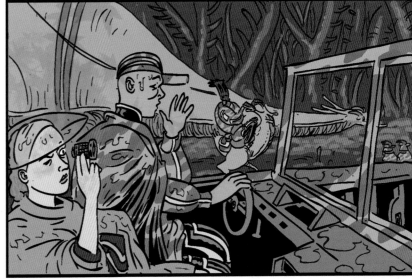

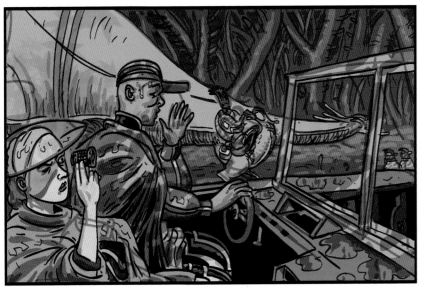

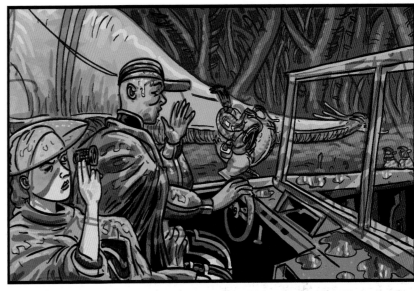

▶ THE VORT,
2000 AD #1594,
REBELLION, JUNE 2008

British artist and colorist D'Israeli has created his color artwork entirely by computer for many years. *The Vort* is his first *2000 AD* collaboration with writer G. Powell.

D'Israeli's "pencil" roughs, created by the use of a Wacom tablet and stylus, are "inked" in Adobe Illustrator. Here you can see that in addition to black line work, a brownish hue is used to delineate background elements and other details.

The Illustrator file is exported to Photoshop, where flat layers of color are applied with pencil and brush tools.

Next, the artwork is rendered with color details, shadows, and modeling to give the illusion of depth and form. D'Israeli says, "Because I use the pencil tool, all the areas of color are hard-edged. I avoid using soft, airbrush-type brushes for shading as it makes the coloring look too bland."

Highlights are then painted on in the appropriate areas. Finally, layers of rain are painstakingly added—three different sizes of raindrops, each with a slightly different degree of Photoshop's motion blur filter, adding a further impression of depth.

The final stage is to open the file in Corel Painter and do just a little softening of edges. "I do this to the absolute minimum—I don't want to destroy the 'bite' of the image by softening everything too much."

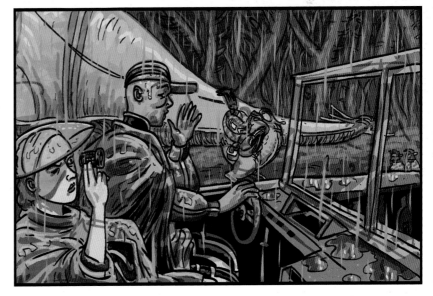

Designer Spotlight: **Chip Kidd**

In 2003, book designer and author Chip Kidd was commissioned to collaborate with Art Spiegelman to produce a biography about one of the industry's Golden Age greats. The book, *Jack Cole and Plastic Man: Forms Stretched to Their Limits*, brought Kidd to the attention of comic book readers.

"The design approach to me was obvious: what if Plastic Man had turned himself into a book?" The final result included a cover made of plastic, interior pages printed on a variety of paper stocks, wild page designs, no discernible grid, and colored type that defied the rules of graphic design.

The super-enlarged reworking of existing comic book art caught Frank Miller's attention, who asked Kidd to design the covers for both *The Dark Knight Strikes Again* and the reissue of the seminal *The Dark Knight Returns*. "I had been trying to attract Frank Miller's eye for years."

Miller was so happy with the results that he enlisted Kidd to redesign the entire seven-volume *Sin City* back catalog.

Kidd was already the most in-demand designer for comics-related books, having applied his trademark style on projects such as *The Golden Age of DC Comics: 365 Days*; *The Complete History* series featuring Batman, Superman, and Wonder Woman; and *Mythology: The DC Comics Art of Alex Ross*.

Although he did contribute a six-page Batman/Superman story for Alex Ross to draw for the *Mythology* retrospective, Kidd is not himself a comics creator. He is, however, widely known to be a passionate fan of comic book media, and in particular, Batman. Pieces from his extensive collection of memorabilia are featured in his first book, *Batman: Collected*, which Kidd wrote and designed.

Kidd has since co-written other books on the caped crusader; *Batman Animated* (with Paul Dini) and *Bat-Manga!: The Secret History of Batman in Japan* (with Saul Ferris).

The graphics-heavy design for new cover templates for the Batman titles in 1999 by Chip Kidd was a radical departure for superhero comics. The mastheads were typography based with elements butting up against each other. Kidd also created a new bat symbol based on Batman's mask.

In 2005, DC Comics commissioned him to produce new logos for the All-Star line of comics featuring their iconic heroes Batman and Superman.

Kidd has designed, edited, and provided commentary for *Peanuts*, a lavish retrospective of the career of Charles Schulz, which features developmental sketches and other rare materials along with over 500 strips photographed from the original newsprint.

After graduating from Penn State University, he took a design job at Knopf, an imprint of Random House. Together with his freelance work, he has produced over 800 book jacket designs, and as a result, initiated a revolution in American book packaging.

The iconic dinosaur skeleton silhouette image for the cover of Michael Crichton's *Jurassic Park* novel was so successful that it was carried over into marketing for the film adaptation.

The design process which Kidd says can last anything between ten minutes and six months begins with the manuscript, which he reads and digests. "Along the way, I may or may not involve photographers or illustrators, or any amount of ephemeral detritus that washes up on my shores in the pursuit of solving the problem. And that is what it always amounts to: visually solving a problem."

Kidd has been described as a master of contemporary book design, his distinctive style created by combining and manipulating found images and type.

Currently Kidd is an associate art director at Knopf and an editor at Pantheon, where he has overseen the publication of their graphic novel line including books by Daniel Clowes, Charles Burns, Kim Deitch, Ben Katchor, and of course Chris Ware.

He has written two satirical best-selling novels, *The Cheese Monkeys* and *The Learners* about state college art students. Kidd also writes about graphic design and popular culture for a variety of high profile publications and has his own rock band, Artbreak.

CLOCKWISE FROM TOP LEFT:

Batman Animated, Harper Collins, 1998

Jack Cole and Plastic Man: Forms Stretched to Their Limits, Chronicle Books, 2001

Detective Comics #746, DC Comics, 2000

All-Star Batman & Robin #9, DC Comics, 2008

Peanuts: The Art of Charles M. Schulz, Pantheon, 2001

Peanuts: The Art of Charles M. Schulz, Pantheon, 2001

Peanuts: The Art of Charles M. Schulz, Pantheon, 2001

All-Star Superman #1, DC Comics, 2005

BATMAN:
ANIMATED
PAUL DINI and CHIP KIDD

FORMS STRETCHED TO THEIR LIMITS!

JACK COLE
AND
PLASTIC MAN

ART SPIEGELMAN and CHIP KIDD

DETECTIVE BATMAN

RUCKA · MARTINBROUGH · WATKISS · MITCHELL

PLUS: THE JACOBIAN BY GORFINKEL & JOHNSON

dccomics.com

DIRECT SALES

$2.50 US $3.95 CAN

GRANT MORRISON + FRANK QUITELY
WITH JAMIE GRANT

SUPERMAN
JAN. NO.

DIRECT SALES

FRANK MILLER + JIM LEE

BATMAN & ROBIN
THE BOY WONDER
NO. 9 APR.

DIRECT SALES

$2.99 US $3.95 CAN

LIFE

HOFFA GOES TO JAIL

The great 'Peanuts' pair
CHARLIE BROWN and SNOOPY
WINNERS AT LAST

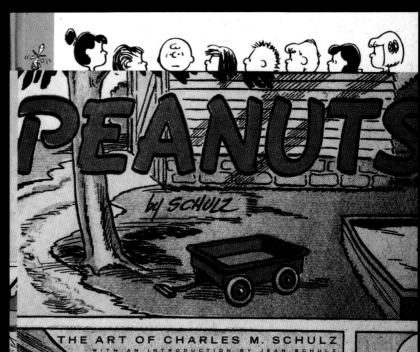

PEANUTS
by SCHULZ

THE ART OF CHARLES M. SCHULZ
WITH AN INTRODUCTION BY JEAN SCHULZ

PEANUTS

AAUGH!

I CAN'T
STAND IT!

SHE'S
GOING TO
DRIVE ME
CRAZY!

RAUGHHH!

RIP! RIP!

GOOD GRIEF!

Chapter 6
Covers and Publication Design

Introduction

Much of this book has been concerned with the design and mechanics of the sequential art form of comics itself. But how a comic or graphic novel is presented also has a big influence on how the reader perceives the work.

Powerful page layout software has enabled cutting-edge design to be available to publishers of all sizes and independent creators alike. More affordable print technologies and the ease of communication with overseas printing houses have opened up a wider variety of formats to the designer.

All components of a graphic novel or comic book—including cover artwork, title masthead, publisher logo, end papers, and text content—have to be subject to the design process, while format considerations such as size, page count, and paper stock can all affect the reader's experience of the work.

Today, the design of comics publications is far more varied and influenced by current graphic design trends than it has ever been before. The cover, interior design, and layout of a contemporary graphic novel might now look less like a comic book and more like a magazine or mainstream novel.

The scope for comic book design has never been wider.

◉ SEA OF RED #1,
IMAGE COMICS, 2005

Salgood Sam's exquisitely designed "split" cover. The title masthead cleverly mirrors the colors of the two images.

Unusual Formats

Format should always support the content, and with the maturation of the comic art form, a more sophisticated design approach has become appropriate for many contemporary comics publications.

Rather than simply designing to the standard "comic book size," we are now seeing rectangular publications of all sizes as well as square and landscape-shaped formats. Hardcover volumes with embossing and debossing, innovative dust jackets, softcovers with French-style end-flaps, gloss and matt lamination, spot varnishing, and die-cuts are all becoming more common. Particular paper stocks are often specified and bespoke color printing in any number of spot colors is no longer unusual.

The growth of the original graphic novel in recent years has driven innovation in design, with historical collections of classic newspaper strips in particular finding a market that is prepared to pay for high-end production values.

The traditional portrait format is still most common, particularly for the periodical comic book, where the ratio of 2:3 remains prevalent.

 + ▷ **RAW #1,**
RAW BOOKS, FALL 1980, 10½" x 14"

Art Spiegelman and Francois Mouly's groundbreaking *Raw* was quite unlike any other comic previously published. Its large, tabloid format incorporated inserts, pasted-on color panels, and in one case had a corner of the cover literally torn off and taped inside. One such insert included in *Raw*'s second issue was a serialized mini-comic, which when collected became one of the most important and celebrated graphic novels to date: Spiegelman's *Maus*.

▷ **WHITECHAPEL FREAK,**
BLACK BOAR PRESS, 2001, 12" x 15½"

Dave Hitchcock's finely rendered version of the Jack the Ripper story was self-published in an authentic tabloid newspaper format, perfectly evocative of the Victorian period in which the tale is set.

▷▷ **CAVE-IN,**
HIGHWATER BOOKS, 1999, 5" x 6"

Brian Ralph's wordless tale about a lost cave-boy was published in a cute, chunky format with rounded corners. Ralph's thick, expressive line work is printed in brown ink and a variety of colors on heavy, cream-colored paper stock, while the cover is textured card, making the whole package a tactile experience as well as a visual one.

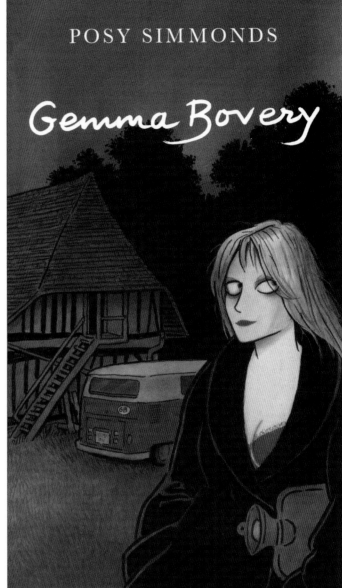

◆◆ SHUTTERBUG FOLLIES,
DOUBLEDAY, 2002, 9¼" x 6½"

When mainstream book publishers started to dip their toe into the waters of graphic novel publishing, quality production values came as standard. Jason Little's first major work was published in a full color, landscape hardcover format.

◆ EL LARGO TREN OSCURO,
LA LUZ COMICS, 2005, 9¼" x 4¼"

Sam Hiti decided to create this original graphic novel in a long, landscape format, printed entirely in shades of brown. The cover added yellow to create a reddish tint.

◆ GEMMA BOVERY,
JONATHAN CAPE, 1999, 6½" x 11¼"

Originally published in British newspaper *The Guardian*, Posy Simmonds' tour-de-force of comics storytelling has been collected in an unusually tall format. This is a clear case of the content dictating the design for the graphic novel compilation.

The shape was three columns wide by the height of the *G2 Guardian* supplement. Simmonds has said that she "sort of agreed to that without realizing it was very vertical."

◆ RED ROCKET 7 #6,
DARK HORSE COMICS, 1998, 10" x 10"

Mike Allred's typically outlandish tale of a rock star alien was serialized in a lush, square format that suggested the size and shape of a vinyl record.

Comic Book Covers

It's a well-worn adage, but it's true: You can't judge a book by its cover. Unfortunately, most people do exactly that, and with the vast number of new comic books and graphic novels being published every month, you can't blame them.

Therefore, a cover design needs to reflect the content of the book and be designed to attract the attention of its target audience. Obviously, mature subject matter should sport a more sophisticated cover illustration and must also be reflected in the choice of typeface and overall design.

Creating a distinctive cover design, especially for a series of comic books, can help the reader find their favorite titles more easily. But the design must also strive to intrigue and lure in casual browsers. It should always be remembered that the primary purpose of the cover is to sell the book, however crass that may sound.

It's important, then, for a cover to have a strong, clear design that can be "read" from a distance. The image should be eye-catching and distinctive, standing out from a bank of possibly dozens of other books competing for the purchaser's dollar.

It helps enormously if the designer is aware of contemporary trends. Strong, iconic graphics can stand out against a wall of more illustrative covers. But of course, there is no single formula that will make for a successful cover; if all covers were designed to the same recipe, they would blend into one.

It's also important that the cover illustration, title logo, and other necessary elements work together as a cohesive design.

A good cover, in the simplest terms, will attract the attention of its potential readership. Whether for comics covers or not, good design is good design.

ANATOMY OF A COVER

Ⓐ THE UMBRELLA ACADEMY #1,
DARK HORSE COMICS, OCTOBER 2007

① **Title logo**—Nicely designed title logo with miniature umbrella.

② **Cover image**—Typically beautiful cover image by the enormously talented James Jean. A muted, monochromatic color scheme and a symmetrical design, neatly incorporating the huge cast while retaining a strong visual image.

③ **Price details and issue number**

④ **Cover text**—The cover logo has been converted into a font to display the names of the writer and artist.

⑤ **Barcode**—An unfortunate but necessary inclusion in the cover design.

⑥ **Publisher logo**—The recently redesigned Dark Horse logo.

Ⓐ ELEKTRA ASSASSIN #4,
EPIC COMICS, NOVEMBER 1986

An exquisite example of Bill Sienkiewicz's cover artwork for an issue of *Elektra Assassin*. The white background and heart shape give strong graphic impact, despite the fact that Sienkiewicz's painting is highly detailed. The image also communicates the secret intentions of each of the characters with the result that the cover is not only beautiful but funny.

COVER ARTWORK

Artwork created for the cover of the book can be based on a number of different concepts; a single key moment, a montage of elements from the story, a portrait of the central protagonist, or an image that sums up the subject and mood of the book.

The artist must endeavor to boil down the story to its very essence, encapsulating the content of the comic in a single illustration. Unlike the comic itself, the cover is not sequential art; it's a single piece that needs to convey the appropriate message to the potential purchaser.

The cover illustrator should always bear in mind that space needs to be allotted for the title logo, publisher logo, inclusion of barcode, display text, or caption boxes and any other necessary elements. Neglecting to do so can result in important parts of the image being obscured, or lead to a badly balanced composition.

Heavily design-based covers can include enlarged images from the book's content, make use of photographic material, and incorporate typography as a major element.

PORTRAIT-STYLE

Poster-style, iconic images of the main protagonist are common and can be extremely effective. A generic pose featuring a central character is often used for superhero books; the best ones can be re-used for "trade paperback" collections and also to avoid deadline dramas if the cover doesn't match the interior.

On the downside, if the images do not relate to the content of the book in some way, this approach can create a series of generic and interchangeable covers, making them hard to distinguish from each other.

⊙ **NEW X-MEN #116,**
MARVEL COMICS, NOVEMBER 2001

⊙ **NEW X-MEN #118,**
MARVEL COMICS, SEPTEMBER 2001

Two from a series of sensational covers by Frank Quitely for *New X-Men*, which featured static, un-dramatic character portraits. In another artist's hands, this approach could have quickly become generic, but Quitely's highly distinctive style, combined with sharp cover dress design and bold color, made these covers really pop.

The cool, unusual title logo and the vertical text were a real departure for mainstream comics and remain great examples of modern comics cover design.

⊙ **CHANNEL ZERO #1,**
IMAGE COMICS, NOVEMBER 1998

Brian Wood is a writer, artist, and cover designer who enjoys making extensive use of photographic and textual elements for his covers. This high contrast chiaroscuro image combined with a neutral palette and modern logo results in a cutting-edge comic book cover.

▷ **CASANOVA #1,**
IMAGE COMICS, JUNE 2006

Gabriel Ba's cool "swinging '60s" style cover design is perfectly in keeping with the genre-bending sci-spy adventures of the comic book's hero. Lots of white space, color holds, and a clever two-color analogous scheme along with a definitive character pose and smart typography combines to make a truly distinctive and eye-catching cover.

▷▷ **LOVE & ROCKETS #1,**
FANTAGRAPHICS BOOKS, FALL 1982

Jaime Hernandez's cover for the first Fantagraphics issue of the long-running art comics title has become a celebrated classic. The solid black shadow at the top of the cover and behind the figures helps to make the image almost three-dimensional. Hernandez's figure work and sense of composition, even at this early stage of his career, makes this cover come alive.

▷ **NICK FURY, AGENT OF S.H.I.E.L.D. #1,**
MARVEL COMICS, JUNE 1968

A classic pop art cover from comic book design innovator Jim Steranko. The comic's main characters are set among giant cubes with patterns and emblems on their faces, creating an image that encapsulates the mood and content of the book.

SPLIT COVER DESIGN

▷▷ **STRAY BULLETS #1,** *EL CAPITAN BOOKS, MARCH 1995*

The first issue of David Lapham's hugely successful self-published violent crime series sported a sophisticated layout that has been utilized for every cover to date.

Reacting to the typical comic book cover design, Lapham uses only two-fifths of the available space for his image, allocating the top section for title logo and display text against a solid color background. More recently, this layout has been echoed by titles like *Fell* and Marvel's *Civil War*.

COMIC COVER CREATION

TRADITIONAL METHOD

WOLVERINE: FIRST CLASS #4,
MARVEL COMICS, JUNE 2008

Often a publisher will request a couple of alternate rough sketches from the cover artist; these are sometimes called preliminary drawings, or prelims.

For this issue of a Wolverine spin-off, Alan Davis was given a brief description of the required image by the editor; "Wolverine and Shadowcat leading the Knights of Wundagore into battle." The roughs are first drawn at print size and then sent to the editor, who chooses an image or requests further sketches.

Once a selection has been made, the art is penciled. In this case, the cover was inked by Mark Farmer and colored by Paul Mounts before being passed to the design department for the addition of title logo and cover dress.

DIGITAL COVER CREATION

2000 AD #1575,
REBELLION, FEBRUARY 2008

▶ Even though the final illustration will be rendered in monochrome, D'Israeli uses an unusual method of color coding to design the cover layout.

The tentacles of the mysterious monster act as a neat framing device, looping around the ensemble cast of the *2000 AD* serial *Stickleback*. Note that even at this early stage, the rough layouts incorporate the cover logo.

▶▶ After refining his drawing in Illustrator, D'Israeli adds blocks of distinct, flat color to quickly mask off the different areas of the image to add texture or shading. He then adds textures and gray tones in Photoshop.

▶ After importing the image into Corel Painter, he tweaks the blacks and further shading before removing the color masks.

▶▶ Finally, D'Israeli's cover illustration is passed to the production department at Rebellion. The *2000 AD* logo and other cover furniture are added, as well as a black band containing some display text and a suitably creepy font for the title.

The illustration is given a muted blue cast while a complimentary shade of bright orange is used for most of the cover type. The swooping tentacles are cleverly placed between the cover type and the black background, maintaining the cover composition with covering the logo.

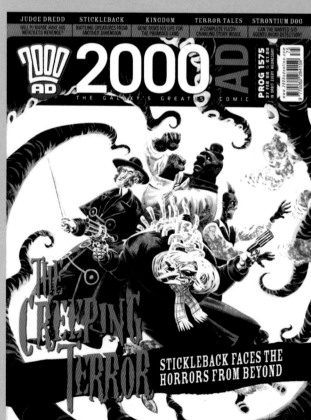

COVERS FOR GRAPHIC NOVELS

Graphic novels and trade paperbacks (collections of previously published, often serialized stories) are usually designed specifically for the bookstore market and differ from the standard layout of the periodical pamphlet comic book cover.

There are usually fewer elements to include, as the back cover will house details such as publisher and purchasing information, barcodes, and testimonials.

Typical comic book-style logos are often swapped for a more mature typographical title font.

❶ EXIT WOUNDS,
DRAWN & QUARTERLY, 2007

The excellent design for the cover of Rutu Modan's story of mystery and romance in Tel Aviv looks sophisticated and contemporary, and yet also communicates the fact that it's a comic book by the inclusion of small inset panels along the bottom edge.

❷❷ HICKSVILLE,
DRAWN & QUARTERLY, 1998

A downbeat image of a road sign balanced with a small segment from a map perfectly captures the atmosphere of Dylan Horrocks' heartbreaking story of a community that exists for comics. Sophisticated cover design by the original publisher, Michel Vrana of Black Eye Productions.

❸ CHANNEL ZERO,
AIT/PLANETLAR, 2000

This stunning graphic image is typical of Brian Wood's design-influenced cover work. A straightforward side-on image of a weapon is transformed by a high contrast negative treatment and the addition of a simple, bold typeface, creating an incredibly effective cover.

❹❹ THAT SALTY AIR,
TOP SHELF PRODUCTIONS, 2007

Tim Sievert's bittersweet fable about relationships and change is perfectly illustrated in this fresh and understated cover design.

❺❺❺ BOX OFFICE POISON,
TOP SHELF PRODUCTIONS, 2001

The cover design for the massive 600-page collection of Alex Robinson's long running series took the unusual route of foregoing any illustrative element at all. Designer Brett Warnock said that the abstract shapes and colors, reminiscent of a 1950s cinema poster, "represent the wide range of characters in the cast of the story."

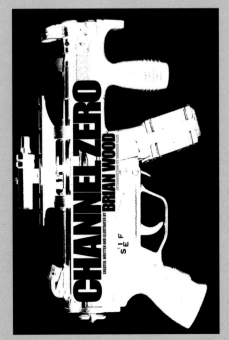

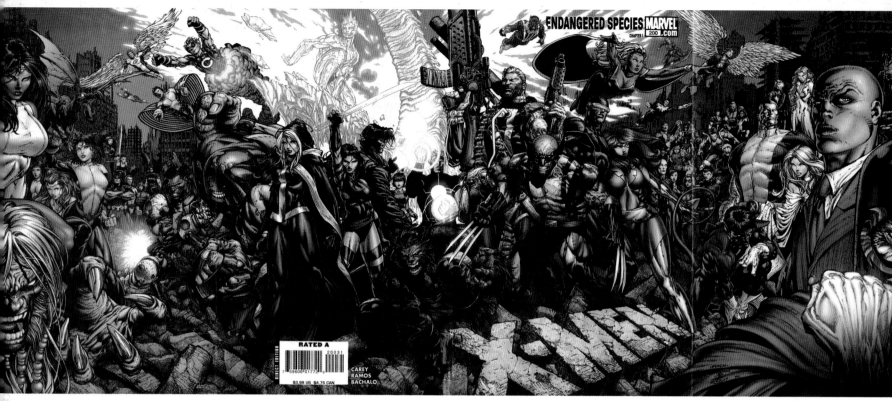

WRAPAROUND COVERS AND GATEFOLDS

Back covers were traditionally prime advertising space for the periodical comic book, but with the growth of the direct market in the 1970s—a global network of comic shops that sell directly to the comics enthusiast—this became less critical. Cover illustrations that wrapped around to the back cover for special anniversary issues, or for books that had no general newsstand distribution became more common.

For the cover artist, it is important that the front cover works as an attractive image in its own right, as well as being part of a larger composition. Special attention must be given to the placement of masthead and cover furniture, as well as any additional items required for the back cover.

○ X-MEN #200,
MARVEL COMICS, AUGUST 2007

An alternative to a wraparound cover is a gatefold or foldout. In this case, to celebrate the 200th issue of the X-Men, a double-gatefold cover produced with an illustration spread over four pages. The front cover itself is designed to work as a self-contained composition, as well as being part of the entire ambitious quadruple-page spread.

○ FANTASTIC FOUR/IRON MAN: BIG IN JAPAN,
MARVEL COMICS, DECEMBER 2005

Seth Fisher's cartoon-influenced psychedelic composition spirals elegantly from the center of the front cover to the back. The front half contains all five major characters in some peril, while the raft of beautifully designed and colorful monsters sweep round to attack from the reverse half.

◐ **CRIMINAL #4,**
MARVEL COMICS/ICON, JULY 2008

Sean Phillips' elegant wraparound design is more in keeping with a book cover, with plenty of dead space on the back cover for promotional text. The figures are restricted to the front part of the cover, while the background setting wraps around to the reverse.

The white logo and display text are interestingly overlaid on the art and, together with the white areas at the top and bottom, create a strong, graphic, and fresh-looking design.

◐ Phillips' cover rough enables him to figure out the composition and color scheme before commencing the artwork proper.

◑ **THE UMBRELLA ACADEMY #2,**
DARK HORSE COMICS, NOVEMBER 2007

James Jean's beautifully muted tones evoke the somber mood of the funereal scene.

◓ **PALOOKA-VILLE #19,**
DRAWN & QUARTERLY, FEBRUARY 2008

The always-innovative Seth designs an almost wallpaper-like arrangement of diamond shapes for this cover of his *Palooka-Ville* series. Black, green, and gold inks are printed onto a matte laminated card stock to produce an unusual, luxurious package.

Title Masthead Design

Title mastheads—the distinctive brand logotype that identifies the book or publication—may incorporate a graphic logo, follow specific design rules, or simply be a modified display typeface.

Logos should always be graphically striking and distinctive—so that the regular reader can instantly pick out their favorite titles from the rack—or in conjunction with the rest of the cover design, to attract the new readers.

Mastheads are usually placed at the top of the cover, as traditionally, magazines and comics were always racked with only a small portion of the top of the cover being visible to the potential purchaser.

Cover mastheads and logos should be versatile enough for their colors to be changed, or reversed out to avoid blending in with the cover image. The style of the masthead should also be appropriate to the subject matter of the book or story, and designed to appeal to the target audience.

BRANDING

Classic comic book mastheads have become brands in their own right. Everyone will be familiar with the "telescoped" Superman logo, almost as much as his famous "S" chest insignia. The classic design has been much imitated, and even today, seventy years after its inception, the type style is still instantly recognizable as a comic book title.

Inspiration for masthead design can be found in any number of places, from books and magazines to CD covers, movie posters, and more.

Graphic novel designers have greater freedom than comic book designers for title placement, as book covers are usually displayed in stores in their entirety. Distinctive mastheads are not often used on books, as books tend to be one-off purchases, although book series usually follow a consistent cover design.

Custom hand-lettered mastheads have given way to computer-designed logotypes and even simple typography. In the latter case, color and the relationship with the rest of the cover design becomes more important for brand recognition.

◆ Howard Chaykin's *American Flagg!* masthead logo perfectly encapsulates the frenetic, ironic, all-American thrust of the 1980s comic book series.

For a regular title, readability is not such a vital concern so much as the distinctiveness of the design. Familiar mastheads are not usually "read," but unconsciously recognized as a shape. Of course, the logo design should never be so extreme that it becomes unreadable, as there are always new readers to attract.

◀ Comicraft's pleasingly symmetrical masthead design for Marvel's *New X-Men* comic book transforms part of the title into a logo.

◔ **EPIC ILLUSTRATED #1,**
MARVEL COMICS, SPRING 1980
Marvel's response to *Heavy Metal* was *Epic Illustrated*, a comic book periodical with mature content in a magazine-style format. The masthead was an ingenious design, that allowed Frank Frazetta's painted artwork to show through the lowercase letters.

berlin

jason lutes

◑◑ CLUMSY,
TOP SHELF PRODUCTIONS, 2004

◑◑◑ OMEGA THE UNKNOWN #1,
MARVEL COMICS, DECEMBER 2007

Independent comics have typically bucked the digital trend, and masthead design is no different. Jeffrey Brown's shaky logos are charmingly hand-drawn; this style has even influenced major comics publishers like Marvel.

◑◑◑◑ BERLIN #14,
DRAWN & QUARTERLY, DECEMBER 2007

The covers of Jason Lutes' epic serialized novel about pre-war Germany rely on a straightforward lowercase font. But in conjunction with a consistent black-on-gray color scheme, other cover elements such as the placement of the author's name, and the tiny black shape suggesting part of a swastika, result in a striking and instantly recognizable masthead.

◑ FANTASTIC FOUR #1,
MARVEL COMICS, NOVEMBER 1961

◑◑ FANTASTIC FOUR #552,
MARVEL COMICS, FEBRUARY 2008

The timeless classic *Fantastic Four* masthead logo has survived over forty years and returns to its cover on a regular basis.

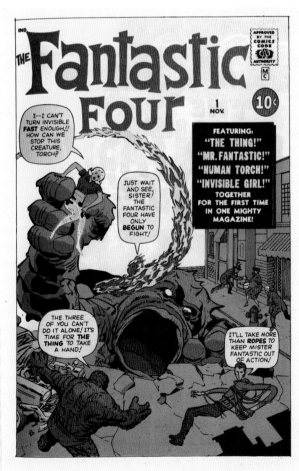

DESIGNING A MASTHEAD

Most comic mastheads are now created with computer programs such as Adobe Illustrator which has had a big impact on logo design.

▶ Comicraft's J. G. Roshell designed the masthead for Marvel's major 2008 crossover event, *Secret Invasion*. "'Something paranoid' was all the guidance editor Tom Brevoort gave us, so I assembled a bunch of different ideas pretty quickly, thinking about top secret dossiers, top secret military stamps, that sort of thing."

From the initial pencil sketches, the best ideas were worked up in Adobe Illustrator. After the first batch of samples was submitted, the design developed in a more pulpy, sci-fi horror direction. The editors at Marvel chose one of the three variations from the second batch, which was based on Comicraft's font Sticky Fingers.

▶ **SECRET INVASION #1,**
MARVEL COMICS, JUNE 2008

The chosen masthead design was tweaked by altering the spacing and adding stroke outlines and gradient fills, and is seen here incorporated into the final cover design for issue #1.

COVER FURNITURE

Cover design also has to incorporate a number of other necessary elements in addition to the masthead and cover image. The publisher's logo, sometimes as part of a consistent "corner box" template, as popularized by Marvel Comics in the 1960s, is usually compulsory. Typographical elements such as issue number, publication date, price, and creator names are also often required, as is a UPC barcode.

When there is no advertising, many of these elements can be placed on the back cover, especially in the case of art comics and wraparound cover designs. Certainly in the case of graphic novels, the front jacket invariably consists only of the image, title, and creator names.

▶▶ **AMAZING SPIDER-MAN #13,**
MARVEL COMICS, JUNE 1964

This classic Steve Ditko cover incorporates the distinctive Spider-Man masthead, complete with drop shadow and cobwebs. A secondary logo for the villain Mysterio is also prominently displayed, along with a number of text captions, the Marvel corner box, issue number and date box, and Comics Code Authority approval stamp.

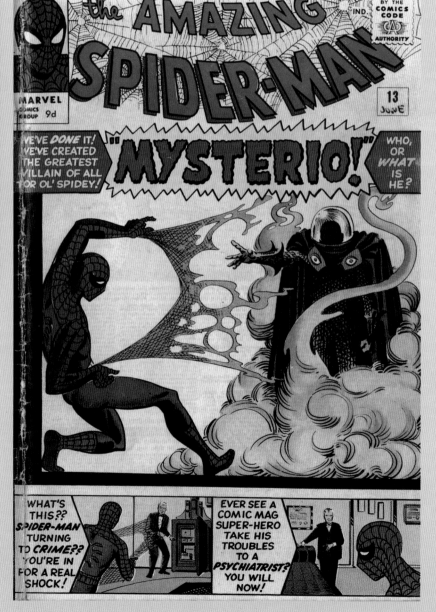

COVER TYPOGRAPHY

Typographical elements on comic book covers—other than the essential elements—are something that has become less common in recent years. The masthead, cover image, and creators' names are usually all that's deemed necessary to ensure the book is picked up.

Simple sans-serif display fonts are sometimes used on covers as a graphical element, intentionally giving a more literate, modern appearance to the design.

▶ **KICK-ASS #1,**
MARVEL ICON, APRIL 2008

Mark Millar and John Romita Jr.'s *Kick-Ass* cover design incorporates a distinctively simple type-based masthead with a prominent tagline imposed over the illustration, making it a very different-looking comic book.

▶▶ **GLAMOURPUSS #1,**
AARDVARK-VANAHEIM, APRIL 2008

Dave Sim's spoof fashion magazine covers for his *Glamourpuss* series make heavy use of typography as a design element.

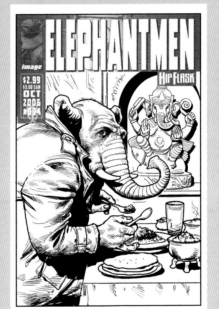

COVER IMAGE AND TYPE DESIGN

Brian Bolland was commissioned to draw the cover illustration for an issue of Active Images' *Elephantmen*. Writer Richard Starkings requested an image of Ebony eating in an Indian restaurant with a statue of the god Ganesh in the background.

◀ This is Bolland's cover rough, with masthead and cover furniture pasted in from a previous issue to assist the artist with his layout.

◐ + ◑ Working from Bolland's partially inked artwork, J. G. Roshell started experimenting with the masthead and cover display text. "This was just one of those instances I tried a bunch of typefaces and see what worked. In this case, something with Indian flavor that was still bold and almost as readable as our standard logo. I was worried about covering too much of the background art, but Richard said no, Bolland intended that to be covered."

◀◀ **ELEPHANTMEN #3,**
IMAGE COMICS, SEPTEMBER 2003

The final result is a stunning combination of Bolland's beautifully colored, intricate linework, and Roshell's highly decorative and striking graphic design.

Company Logo Design

The creation of a comic book publisher logo is not just a standalone design; it's part of their corporate identity.

A logo is a unique combination of a graphical symbol and text that represents a company (or other organization) as part of its commercial brand. It's also commonly a registered trademark. Its purpose is to identify the company and create immediate recognition to its market. Logos representing Nike and Coca-Cola, for example, are instantly recognizable in any language.

Therefore, the logo should be highly distinctive. Because of the multiple uses that the logo may have, it's also vital that the logo is versatile. Color can be important but should not be an integral part of the design, as there may be instances where the logo is reproduced in black and white—for example on a fax document.

The graphic part of the logo also needs to be simple enough to be reproduced at small sizes, for business cards, websites, or on the spine of the publisher's books; as well as suitable for enlargement to decorate vehicles and offices.

It's in a comics company's interest to include their logo on everything from letterheads and other stationery, to advertising and promotional materials, so a distinctive, high-quality design that captures the spirit of the publisher is very desirable. Having said that, their logos will still most often be seen on the covers of their comic books and graphic novels.

Brainstorming ideas by making loose sketches with pencil and paper is usually the first stage of creating a logo, and feedback from the company is necessary to choose and refine the final design. The logo artwork is invariably created in a vector drawing program like Adobe Illustrator or CorelDraw, so that the image can be scaled up and down as required without losing quality. For that reason, logos that incorporate bitmapped images, gradient fills, or are otherwise overly complex are usually unsuccessful.

Custom-designed fonts for the text element of the logo (often just the company name) aren't essential, but some tweaking can add a degree of uniqueness and help create a unified design.

⬡ The Top Shelf Productions logo was created by Brad Engle using Illustrator. Part of its conception was that the color of the different components of the design could easily be changed to match the color scheme of its environment.

⬡⬡ It's counterproductive to frequently redesign logos, as the objective of the logo is to promote brand awareness. Occasionally, though, a redesign is necessary for re-branding or modernizing the image of a company. The original Dark Horse Comics logo with a chess piece at the center of a conventionally comic-booky circular design was looking a little dated.

⬡⬡⬡ Mark Cox's excellent redesign introduced a much fresher, more contemporary appearance, without sacrificing the company's characteristic black horse head emblem. The fact that the company name itself can be easily visualized is a great advantage in designing an appropriate symbol.

❶ + ❷ EC's "postmark" logo is a much-imitated classic. Even today, it's echoed in publisher logos like Bongo Comics and Drawn & Quarterly.

❸ The IDW (Idea + Design Works) logo is rarely seen in its original color form. It's often "reversed out," allowing the background cover art to show through. A rough, hand-drawn approach suggests the "design" part of the name, while the "idea" part is represented by a light bulb with an eye-shaped filament.

❹ + ❺ The Image Comics "I" logo is a wonderfully simple design, allowing for great flexibility of use while remaining distinctive. Various coloring and rendering effects can be added, it can be reversed out, reduced, used as a container for images, and more.

❻ Even when cropped to a short, stumpy shape, as here for the Shadowline imprint, the brand is still instantly recognizable.

❼ – ❾ Interestingly, one of the market leaders in comics publishing for the past fifty years has survived without a particularly distinctive emblem or graphic symbol. Marvel's current logo is composed entirely of a heavy sans-serif typeface tweaked just enough to make it distinctive. Sometimes the company's name is enough.

❿ Canadian publishers Drawn & Quarterly deliberately chose a retroactive, nostalgic design to promote their company, which prides itself on publishing high quality literary and art comics.

⓫ Oni Press' cute devil face logo as designed by Dave Gibbons.

⓬ The logo for Terry Moore's self-publishing company cleverly makes an "S" shaped cut in an "A" shaped triangle, softening the hardness of the geometric shape. Simple but distinctive.

⓭ Sharp edge logos can denote hi-tech, aggressiveness, and energy, while curves suggest a warmer, friendlier company. Here, SLG Publishing's logo combines both.

⓮ – ⓰ Three landmark examples of the designs that DC Comics have used over the years, from the "postmark," through the DC "bullet," to the multi-media redesign for the new century.

1

2

3

4

5

6

7

8

9

10

11

12

13

14

15

16

Publication Design

High-quality graphic design for comic books and graphic novels has been neglected until recent years. A hastily assembled letters page for periodical pamphlets, or an uninspired cover design wrapped around a number of collected issues stripped of all other material for a "trade paperback" version was the norm. Even now, many periodicals contain extremely dated and, frankly, poorly designed text page layouts.

However, some publishers today give much more attention to the design of their graphic novels and even their regular comic books, borrowing more heavily from traditional book design. Front and end matter have become much more common, adding a sense of quality and value to a traditionally maligned and underappreciated art form.

COMPONENTS OF A BOOK

Traditional comic books rarely contained more than a cover, letters page, and advertising material in addition to the comics content. Most of today's major superhero books aren't much different, but some art comics creators have pushed the boundaries to include ancillary material such as articles, end papers, and title pages. The editorial structure of a "mature readers" graphic novel has more in common with a prose novel than a comic book.

Hardcover books often boast cloth binding, wraparound dust jackets, and endpapers. Front matter (sometimes called prelims) can include separate pages for title and half-title, frontispiece, publishing indicia, contents, dedication, preface, foreword, introduction, plus a number of blank pages. End matter can consist of all kinds of appendices, including pages for notes, glossary, bibliography, biography, index, acknowledgements, some limited advertising, and more. Sandwiched in between all this is the "body" of the book: the comics.

Of course, most graphic novels won't require all or even most of these extra pages, but the study of general book layout will always be an asset for the designer. None of these book components are fixed either; they can be creatively placed according to the designer's taste and the material available.

⊘ PERSEPOLIS,
JONATHAN CAPE, 2003

The first hardcover printing of Marjane Satrapi's breakthrough graphic novel in the UK contained front and end matter characteristic of a prose book.

The **dust jacket** is printed in black and flat, clashing red and blue primary colors, and introduces the distressed title typeface and decorative border.

FRONT MATTER:

❶ The **endpapers** here are simply black, although often these can contain a single expanded image or repeated pattern.

❷ The **verso** (left-hand) page here is also black, intentionally offsetting the opposite, recto (right-hand) page.

The **half-title** page often simply contains the title, here set in the same type as the cover.

❸ Blank **verso** page.

The **title page** itself usually adds the creators' names and the publisher. Here, the border from the cover has been reintroduced as a design element.

❹ **Publishing indicia.** This page, invariably on the verso page, contains copyright and other legal information, library cataloging information, the publisher's address, production details, and so on.

Introduction. Here the author has provided her own introduction. Often a third party will be commissioned to write a foreword to help give the book a higher profile.

❺ **Introduction continues.**

Second title page, used here to add further anticipation to the start of the story, simply using the title and another small design element from the front cover. Sometimes this page is a chapter opener, usually when the graphic novel is a collection of serialized episodes.

❻ **Blank page** to offset the start of the body of the book.

First page of the body of the book.

BACK MATTER:

❼ **Credits and Acknowledgments.** End matter such as an index is often irrelevant for comics material, but it varies from project to project.

Recto blank page mirrors the front of the book.

❽ Front and back **endpapers** usually mirror each other.

⊘ The **back cover** often contains a synopsis of the story, or sometimes, as in this case, simply review quotes, testimonials, and a barcode. The synopsis, author biography, price, and other details are provided on the inside flaps of the dust jacket.

1

2

3

4

5

6

7

8

149

PAGE PLANS

Roughing out "page plans" can help to clarify a logical sequence to the content of the book and helps the designer make decisions about pagination; which pages face which and so on. Magazines and books are always printed in multiples of at least four pages (a single sheet folded once) and, depending on the printing method used, sometimes eight, sixteen, or more. So the planning of front and end matter, chapter breaks, and so on can help add balance and allow the book's contents to breathe.

Blank pages and lots of negative space help to give an impression of quality and luxury.

Printed publications are often laid out in miniature as page plans several times before the layout proper is begun. This enables the designer not only to refine the overall design and nail down exactly what goes on which page, but also acts as a checklist for all necessary materials, images, and text.

◐ + ♡ My page plan for my graphic novel *Strangehaven: Conspiracies* allowed me to make sure that I had calculated the correct number of pages for all the required material, including the unnumbered inside covers. It also confirmed that page spreads fell as intended and that facing pages were balanced before I started to place them in page layout software.

▶ WIMBLEDON GREEN,
DRAWN & QUARTERLY, 2005

Seth's design for his own lavish *Wimbledon Green* hardcover included an extensive amount of front matter. Illustrations in his distinctive brush style, colored in a number of monochromatic palettes, provided verso title pages, background images for the endpapers, dedication page, and many other double-page spreads.

Despite some sixteen pages of prelims, Seth placed the publishing indicia on the same page as his biography at the back of the book.

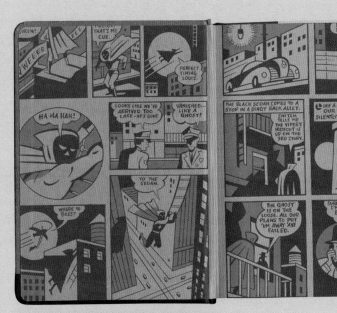

TEXT PAGES AND TYPE

Once upon a time, text page layouts were created using an extremely laborious and rather bizarre method of measurement, often using the Golden Rectangle as a basis. Thankfully, modern technology has provided a more convenient solution in the form of computer software.

Professional designers use a limited number of page layout programs. In the formative years of desktop publishing, QuarkXPress was preferred over PageMaker, but Adobe's InDesign provides excellent integration with Illustrator and Photoshop and is now considered a viable alternative.

Templates for page layout are included in these programs, but it is a straightforward task to create new ones. Text and images are easily imported and modified, making it a relatively simple task to create professional quality layouts. Of course, the designer's eye is required to make those layouts attractive and original.

Text pages are almost always based on an underlying grid system. These can range from a simple, two or three column layout up to highly flexible, complex grids which allow for a variety of material to be incorporated while maintaining a distinctive design.

Layouts should be planned across facing pages. Often, the design is mirrored on verso and recto pages, but it can also be designed asymmetrically, or even as a single unit.

Margins for high-quality books are usually wider than for paperback novels, magazines, and comic books. Wider margins, like all negative space, suggest luxury, while the thinner margins give an impression of value-for-money.

For the purposes of legibility it's important to use a clear, simple typeface for big chunks of text, particularly for a prose novel. The optimum number of characters per line is between sixty and seventy-two. Too many and it becomes hard to read; too few and the eye has to drop down to the next line too quickly.

Serif typefaces are generally understood to be easier to read in large blocks of text, while sans-serif fonts are used for headings. This rule has become less rigid in modern publications, with sans-serif type becoming more commonplace as body text. For magazines—or the occasional page in a comic book or graphic novel—the choice of font can be much more adventurous if desired.

Despite the enormous range of fonts available, it's important to limit the number of typefaces within one publication to retain an overall unity and style. Often, one display font for headings (possibly the same as the book's title logo) and another for the body of text is enough for a comic book with limited textual content. By judicious use of bold, italic, and point size variations, one font can prove very versatile.

Lines of type can be flush left or right, or justified to both edges of a column. Line spacing and other typographical options such as tracking can provide further flexibility.

Using too many different fonts, no matter how cool, can give the page an overall impression of being messy and unplanned.

Publishing houses may also have "style guidelines"; set rules for hyphenation, bold and italic use, punctuation, and more. They may also provide color palettes and other compulsory house design systems.

⊙ **LOVE & ROCKETS VOLUME II #15,**
FANTAGRAPHICS BOOKS, NOVEMBER 2005

This typically well-designed Fantagraphics text page makes great use of a clean, modern sans-serif font with reversed-out sidebar, and plenty of bold type and upper-case lettering to help break up the text.

It's easy to flow the text around irregular shaped illustrations using page layout programs, as the first page shows here. Based on a two-column grid with text flush left, the layout becomes more obvious on the second, more conventional page.

⊙ **FORLORN FUNNIES #1,**
ABSENCE OF INK, JUNE 2002

Art comics creator Paul Hornschemeier's books are always experimental, not just in content but in choice of print format and design. This inventive contents and indicia page, set opposite an equally unusual title page, from the first issue of his self-published series *Forlorn Funnies*, is a typical example of his imaginative work.

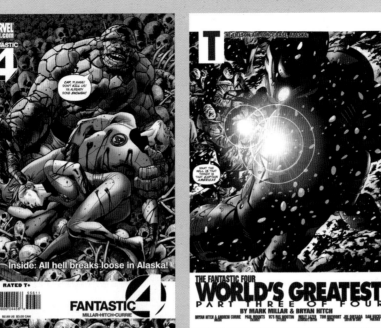

UNIFIED DESIGN

A modernist page layout with a mechanical type can look out of place in some publications. As always, the choice of layout and font should relate to the content of the book.

Ⓐ EIGHTBALL #17,
FANTAGRAPHICS BOOKS, AUGUST 1996

Carefully crafted hand-lettered text pages by art comics creators such as Seth, Chester Brown, and Dan Clowes add to the personality and value of the overall package, encouraging a further intimacy with the reader. Ever unconventional, Clowes even hand-letters his indicia and places it in the middle of the page.

Ⓑ FANTASTIC FOUR #556
MARVEL COMICS, JUNE 2008

The 2008 re-launch of *Fantastic Four* by Mark Millar and Bryan Hitch was propelled by its unified cutting edge design. The magazine-style cover features a sharply redesigned masthead that includes the barcode in a horizontal band.

The fresh, contemporary layout is mirrored in the recap page, the splash page, and even as panel captions throughout the comic.

Ⓒ MR. X #1,
VORTEX COMICS, JUNE 1984

Writer and Designer Dean Motter made a big impact in the mid 1980s with his *Mr. X* comic book. Not only was he able to enlist the artistic services of hot creator Jaime Hernandez, but the high production values and cutting-edge design were way ahead of their time, particularly for an independent comic.

Ⓓ COMPLETELY PIP AND NORTON VOLUME 1,
DARK HORSE COMICS, SUMMER 2002

Dave Cooper's unique illustrative cartoon style is utilized to its fullest in the prelims for his *Pip and Norton* collection. The publication indicia and contents are incorporated into a computer printout and Dave's own forehead respectively, perfectly integrating with the book's wildly colorful and frenetic content.

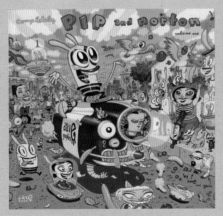

SPINE DESIGN

The spine should be conceived as part of the whole design structure of the book. Often the spine is an extension of the front and back covers, with images and color schemes wrapping around onto it.

In many cases the graphic novel's spine is only wide enough to accommodate the name of the book, its creators, and the publisher's logo. However, when locating a book on a shelf at home, the reader will look primarily for the predominant colors, size, and shape of the spine design, rather than reading the actual text.

Most books in shops, apart from the very latest releases, are stored on shelves spine out, due to space considerations. This can make the spine design vitally important.

Legibility is key. Upper case letters are often advisable for narrow spines, as the ascenders and descenders can force the reduction in size of the type.

The designer should emphasize the best known aspect of the book on the spine, whether it's the title of the book, the creative team or, in the case of a multi-volume series, the overarching name—like *Tintin* for example.

Wide spines can accommodate horizontal text, which is a bonus. Sometimes it's even possible to incorporate a small image.

⊙ Terry Moore's hugely successful and long-running *Strangers in Paradise* comic book series has been collected in a number of formats, most recently this set of manga-format pocket books. Given the physical dimensions of the books and the fact that the material was already published, this allowed the luxury of a design being planned to run across the spines of all six volumes.

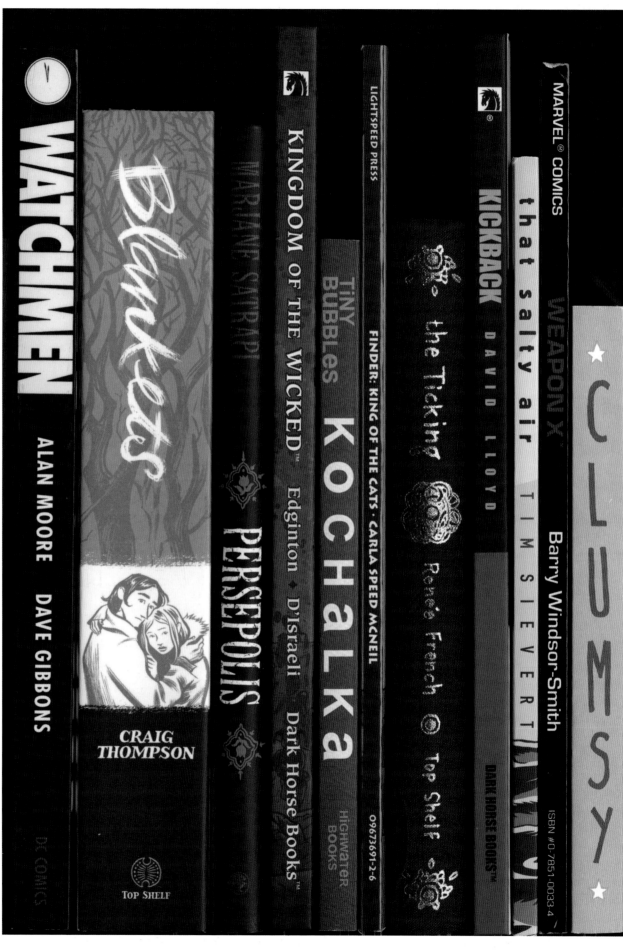

DUST JACKETS AND END FLAPS

The dust jacket can give the designer scope to produce a layout that extends across five areas; front and back covers, the spine, and both flaps. These are invariably wrapped around a hardcover which itself can be printed in full process color, or sport an embossed, cloth-covered, board cover.

End flaps are a recent development for paperback volumes, giving the designer as much canvas space as a traditional dust jacket.

◑ PALOMAR,
FANTAGRAPHICS BOOKS, 2003

The enormous collected omnibus edition of Gilbert Hernandez's masterpiece *Palomar* from the pages of *Love & Rockets,* is justly given sumptuous production values and a smart, appropriate design.

The embossed cloth hardcover is wrapped with a dust jacket, featuring a monochromatic montage of panels and an enlarged image section from the interior pages. Red and orange text provides the only color to the jacket, smartly placed on the large, black areas of negative space of the main image that wraps across front, spine, and back.

Picture Credits

Every effort has been made to credit the artists and/or publishers and copyright holders whose work has been reproduced in this book. We apologize for any omissions, which will be corrected in future editions, but hereby must disclaim any liability.

KEY:

T Top
B Bottom
L Left
R Right
C Center
BG Background

2 Lewis Trondheim, *Mister O*, © Guy Delcourt Productions
3 Jeff Smith, *Bone*, © 2009 Jeff Smith
4–5 Terry Dodson, *Spider-Man and the Black Cat: The Evil that Men Do*, © 2002 Marvel Characters, Inc.
7 Dave Gibbons, *The Originals*, © 2004 Dave Gibbons

INTRODUCTION

9RC Carlos Segura, *The Filth #1*, © 2002 DC/Vertigo Comics
11TC ILYA, *End of the Century Club: Countdown*, © 1995 ILYA
11TL Dave McKean, *Mr. Punch*, © 1994 Neil Gaiman & Dave McKean
9TL Frank Miller and Lynn Varley, *Elektra Lives Again*, © 1990 Epic Comics
9TR Cliff Sterrett, *The Complete Color Polly and Her Pals*, © 1990 Remco Worldservice Books
10 Alan Moore and Dave Gibbons, *Watchmen #1*, © 1986 DC Comics

CHAPTER 1

12 Dave Cooper, *Completely Pip and Norton Volume 1*, © 2002 Dave Cooper & Gavin McInnes
13 Dave McKean, *Cages*, © 1990, 91, 92, 93, 96, 98 Dave McKean
14L Brian Bolland, *The Killing Joke*, © 1988 DC Comics
14TC Glen Fabry, *Preacher: Proud Americans*, © 1997 DC Comics/Vertigo
14TR Tim Bradstreet, *The Punisher #1*, © 2007 Marvel Characters, Inc.
15BL Frank King, *Walt & Skeezix*, © 2005 The Estate of Frank King
15BR Terry Moore, *Strangers in Paradise Source Book*, © 2005 Terry Moore
15T Todd McFarlane, *Spider-Man: Birth of Venom*, © 2007 Marvel Characters, Inc.
16BL Alan Davis, *Excalibur*, © 2008 Marvel Comics Group
16BR James Kochalka, *American Elf Book 2*, © 2007 James Kochalka
16BC Shaun Tan, *The Arrival*, © 2006 Shaun Tan
16RC Alec McGarry, *Alec: Three-Piece Suit*, © 2001 Eddie Campbell
16TL Gipi, *Garage Band*, © 2005 Gipi
16TR Chester Brown, *Louis Riel*, © 2006 Chester Brown
17BR Lewis Trondheim, *A.L.I.E.E.E.N.*, © 2006 Lewis Trondheim
17CC Frank Miller, *The Big Guy and Rusty the Boy Robot*, © 1995 Dark Horse
17CR Jeff Smith, *Bone #5*, © 1992 Jeff Smith
17TC Art Spiegelman, *Maus II: A Survivor's Tale*, © 1986, 1989, 1990, 1991 Art Spiegelman
17TL Dave Sim, *Cerebus #75*, © 1985 Dave Sim & Gerhard
17TR Todd Dezago,*Tellos: Reluctant Heroes*, © 2001 Todd Dezago & Mike Wieringo
18BL Chris Ware, *Acme Novelty Library Vol 10 #4*, © 1998 Mr. C. Ware
18BR Moon Knight, © Marvel Characters, Inc.
18BC Batman, © 1986 DC Comics
18TL Jeff Smith, *Shazam: The Monster Society of Evil*, © 2007 DC Comics
18TR Superman #233, © 1971 DC Comics
19TR Alex Maleev, *Daredevil #41*, © 2003 Marvel Characters, Inc.
19BL Garth Ennis, *Midnighter #1*, © 2007 Wildstorm/DC Comics
19BR Bryan Hitch, *Fantastic Four #554*, © 2008 Marvel Characters, Inc.
19BC Kurt Busiek, Alex Ross, Brent Anderson, John Roshell and Steve Buccellato, *Astro City: Life in the Big City*, © 1995 Kurt Busiek
19CR Steve Gerber, *The Defenders*, © Marvel Comics Group
19TL Alan Moore, *Supreme* © Rob Liefeld
20BC Trevor Hairsine, *X-Men* (sketch), © 2008 Marvel Characters, Inc.
20BR Trevor Hairsine, *X-Men* (sketch), © 2008 Marvel Characters, Inc.
20BL *Amazing Spider-Man #070*, © 1969 Marvel Comics Group
20T Jim Steranko, *Captain America #111*, © 1969 Marvel Comics Group
21BC Gilbert Hernandez, *Palomar*, © 2003 Gilbert Hernandez
21BL *The Punisher* logo, © 2007 Marvel Characters, Inc.
21BL2 *X-Men* logo, © 2008 Marvel Characters, Inc.
21CL *Fantastic Four* logo, © 2008 Marvel Characters, Inc.
21CR Charles Schulz, *The Complete Peanuts 1953 to 1954*, © 2004 United Features Syndicate, Inc.
21TC Steve Ditko, *Strange Tales #110*, © 1963 Marvel Comics Group
21TL *Batman* logo, © 2008 DC Comics
21TL2 *Superman* logo, © 2008 DC Comics
22BL D'Israeli, *2000AD #15*, © 2008 Rebellion Developments/2000AD; Stickleback created by Ian Edginton & Disraeli
22BR D'Israeli, *2000AD #15*, © 2008 Rebellion Developments/2000AD; Stickleback created by Ian Edginton & Disraeli
22C D'Israeli, *2000AD #1594*, © 2008 Rebellion Developments/2000AD; The Vort created by G. Powell & D'Israeli
22T D'Israeli, *2000AD #1594*, © 2008 Rebellion Developments/2000AD; The Vort created by G. Powell & D'Israeli
23BL Trevor Hairsine, *X-Men: Deadly Genesis #4*, © 2006 Marvel Characters, Inc
23BC Trevor Hairsine, *X-Men: Deadly Genesis #4*, © 2006 Marvel Characters, Inc
23BR Trevor Hairsine, *X-Men: Deadly Genesis #4*, © 2006 Marvel Characters, Inc
23CL Shannon Wheeler, *Too Much Coffee Man*, © 2008 Shannon Wheeler
23CT Shannon Wheeler, *Too Much Coffee Man*, © 2008 Shannon Wheeler
23CR Shannon Wheeler, *Too Much Coffee Mystery Woman*, © 2008 Shannon Wheeler
23TR Shannon Wheeler, *Too Much Coffee Man #1*, © 1993 Shannon Wheeler
24BL *Amazing Spider-Man #252*, © 1984 Marvel Comics Group
24BR Olivier Coipel, *Thor #1*, © 2007 Marvel Characters, Inc.

24BC Jack Kirby and Chic Stone, *Journey into Mystery #105*, © 1963 Marvel Comics Group
24TR Grant Morrison and Frank Quitely, *New X-Men #114*, © 2001 Marvel Characters, Inc.
25T Alan Davis, *Fantastic Four: The End* (sketch), © 2006 Marvel Characters, Inc.
25BL Alex Ross and Jim Krueger, *Project Superpowers*, © Alex Ross/Jim Krueger
25BC Alex Ross and Jim Krueger, *Project Superpowers*, © Alex Ross/Jim Krueger
25BR Alex Ross and Jim Krueger, *Project Superpowers*, © Alex Ross/Jim Krueger
25CR Alan Davis, *Fantastic Four: The End #2*, © 2006 Marvel Characters, Inc.
26L Eddie Campbell, *From Hell*, © 1989, 1999 Alan Moore & Eddie Campbell
26R Charles Schulz, *The Complete Peanuts 1953 to 1954*, © 2004 United Features Syndicate, Inc.
27BL Seth, *Palooka-Ville #19*, © 2008 Seth (Gregory Gallant)
27BR Bryan Talbot, Dee's Laboratory from Bryan Talbot's *Luther Arkwright: Heart of Empire*, © 2001 Bryan Talbot
27CR Herge, *Tintin: Explorers on the Moon*, © 1954 Casterman
27TL Sam Hiti, *Tiempos Finales*, © 2004 Samuel Hiti
27TR Todd Dezago,*Tellos: Reluctant Heroes*, © 2001 Todd Dezago & Mike Wieringo
28 TL Dave Sim and Gerhard, *Cerebus: The Last Day*, © 2004 Dave Sim & Gerhard
28TC Dave Sim and Gerhard, *Cerebus: The Last Day*, © 2004 Dave Sim & Gerhard
28TR Dave Sim and Gerhard, *Cerebus: The Last Day*, © 2004 Dave Sim & Gerhard
28 CL Dave Sim and Gerhard, *Cerebus: The Last Day*, © 2004 Dave Sim & Gerhard
28CC Dave Sim and Gerhard, *Cerebus: The Last Day*, © 2004 Dave Sim & Gerhard
28CR Dave Sim and Gerhard, *Cerebus: The Last Day*, © 2004 Dave Sim & Gerhard
28BC Gerhard, *Cerebus #139*, © 1990 Dave Sim & Gerhard
28BL Shaun Tan, *The Arrival*, © 2006 Shaun Tan
28BR Gerhard, private photo, © 1990 Gerhard
29BL Wally Wood, *Weird Science #16*, © 1985 William M. Gaines
29R Kevin O'Neill, *The League of Extraordinary Gentlemen: The Black Dossier*, © 2007 Alan Moore & Kevin O'Neill
29TL Paul Grist, *Kane #13*, © 1996 Paul Grist
31TR Seth, *The Complete Peanuts 1951 to 1952*, © 2004 United Features Syndicate, Inc.
31BL Seth, *Clyde Fans*, © 2006
31BR Seth, *Clyde Fans*, © 2006
31CBL Seth, *Bannock Beans and Black Tea*, © Seth (Gregory Gallant)
31CBR Seth, *Clyde Fans*, © 2006
31CTR Seth, *The Complete Peanuts 1951 to 1952*, © 2004 United Features Syndicate, Inc.
31TL Seth, *Palooka-Ville #19*, © 2008 Seth (Gregory Gallant)

CHAPTER 2

33 P. Craig Russell, *The Ring of the Nibelung Volume 2*, © 2000, 2001 and 2002 P. Craig Russell
34 John Romita Jr., *Amazing Spider-Man*, © 2003, Marvel Characters Inc.
35T Jim Woodring, *Frank Volume 2 #4*, © 1994 Jim Woodring/ Fantagraphics Books
35B Jim Woodring, *Frank Volume 2 #4*, © 1994 Jim Woodring/ Fantagraphics Books
36T Ed Brubaker, *Criminal*, © 2006 Ed Brubaker and Sean Phillips
36C Ed Brubaker, *Criminal*, © 2006 Ed Brubaker and Sean Phillips
36B Ed Brubaker, *Criminal*, © 2006 Ed Brubaker and Sean Phillips
37L Ed Brubaker, *Criminal*, © 2006 Ed Brubaker and Sean Phillips
37R Ed Brubaker, *Criminal*, © 2006 Ed Brubaker and Sean Phillips
37BG Ed Brubaker, *Criminal*, © 2006 Ed Brubaker and Sean Phillips
38 Bernie Krigstein, *Impact #1*, © 1985, William M. Gaines
39T Lewis Trondheim, *La Mouche*, © 1995 Edicions du Seuil
39BL Paul Gulacy, *Master of Kung Fu #38*, © 1976 Marvel Comics Group
39CR Chester Brown, *Yummy Fur*, © 1987 Chester Brown
40L Ian Edlington and D'Israeli, *Kingdom of the Wicked*, © 1997, 2004, Ian Edlington and D'Israeli
40R Cathy Malkasian, *Percy Gloom*, © 2007, Cathy Malkasian
41 Mike Mignola, *Hellboy, The Corpse*, © 1996, 1998, 2004, Mike Mignola
42T Jeffery Brown, *Unlikely*, © 2003 Jeffery Brown
42B Simone Lia, *Fluffy*, © 2007, Simone Lia
43TL Alan Moore and Bill Sienkiewicz, *Big Numbers #1*, © 1990 Alan Moore and Bill Sienkiewicz
43TR Brian Hitch, *Fantastic Four # 556*, © 2008 Marvel Characters Inc
43BL Chester Brown, *The Little Man and Other Stories*, © 1987 Chester Brown
43BR Charles Burns, *Skin Deep* © 1988-1992 Charles Burns
44TL Rick Geary, *At Home with Rick Geary*, © 1985 Rick Geary
44TR Ted Naifeh, *Death Jr. #3*, © 2005 Back Home Entertainment
44CL Melinda Gebbie, *Lost Girls*, TM & © 1991-2006 Alan Moore and Melinda Gebbie
44BR Kim Deitch, *Karla in Kommieland*, © 1989 Kim Deitch
44BG Rick Geary, *At Home with Rick Geary*, © 1985 Rick Geary
45L Ben Templesmith, *Fell #9*, © 2007 Warren Ellis and Ben Templesmith
45R Carla Speed McNeil, *Finder: King of the Cats*, © Carla Speed McNeil
46CL Golden Rectangle
46TR Gilbert Hernandez, *Love & Rockets* © 1985 Gilbert Hernandez
46CR Gilbert Hernandez, *Love & Rockets* © 1985 Gilbert Hernandez
46CB Gilbert Hernandez, *Love & Rockets* © 1985 Gilbert Hernandez
47TL Gipi, *Garage Band*, © 2005 Gipi
47TR Gipi, *Garage Band*, © 2005 Gipi
47C Jack Kirby, *Fantastic Four #087*, © 1969 Marvel Comics Group
47BL Jack Kirby, *Fantastic Four #087*, © 1969 Marvel Comics Group
47BC Jack Kirby, *Fantastic Four #087*, © 1969 Marvel Comics Group
47BR Jack Kirby, *Fantastic Four #087*, © 1969 Marvel Comics Group
48T Gipi, *Garage Band*, © 2005 Gipi
48B Lorenzo Mattotti, *Fires*, © 1986-1988 Editions Albin Michel S.A
49 Joe Sacco, *Notes from a Defeatist*, © 2003 Joe Sacco
50L Sean Phillips, *Marvel Zombies #3*, © 2006 Marvel Characters, Inc.
50R Francois Schuiten, *Cities of the Fantastic: Brusel*, © 1992 Casterman
51L Francois Boucq, *The Magician's Wife*, 9c) 1987 Jerome Charyn and Francois Boucq
51CR Oscar Zarate, *A Small Killing*, © 1991 Alan Moore and Oscar Zarate

51BR Will Eisner, *A Contract with God*, ©1978, 1985 Will Eisner
52 David Lloyd, *Kickback*, © David Lloyd www.lforlloyd.com
53TL Alex Toth, *Torpedo 1936*, ©1982 Enrique Sanchez Abuli and Alex Toth
53CL David B, *Epileptic*, ©2005 L'Association, Paris, France
53R Mike Mignola, *Hellboy: The Corpse*, © 1996, 1998, 2004 Mike Mignola
54 Jim Steranko, *Captain America #111*,© 1969 Marvel Comics Group
55TR Frank King, *Gasoline Alley*, © Tribune Media Services
55TC Seth *Palooka-Ville #19*, © 2008 Seth (Gregory Gallant)
55TL Bryan Talbot, *The Adventures of Luther Arkwright*, © 1989 Bryan Talbot
55BL Robert Crumb, *A Short History of America*, © 1979 Robert Crumb
55BC Posy Simmonds, *Gemma Bovery*, ©1999 Posy Simmonds
56L Alison Bechdel, *Fun Home*, © 2006 Alison Bechdel
56R Paul Grist, *Kane #13*, © 1996 Paul Girst
57L Shaun Tan, *The Arrival* © 2006 Shaun Tan
57R Eddie Campbell, *From Hell*, ©1991, Alan Moore and Eddie Campbell
58 Matt Kindt, *Super Spy*, © 2007 Matt Kindt
59TL Matt Kindt, *2 Sisters*, © 2004 Matt Kindt
59TR Matt Kindt, *Super Spy*, © 2007 Matt Kindt
59BR Matt Kindt, *Pistolwhip*, © 2001 Matt Kindt
59BC Matt Kindt, *Super Spy*, © 2007 Matt Kindt
59BL Matt Kindt, *Super Spy*, © 2007 Matt Kindt

CHAPTER 3

61 Farel Dalrymple, *Omega the Unknown #2*, © 2008 Marvel Characters, Inc
62 Steve Ditko, *Amazing Spider-Man #024*, © 1965 Marvel Comics Group
63 John Romita Jr. and Tom Palmer, *Incredible Hulk #36*, © 2002 Marvel Characters, Inc.
64BL Marjane Satrapi, *Persepolis*, © 2003 L'Association, Paris, France
64BR Eddie Campbell, *From Hell*, © 1989, 1999 Alan Moore & Eddie Campbell
64CL Marjane Satrapi, *Persepolis*, © 2003 L'Association, Paris, France
64T Nine-Panel Grid
65L Dan Clowes, *Caricature*, © 1996 Daniel G. Clowes/Fantagraphics Books
65R Farel Dalrymple, *Omega the Unknown #6*, © 2008 Marvel Characters, Inc.
66 Jack Kirby, *Fantastic Four #099*, © 1970 Marvel Comics Group
67BR Dave Gibbons, *The Originals*, © 2004 Dave Gibbons
67TR James Kochalka, *Tiny Bubbles*, © 1998 James Kochalka
67TL Charles Burns, *Black Hole*, © Charles Burns
68BL Jason Lutes, *Berlin #14*, © 2007 Jason Lutes
68BR Howard Cruse, *Stuck Rubber Baby*, © 1995 Howard Cruse
68TL Neil Gaiman, *Signal to Noise*, © 1989, 1992 Neil Gaiman & Dave McKean
68TR Frank Miller, *Elektra Lives Again*, © 1990 Epic Comics
69 Lewis Trondheim, *Mister O*, © Guy Delcourt Productions
70 George Herriman, *Krazy & Ignatz 1939-1940*, © 2007 Fantagraphics Books
71BR Herge, *Tintin: The Blue Lotus*, © 1946 Casterman
71TL Baru, *The Road to America*, © 2002 Baru
71TR Albert Uderzo, *Asterix in Britain*, © 1966 Dargaud Editeur
72L Adrian Tomine, *Optic Nerve #9*, © 2004 Adrian Tomine
72R Dan Clowes, *Eightball #23*, © 2004 Daniel G. Clowes
73 Gilbert Hernandez, *Love & Rockets*, © 1985 Gilbert Hernandez
74B David Lloyd, *Kickback*, ©2008 David Lloyd www.lforlloyd.com
74T Lenil Yu, *Secret Invasion #1*, © 2006 Marvel Characters, Inc.
75BR Dave Sim, *Cerebus: Melmoth*, © 1991 Dave Sim & Gerhard
75L Howard Chaykin, *American Flagg! Hard Times*, © 1985 First Comics Inc. & Howard Chaykin
75TR Raymond Briggs, *When the Wind Blows*, © 1982 Raymond Briggs
76 Frank Miller, *Elektra Lives Again* © 1990 Epic Comics
77BL Bryan Talbot, *Alice in Sunderland*, © 2007 Bryan Talbot
77BR Paul Grist, *Kane Volume 5: The Untouchable Rio Costas*, © 2005 Paul Grist
77CL Jim Starlin, *Warlock #12*, © 1976 Marvel Comics Group
77T Will Eisner, *Minor Miracles*, © 2000 Will Eisner
78B Gary Panter, *Invasion of the Elvis Zombies*, © 1984 Gary Panter/ Raw Books
78TL Gabriel Ba, *The Umbrella Academy #1*, © 2007 Gerard Way
78TR Steve Niles, *Dead She Said #1*, © 2008 Steve Niles & Bernie Wrightson
79T Matt Kindt, *Super Spy*, © 2007 Matt Kindt
79BL Renee French, *The Ticking*, © & T 2005 Renee French
79BR Dave Gibbons, *The Originals*, © 2004 Dave Gibbons
80L Howard Cruse, *Stuck Rubber Baby*, © 1995 Howard Cruse
80R Joe Sacco, *Palestine*, © 1993, 94, 95, 96, 2001 Joe Sacco
81BC Alan Davis, *Fantastic Four: The End* (sketch), © 2006 Marvel Characters, Inc.
81BR Alan Davis, *Fantastic Four: The End #5*, © 2006 Marvel Characters, Inc.
81TR Alan Davis, *Fantastic Four: The End* (sketch), © 2006 Marvel Characters, Inc.
81TL Neal Adams, *X-Men #58*, © 1969 Marvel Comics Group
82L Jim Steranko, *Captain America #113*, © 1969 Marvel Comics Group
82R Chris Ware, *Acme Novelty Library #18*, © 2007 F. C. Ware
83L Craig Thompson, *Blankets*, © 2003 Craig Thompson
83R Melinda Gebbie, *Lost Girls*, TM & © 1991-2006 Alan Moore & Melinda Gebbie
84L Jack Kirby, *Fantastic Four #083*, © 1968 Marvel Comics Group
84R Dave Stevens, *The Rocketeer*, © 1985 Dave Stevens
85B Moebius, *Arzach*, © 1976 Les Humanoides Associes
85T Gipi, *Garage Band*, © 2005 Gipi
86BR D'Israeli, *Leviathan*, © 2008 Rebellion A/S. All rights reserved. www.2000adonline.com
86BL D'Israeli, *Leviathan* (sketch), © 2008 Rebellion A/S. All rights reserved. www.2000adonline.com
86CL D'Israeli, *Leviathan* (sketch), © 2008 Rebellion A/S. All rights reserved. www.2000adonline.com
86T Bryan Talbot, *Fantastic Four #557*, © 2008 Marvel Characters, Inc.
87B Ron Embleton, *Wrath of the Gods*,
87T Alex Robinson, *Box Office Poison*, © 2001 Alex Robinson
89B Chris Ware, *Jimmy Corrigan: The Smartest Kid on Earth*, © Mr. C. Ware
89TC Chris Ware, *Krazy & Ignatz 1939-1940*, © 2007 Fantagraphics Books
89TL Chris Ware, *Acme Novelty Library Vol 3 # 4*, © 1994 Mr. C. Ware
89TR Chris Ware, *Acme Novelty Library Vol 2 #2*, © 1994 Mr. C. Ware

Index

Acknowledgments

To my great friend Dave Whitwell whose encouragement, encyclopedic knowledge, and expansive personal collection were of huge benefit in the creation of this book;

To the creators that provided me with valuable and insightful behind-the-scenes materials;
Alan Davis www.alandavis-comicart.com
Ben Dimagmaliw
D'Israeli aka Matt Brooker www.disraeli-demon.com
Eric Shanower www.age-of-bronze.com
Gerhard
J. G. Roshell & Richard Starkings at Comicraft www.comicraft.com
José Villarrubia www.myspace.com/josevillarrubia
Matt Kindt www.supersecretspy.com
Nate Piekos at Blambot www.blambot.com
Trevor Hairsine
Sean Phillips www.seanphillips.co.uk
Shannon Wheeler www.tmcm.com

To the creators and publishers that kindly provided me with advice, quotes, and digital files;
Al Davison www.astralgypsy.com
Brian Biggs http://mrbiggs.com
Brian Wood www.brianwood.com
Bryan Talbot www.bryan-talbot.com
Dan Clowes
David Hitchcock www.blackboar.co.uk
David Lloyd www.lforlloyd.com
Diana Schutz at Dark Horse Comics
Eddie Campbell http://eddiecampbell.blogspot.com
Howard Cruse www.howardcruse.com
Jim Titus
Kurt Busiek www.astrocity.us
Terry Moore www.strangersinparadise.com
Vijaya, Kathleen, and Tom at Cartoon Books www.boneville.com

For his extremely flattering introduction;
Dave Gibbons

For permission to use Fone Bone on the cover;
Jeff Smith

For help and advice in obtaining rights, permissions, and other information;
Chris Staros and Brett Warnock at Top Shelf Productions, Inc.
www.topshelfcomix.com
Dylan Horrocks www.hicksville.co.nz
Joel Meadows

To the huge number of creators and publishers that so kindly granted permission for their copyright images to be reproduced here;

To all at Ilex that made this book happen;
Chris Gatcum
Isheeta Mustafi
Nick Jones
Tim Plicher

And finally to the dozens of people who deserve to be mentioned by name and whom I have no excuse for forgetting;

Thank you one and all.
This book would have been slightly less wonderful without your input.

SPINE DESIGN

The spine should be conceived as part of the whole design structure of the book. Often the spine is an extension of the front and back covers, with images and color schemes wrapping around onto it.

In many cases the graphic novel's spine is only wide enough to accommodate the name of the book, its creators, and the publisher's logo. However, when locating a book on a shelf at home, the reader will look primarily for the predominant colors, size, and shape of the spine design, rather than reading the actual text.

Most books in shops, apart from the very latest releases, are stored on shelves spine out, due to space considerations. This can make the spine design vitally important.

Legibility is key. Upper case letters are often advisable for narrow spines, as the ascenders and descenders can force the reduction in size of the type.

The designer should emphasize the best known aspect of the book on the spine, whether it's the title of the book, the creative team or, in the case of a multi-volume series, the overarching name—like *Tintin* for example.

Wide spines can accommodate horizontal text, which is a bonus. Sometimes it's even possible to incorporate a small image.

⊙ Terry Moore's hugely successful and long-running *Strangers in Paradise* comic book series has been collected in a number of formats, most recently this set of manga-format pocket books. Given the physical dimensions of the books and the fact that the material was already published, this allowed the luxury of a design being planned to run across the spines of all six volumes.

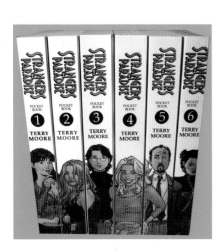

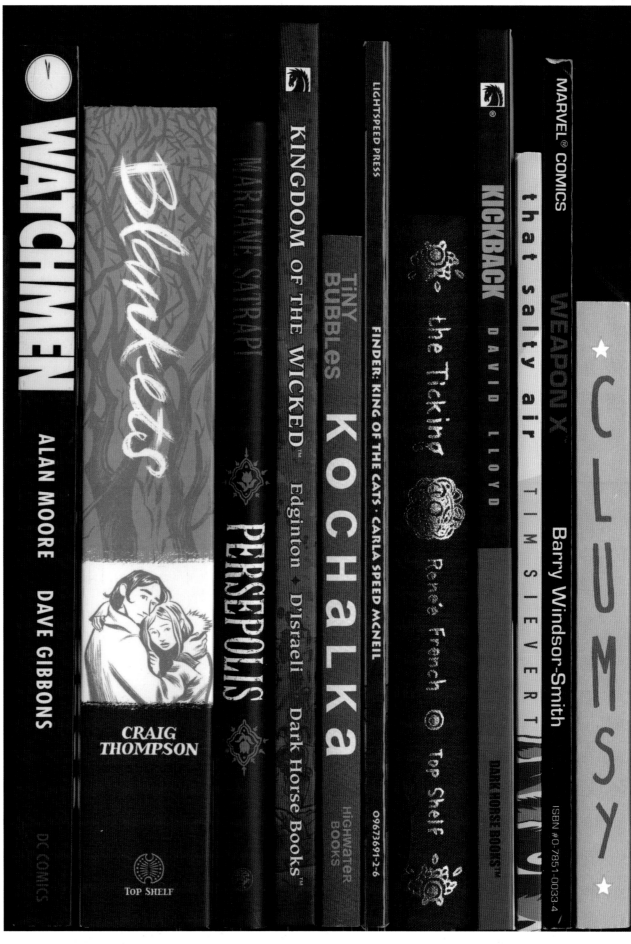

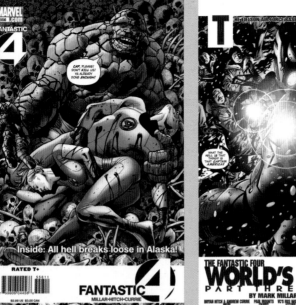

Inside: All hell breaks loose in Alaska!

FANTASTIC 4
MILLAR-HITCH-CURRIE

THE FANTASTIC FOUR
WORLD'S GREATEST
PART THREE OF FOUR
BY MARK MILLAR & BRYAN HITCH

A team—and a family—of adventurers, explorers and imaginauts, the Fantastic Four lead lives both ordinary—and extraordinary!

UNIFIED DESIGN

A modernist page layout with a mechanical type can look out of place in some publications. As always, the choice of layout and font should relate to the content of the book.

Ⓐ EIGHTBALL #17,
FANTAGRAPHICS BOOKS, AUGUST 1996

Carefully crafted hand-lettered text pages by art comics creators such as Seth, Chester Brown, and Dan Clowes add to the personality and value of the overall package, encouraging a further intimacy with the reader. Ever unconventional, Clowes even hand-letters his indicia and places it in the middle of the page.

Ⓑ FANTASTIC FOUR #556
MARVEL COMICS, JUNE 2008

The 2008 re-launch of *Fantastic Four* by Mark Millar and Bryan Hitch was propelled by its unified cutting edge design. The magazine-style cover features a sharply redesigned masthead that includes the barcode in a horizontal band.

The fresh, contemporary layout is mirrored in the recap page, the splash page, and even as panel captions throughout the comic.

Ⓒ MR. X #1,
VORTEX COMICS, JUNE 1984

Writer and Designer Dean Motter made a big impact in the mid 1980s with his *Mr. X* comic book. Not only was he able to enlist the artistic services of hot creator Jaime Hernandez, but the high production values and cutting-edge design were way ahead of their time, particularly for an independent comic.

Ⓓ COMPLETELY PIP AND NORTON VOLUME 1,
DARK HORSE COMICS, SUMMER 2002

Dave Cooper's unique illustrative cartoon style is utilized to its fullest in the prelims for his *Pip and Norton* collection. The publication indicia and contents are incorporated into a computer printout and Dave's own forehead respectively, perfectly integrating with the book's wildly colorful and frenetic content.

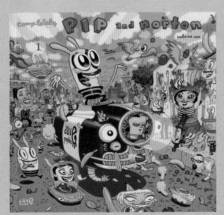